***Featured on CNN TV News!

"A delightful balance between entertaining travel stories of others and resources to plan your own.
The final section is extremely helpful for planning because it contains a list of companies that specialize in adventure travel."

Library Journal

"Expertly written book is a fascinating, practical guide as well as a good read."

Travelwriter Marketletter

"Hot news off the press! Looks like a winner for any woman who wants to raft through the Grand Canyon, scuba dive with sea lions, or walk across Australia."

Travelin' Woman Newsletter

ACTIVE WOMAN VACATION GUIDE

**True Stories by Women Travelers
Plus 1001 Exciting Adventure Trips**

by Evelyn Kaye

A BPP Travel Resource Guide

ACTIVE WOMAN VACATION GUIDE
by Evelyn Kaye

Published by Blue Panda Publications (formerly Blue Penguin)
3031 Fifth Street
Boulder, Colorado 80304
Phone: 303-449-8474

Book design by Christopher Sarson
Cover design by George Roche Design
Cover photo of Antarctica by Evelyn Kaye

© Copyright 1997 by Evelyn Kaye
Printed in the United States of America
First Edition

Publisher's Cataloging in Publication

Kaye, Evelyn, 1937-
 Active woman vacation guide / by Evelyn Kaye.
 p. cm.
 Includes bibliographical references and index.
 Pre-assigned LCCN: 96-085757
 ISBN 0-9626231-8-0

 1. Travel--Guidebooks. 2. Women--Travel--Guidebooks. 3. Women travelers. I. Title.

 G151.K39 1997 910.2'02'082
 QBI96-40896

"A woman's place is wherever she wants to go!"
Beverly Antaeus, *Hawk, I'm Your Sister.*

Books by Evelyn Kaye

Free Vacations & Bargain Adventures in the USA (Blue Penguin, 1995)

Amazing Traveler: Isabella Bird. The biography of a Victorian adventurer. (Blue Penguin, 1994) Award: Third Place Award, Nonfiction, CIPA 1995.

Travel and Learn, 3rd edition, 1995 (Blue Penguin: 2nd edition, 1992; 1st edition, 1990) Awards: National Mature Media Silver Award, Best Travel Book 1992; MIPA, Award of Merit, Best Travel Book 1993.

Family Travel: Terrific New Ideas for Today's Families (Blue Penguin, 1993) Award: Gold First Prize Award for cover and interior design, CIPA, 1994.

Eco-Vacations: Enjoy Yourself and Save the Earth (Blue Penguin, 1991) Quality Paperback Book Club selection.

College Bound with Janet Gardner (College Board, 1988).

The Parents Going-Away Planner with Janet Gardner (Dell, 1987).

The Hole In The Sheet (Lyle Stuart, 1987).

Write and Sell Your TV Drama! *with Ann Loring* (ALEK, revised 1993).

Relationships in Marriage and the Family, with Stinnett and Walters (Macmillan, 1984).

Crosscurrents: Children, Families & Religion (Clarkson Potter, 1980).

The Family Guide to Cape Cod with Bernice Chesler (Barre/Crown, 1979).

How To Treat TV with TLC (Beacon Press, 1979).

The Family Guide to Childrens Television (Pantheon, 1975).

Action for Childrens Television, Editor (Avon, 1972).

THE AUTHOR

Evelyn Kaye's travels began when she sailed to Canada from England as a child with her grandmother and stayed in Toronto for four years. When she returned to England, she went to school in London, and spent time traveling in Europe and Scandinavia.

She loves adventure travel, and has sailed around the Galapagos Islands, camped in an Amazon rainforest, rafted through the Grand Canyon, and horsepacked in Colorado's Sangre de Cristo Mountains. She recently visited Antarctica to observe icebergs, penguins, and seals from a Russian research ship, and Baja California to touch friendly whales. On all her recent trips, she's noticed that more and more women are enjoying the outdoors and joining adventure vacations.

As a journalist, she was the first woman reporter in the *Manchester Guardian's* newsroom, worked in Paris for Reuters News Agency, and wrote articles while living in Jerusalem for a year. Her articles have been published in the *New York Times, Boston Globe, Denver Post, McCalls, New York, Travel & Leisure, Glamour, Ladies Home Journal*, and other major publications. This is her 18th book.

Evelyn Kaye has appeared on ABC-TV's *Good Morning America!* and on TV and radio shows nationwide talking about travel. She is the founder and was first president of Colorado Independent Publishers Association, served on the board of Publishers Marketing Association, was president of the American Society of Journalists and Authors, and is a member of the Society of American Travel Writers. She is listed in *Who's Who in America*. She lives with her family in Boulder, Colorado.

CONTENTS

APPENDICES

INTRODUCTION

On all the recent adventure vacations I have taken—observing penguins in Antarctica, horsepacking in the Colorado mountains, whalewatching in Baja—I'm aware that there are always more women than men on the trips.

This personal observation is not a fluke. There's been an unexpected revolution in the world of adventure travel. Today, the majority of people taking hiking, trekking, camping, canoeing, river rafting, kayaking, sailing, climbing, biking, and other outdoor vacations are women! Statistics from the Adventure Travel Society reveal that women adventure travelers now outnumber men. Adventure travel companies have found that most of the people trekking trails or paddling through the waves are active women.

The increasing number of women adventure travelers is changing the face of the industry. Sheila and Dave Mills run river-rafting trips in Idaho. "Years ago, we used to get 18 guys and 14 kegs of beer on our trips," they say, "which wasn't exactly how we like to go down the river. Now we get more women than men, and have a very different kind of experience."

Women today also run adventure travel companies:

♦ Linda Svendsen began leading groups of men and women across the high plains of Inner Mongolia on horseback in 1985, and now offers dozens of horseriding adventures in Tibet, Xinjian, Mongolia, and South America.

♦ Stanlynn Daugherty's company, Hurricane Creek Llama Treks, began in 1984, and takes small groups hiking with llamas in Oregon's wilderness areas.

♦ The National Womens Sailing Association was created to encourage more women to learn to sail on their own.

♦ Overseas Adventure Travel, a leader in international adventure travel with trips to Antarctica, South America, Asia, Africa, and the Mediterranean, is headed by a woman, has many women on staff, and the majority of the people who travel with them are women, many of them over 40.

The definition of an adventure vacation is that it is a vacation where you actively and physically participate, as opposed to a tour where you are more or less a passive observer. Some vacations are more challenging than others, but all of them demand activity.

Adventure tourism is the fastest growing segment of the travel and tourism industry, and generates more than $400 billion dollars in the United States annually. According to the Travel Industry Association of America, 73.5 million US adult travelers have participated in outdoor adventure vacations at some time during their lives.

One new wrinkle is the growing number of adventure travel companies offering trips for women only. The women who run these trips and those who take them find that for beginners, an all-women group provides a more supportive atmosphere. They don't have to worry as much that their physical limitations will be embarrassing, or that they'll never keep up with the group. Men on outdoor adventures often show a competitive streak, eager to climb the highest or bike the farthest, whereas many women enjoy the adventure as an achievement on a personal level.

One woman from Minnesota who's taken biking, rafting, and rock-climbing trips with women, explained: "Men want to take control and set the pace. All-woman trips are more inter-

esting and relaxed, especially when you're camping. The variety of ages and backgrounds make for a fascinating experience."

Other women praise the camaraderie that develops, the fun of meeting other women from different backgrounds, sharing their stories, and enjoying the experience together. Gloria Smith of Womantours runs a variety of challenging bicycle tours for women and commented: "We like men, but who needs them to show you how fast they can do it?"

The range of women who choose these trips is interesting. Susan Eckert of Montana, who started Rainbow Adventures in 1982, notes: "Women in their 30s through their 70s come on our trips. Most are or have been married and have between one and three children. The average adventurer is 50 years old, and she's quite satisfied with her life and successful in her current job or situation. She is also confident about how she looks and feels, and makes an effort to stay in good physical condition."

Many women respond enthusiastically to their first experience of active outdoor adventure. Peggy Willens of Woodswomen offers women adventure vacations in Minnesota, Wisconsin, and the west. She knows how much women gain from the experience: "Some participants see themselves as active and capable outdoorswomen for the first time, while others use the experience to commemorate an important transition in their lives. Many women over 45 or 50 come away with an increased appreciation for their bodies."

Elaine Frances of Chestnut Hill, Massachusetts, had never camped or paddled a canoe before. She decided to take a canoe trip with an all-women group, and enthuses: "It was the greatest experience of my life, and I fell in love with it. Now I've canoed the Missouri, the Rio Grande, and the Green River in Utah, and I'm planning my next trip."

Life-changing experiences can result from these adventures. After a week in Montana sampling river rafting, hiking, canoeing, horseback riding, and visiting Yellowstone National Park with an all-women group, Suzanne Percer of Memphis, Tennessee, said: "It was fabulous! The hiking—that was my very favorite. When I saw the views of the mountain scenery, I felt as if my whole heart was opening up. My trip motivated me to do some of the things I've always wanted to do. When I came home,

I started learning to fly. Now I'm a month away from getting my pilot's license."

Even companies that offer adventure trips for both men and women sometimes include a few for women only. Journeys International of Michigan offers one all-women trek to Nepal, and Pat Ballard, director of sales, explains: "When men travel with us to Nepal, none of the local women will meet us because it's unacceptable in their culture for women to meet foreign men. When we are all women, the group is invited into people's homes to meet and talk with the families. That's a cultural experience that enhances the trip immeasurably."

This isn't the first time women have traveled for adventure. In the past there have been adventurous women travelers, but they were few and far between. Ida Pfeiffer (1792-1858) dreamed of travel during her childhood years in Austria, and took her first trip around the world after her two sons were grown. Fanny Bullock Workman (1859-1925), born in the United States, moved to Europe after her marriage so that she and her husband could travel and write books about their trips; they went biking in Spain and Africa, and climbed some of the highest peaks of the Himalayas. Isabella Bird (1831-1904) left her home in Scotland and traveled alone through the United States, Japan, China, Korea, Persia, and Tibet.

While yesterday's women travelers were exceptions, today thousands of average women can take off to see the world. It's a result of better health care for women, more education, time for travel, and financial independence. For the first time, this generation of women often earns enough money from a job or their own businesses to be able to afford a personal vacation, which their mothers couldn't do. Men have traditionally taken time off from work and family to enjoy what they like—play golf or tennis, go hunting and fishing—while few women ever demanded vacations on their own. Now, women are discovering the joys of adventurous outdoor vacations, without husbands, families, or responsibilities, where they can relax and be themselves.

The revolution is only beginning. In the years ahead, more and more women will paddle their own canoes, horsepack into the wilderness, and kayak among the whales. The opportunities are endless. One woman tour leader summed it up when she told me: "A woman's place is wherever she wants to go."

HOW TO USE THIS BOOK

T his is a BPP Travel Resource Guide, a pre-trip book with unique, timely, and valuable information for you about how to find unusual, offbeat, and affordable trips with the focus on women and adventure.

The first half of the book contains essays by women who share with you their personal experiences of adventure travel from yesterday and today.

The second half lists, in alphabetical order, the companies that offer adventure trips you can take. At the end are cross-referenced lists and useful information to help you make your choice. Before you call a travel agent, check out what is available.

What will I find in this book?

In the first chapter, there is a look back at the preparations women travelers of the past had to make before they set off—not that much different from today! The next six chapters focus on particular adventure topics: bicycle touring and horse riding, climbing mountains, hiking, walking, sailing, rafting, fishing, scuba diving, skiing, hunting, and a selection of unusual adventures, such as trips to Antarctica and Siberia. Each of these chapters presents a variety of first-hand adventure travel stories, some told by daring Victorian ladies who scaled the moun-

tains in long skirts, and others by modern women who have river rafted through the wild waters of the Grand Canyon. Every entry reflects excellent writing and great traveling.

At the end of these chapters is a list of companies that offer similar adventure vacations.

The second half of the book is a carefully selected A-Z listing of adventure travel companies, with complete details of names, addresses, phone and fax numbers, e-mail and websites, prices, sample trips, if they offer special programs for women only, and first-hand comments from women who have taken these trips recently.

What kinds of trips are these?

There are a wide range of outdoor and active vacations. You can join all-women sailing tours in Florida, cruise on a refurbished 19th century schooner in Maine, canoe along the Minnesota Boundary Waters, river raft in California, sea kayak the coast of Oregon, and paddle among the glaciers of Alaska. You can take week-long walks through England's gardens or the French Riviera, visit South America's ancient monuments, float on canals through Germany and the Netherlands, or explore Egypt and Israel. You can ride a wagon train and re-enact the pioneer trips west, spend time at a dude ranch and round up cattle, gallop across the vast grassy plains of Mongolia, canter along the beaches of western Ireland, or take a riding safari in Africa. Decide where you want to go, when you can take off, pick your activity, and choose your level from easy to strenuous.

How did you find out about these trips?

Much of the information comes from my own long-time adventure travel experiences, which cover a great deal of territory. This I back up with up-to-date research into the places and tours available today from brochures, magazines, questionnaires I send out, and other sources. I collect advice from well-traveled adventuresses, and from people who have taken specific trips recently. This has been an exciting book to research and write because of the fascinating people around the country I've talked to about their adventure vacations. They told me what they

liked, and what they didn't, so you get first-hand research from people who aren't afraid to tell it like it is.

Who offers these trips?

Adventure travel companies in the United States offer these trips. Some are run by men and women who accompany you on the trips. Others employ qualified guides with expertise in the activities and regions to which you travel. Some companies run by women for women provide wilderness and adventure experiences in a supportive all-female environment.

The companies listed in the book are qualified adventure companies carefully chosen for inclusion because of the high standards they maintain. They have replied to a questionnaire, supplied printed materials, and provided the names of two recent participants, whom I have contacted about their trips. Every organization listed in the book has met specific criteria for quality, experience, and reliability. They:

- ♦ offer quality outdoor adventure programs;
- ♦ provide qualified leaders;
- ♦ have been in business for a reasonable period of time;
- ♦ have run successful trips before;
- ♦ provide helpful informational material;
- ♦ describe exactly what their prices include;
- ♦ welcome inquiries and respond promptly;
- ♦ list an address and phone in the United States;
- ♦ provide names and addresses of recent participants.

Who would enjoy these vacations?

The kind of people who choose these vacations are adventurous, active, and eager to try something new. The vacations suggested are designed for the person who has dreamed since childhood of going trout fishing but doesn't know where to start; for the hiker who longs to walk the wilderness trails in Alaska but wonders how to get organized; for the trekker who knows she wants to climb the snow-covered peaks of the Himalayas but isn't sure how to book her trip; for the weekend cyclist who longs to bike through Italy to discover hidden villages but doesn't want to go alone; for the horse rider who's longing to explore

Montana on horseback but needs help finding the best place; and for the kayaker who dreams of paddling close to whales and dolphins and wants advice on where to go.

Here in one place is all the essential information about a wide range of trips in the United States and abroad so that you can find the perfect trip. Just browse through the options, make notes in the margin, and then make your decision.

Whatever you decide, let me know where you went and what you did. I am always delighted to have first-hand recommendations for adventure vacations for the next edition.

Happy travels!

Chapter One
A GLIMPSE OF THE PAST

"In exactly the same manner as an artist feels an invincible desire to paint, so was I with an unconquerable wish to see the world." Ida Pfeiffer, *A Lady's Voyage Round the World*

I t is fascinating to realize that despite the differences in fashion, finances, freedom, and philosophy, the women of the past did much the same in preparation for a trip as women do today. They talked to their friends, made lists of what to take, had clothes made specially for the trip, consulted guidebooks, and packed a trunk carefully. The modern woman talks to her friends, makes lists on her computer, reads guidebooks, buys ready-made clothes, and packs a lightweight case carefully. In every age, women deal with opposition and lack of support from family and friends, learn to keep calm, steady, and stay determinedly focused on what it is they want to do.

In the past, women travelers have been ridiculed, described as encumbrances, and had their accomplishments ignored. An adventurous woman needed a great deal of courage to defy society's expectations of how ladies behaved, confidence to hold fast to what she wanted to do, and enough money to cover the cost of her expeditions. Custom decreed that English, European, and American ladies traveled in long skirts, petticoats, stays, and other uncomfortable but fashionable styles of clothing, and that they behave with politeness and gentility, lest they be mistaken for prostitutes or improper females. In 1873, when Isabella Bird rode her pony alone through the snow-covered mountains of Colorado, she changed from her bloomers and riding skirt into a long black dress before riding into Denver, anxious not to give the wrong impression to the local residents.

In this chapter, you will meet several daring travelers from the past who will share their travel preparations, their experiences, and the advice they offered other women.

One of the earliest modes of travel was horseback riding. Women who could ride had the opportunity to take off on a horse into parts unknown. Visiting the American West, which in the 1870s began west of the Mississippi, was a popular excursion for adventurous travelers, both from Europe and from other parts of the United States. Grace Gallatin Seton-Thompson, a lively young woman from New York, describes in her 1898 book, *A Woman Tenderfoot*, the pleasure she found escaping from her sophisticated city life to go camping and riding out West. Eager to persuade more women to try this new and exciting experience, she offered her own practical advice on preparing for the outdoors at the turn of the century:

> Is it really so that most women say no to camp life because they are afraid of being uncomfortable and looking unbeautiful? Of course one must have clothes and personal comforts, so, while we are still in the city humor, let us order a habit suitable for riding astride. Whipcord, or a closely woven homespun, in some shade of grayish brown that harmonizes with the landscape is best. Corduroy is pretty, if you like it, but rather clumsy. Denim will do, but it wrinkles and becomes untidy. Indeed it has been my experience that it is economy to buy the best quality of cloth you can afford, for then the garment always keeps its shape, even after hard wear, and can be cleaned and made ready for another year, and another, and another.
>
> When off the horse, there is nothing about this habit to distinguish it from any trim golf suit, with the stitching up the left front which is now so popular. When on the horse, it looks, as some one phrased it, as though one were riding side saddle on both sides. This is accomplished by having the fronts of the skirt double, free nearly to the waist, and when off the horse, fastened by patent hooks. The back seam is also open, faced for several inches, stitched and closed by patent fasteners. Snug bloomers of the same material are worn underneath. The skirt is four inches from the ground—it should not bell much on the sides—and about three and a half yards at the bottom, which is finished with a five-stitched hem. Any style

of jacket is suitable. One that looks well is tight fitting, with postilion back, short on hips, sharp pointed in front, with single-breasted vest of reddish leather fastened by brass buttons, leather collar and revers, and a narrow leather band on the close-fitting sleeves.

The next purchase should be stout, heavy soled boots, 13 or 14 inches high, which will protect the leg in walking and from the stirrup leather while riding. One needs two felt hats (never straw) one of good quality for sun or rain, with large firm brim. The other felt hat may be as small and as cheap as you like; it is for evenings, and sunless rainless days. Be sure you supply yourself with a reserve of hat pins.

Though the years have passed, a Western horsepacking trip still requires sturdy riding boots, denim or corduroy jeans, a comfortable vest and jacket, which today may be a waterproof parka or fleece top, and a wide-brimmed hat, though you can forget the hatpins. The details have changed, but the essentials are still the same.

Horse-riding expeditions were also a good way to explore Europe and other places. Many women who found themselves far from home relished the freedom of camp life, and enjoyed the lack of restrictions on what a woman could do. Lady Isabel Burton was one of those who welcomed change and adapted easily to her unusual environment when she lived in Syria. Here's her description of a typical day on her 1875 horseback camping excursion, a pattern of travel that travelers today still find in undeveloped regions.

Our usual traveling day was as follows: the people who had only to get out of bed and dress in five minutes rose at dawn; but all of us who had responsibility rose about two hours before, to feed the horses, to make tea, strike tents, pack, and load. The baggage animals, with provisions and water, are directed to a given place, or so many hours in a certain direction. One man of our party slings on the saddle bags containing something to eat and drink, and another hangs a water melon or two in his saddle.

We ride on for four or five hours, and dismount at the most convenient place where there is water. We spread our little store; we eat, smoke, and sleep for one hour. During this

halt, the horses' girths are slackened, their bridles exchanged for halters; they drink if possible, and their nose-bags are filled with one measure of barley. We then ride on again till we reach our tents.

If the men are active and good, we find tents pitched, the mattresses and blankets spread, the mules and donkeys free and rolling to refresh themselves, the gipsy pot over a good fire, and perhaps a glass of lemonade or a cup of coffee ready for us.

Bicycle travel was just beginning at the end of the 19th century, and women were exhilarated by the freedom of the new bicycles. Lillias Campbell Davidson was a woman who recommended the tricycle, and here she advises women riders on what to wear in 1889:

Wear as few petticoats as possible; dark woollen stockings in winter, cotton in summer; shoes, never boots; and have your gown made neatly and plainly of CTC flannel (not the cloth, which is too thick and heavy for a lady's wear) without ends or loose drapery to catch in your machine. It should be of ordinary walking length, and supplied with a close-fitting plain or Norfolk jacket to match.

Grey is the best color—dark grey. After that, perhaps, comes a heather mixture tweed, which does not show dust or mud stains, and yet cannot lose its color under a hot sun. Let the skirt be as short as possible—to clear the ankles. Nothing else is permissible for mountain work.

I must, however, draw the line at the modern feminine costume for mountaineering and deer-stalking, where the skirt is a mere polite apology—an inch or two below the knee, and the result hardly consistent with a high ideal of womanhood. If stays are worn at all, they should be short riding ones; but tight lacing and tricycle riding are deadly foes.

Collars and cuffs are the neatest wear to those happy women to whom they are becoming. All flowers, bright ribbons, feathers, etc. are in the worst possible taste, and should be entirely avoided.

One of the most successful travel and guidebook publishers in England in the 19th century was John Murray. He thought his favorite author, Isabella Bird, would enjoy a tricycle, and so in 1891 he invited her to try out half a dozen; she pedalled

up and down Albemarle Street in London outside his office, but decided they were not for her. His excellent guidebooks to Europe were so well-known and indispensable that people referred to them as "Murray." When Mary Eyre decided to walk through France in 1862, she took her Murray with her, and her minimal packing is an inspiration.

> I left England in the autumn of 1862, intending to try whether the south of France was really a cheaper place of abode than England. I travelled, for a lady, in rather a peculiar fashion, for I took with me only one small waterproof stuff bag, which I could carry in my hand, containing a spare dress, a thin shawl, two changes of every kind of under clothing, two pairs of shoes, pens, pencils, paper, the inevitable Murray guidebook, and a prayer-book, so that I had not trouble or expense about luggage.
>
> My plan was to locate myself by the week, in any town or village that took my fancy, and ramble about on foot to botanize, and see all that was worth seeing in the environs; and as I was a lone woman, I took for my companion a mischievous but faithful and affectionate rough Scotch terrier, to be my guard in my long solitary walks.

Women began climbing mountains alongside men in the 19th century, when climbing became a recognized sport. They, however, achieved success wearing long skirts. Mrs. H. W. Cole wrote about her climbs in the Alps in 1859, and is frequently quoted in anthologies for her accomplishments. She is always addressed as "Mrs. H. W. Cole" adopting her husband's initials as befitted a proper lady, and never used her own name in public. Here she recommends an ingenious solution to the problem of a long skirt:

> Of course every lady engaged on an Alpine Journey will wear a broad-brimmed hat, which will relieve her from the incumbrance of a parasol. She should also have a dress of some light woollen material, such as carmelite or alpaca, which, in case of bad weather, does not look utterly forlorn when it has been wetted and dried.
>
> Small rings should be sewn inside the seams of the dress, and a cord passed through them, the ends of which should be knotted together in such a way that the whole dress may be

drawn up at a moment's notice to the requisite height. If the dress is too long, it catches the stones, especially when coming down hill, and sends them rolling on those below. I have heard more than one gentleman complain of painful blows suffered from such accidents.

Where women chose to go was an important decision. Visiting the Holy Land, which included Palestine, Egypt, Jordan, Syria, and the desert regions, was a popular destination because it gave the journey a religious motive, deflecting any criticism that might cause people to think a woman was traveling for pure enjoyment.

Though a lady was always urged to take a male companion as a protector, when Agnes Smith read a comment that "A strong lady may accompany her husband" on the journey to the Holy Land, she made up her mind to go, though she didn't have a husband. She believed that she and her friends, Violet and Edith, were strong ladies, and could manage together. Her book about their adventures, published in 1870, describes how they organized their trip, which sounds quite like three women planning to travel together today.

> We agree to a division of labor. Violet makes herself responsible for the management of hotels, and for the direction of the party in general; Edith examines the accounts; Agnes studies the guide-book, and sketches routes for the approval of her companions. The most useful kind of trunk is a basket, covered with strong tarpaulin, needs no extra cover, and is at once light and impervious to rain. For short journeys, a small leather portmanteau called The Gladstone is most suitable, as it holds more than would appear at first sight, and will strap easily on the back of a mule.
>
> A portable bath is only unnecessary lumber, the cost of carrying it being more than the price of a substitute in any good hotel. Side saddles are to be sent for us straight to the Peninsular and Oriental Company's agent at Alexandria; riding costumes of white serge are purchased at Nicoll's, and with Murray's excellent guide-book to Syria in our hands, we feel that we are tolerably well provided for.

Agnes Smith may have read Harriet Martineau's account of her travels in Egypt before setting off on her adventures. In

1848 Harriet Martineau traveled in style to the Holy Land, presumably with her husband and a group of friends. I imagine her as a very elegant European lady who always look perfectly dressed at home and abroad. Here she gives her advice on clothes, food, and smoking, using the pronoun "he" for the traveler even though she was a woman:

> I do not recommend a discontinuance of flannel clothing in Egypt. But it must be carefully watched. The best way is to keep two articles in wear, for alternate days; one on, and the other hanging up at the cabin window, if there is an inner cabin. The crew wash for the traveller; and he should be particular about having it done according to his own notions, and not theirs, about how often it should be. This extreme care about cleanliness is the only possible precaution (against lice), I believe.
>
> Brown Holland is the best material for ladies' dresses; and nothing looks better, if set off with a little trimming of ribbon, which can be put on and taken off in a few minutes. Round straw hats, with a broad brim, such as may be had at Cairo for 4 shillings or 5 shillings, are the best head-covering. A double-ribbon, which bears turning when faded, will last a long time, and looks better than a more flimsy kind.
>
> There can hardly be too large a stock of thick-soled shoes and boots. The rocks of the Desert cut up presently all but the stoutest shoes; and there are no more to be had. Caps and frills of lace and muslin are not to be thought of, as they cannot be got up, unless by the wearer's own hands. Habit-shirts of Irish linen or thick muslin will do; and, instead of caps, the tarboosh, when within the cabin or tent, is the most convenient, and certainly the most becoming head-gear; and the little cotton cap worn under it is washed without trouble. Fans and goggles—goggles of black woven wire—are indispensable.
>
> As to diet—our party are all of the opinion that it is the safest way to eat and drink, as nearly as possible, as one does at home. It may be worth mentioning that the syrups and acids which some travellers think they shall like in the Desert are not wholesome, nor so refreshing as might be anticipated. Ale and porter are much better; as remarkably wholesome and refreshing as they are at sea.
>
> I need not say that every traveller is absolutely obliged to appear to smoke, on all occasions of visiting in the East; and if

> any lady finds refreshment and health in the practice, I hope I
> need not say that she should continue it, as long as she is
> subject to the extraordinary fatigues of her new position.

Traveling by sea made things easier for women travelers, since they could have a cabin to themselves, and be assured of some privacy. In 1908, Agnes Deans Cameron, 45, who had been a teacher and a journalist, took her niece, Jessie Cameron Brown, and set out to spend the summer traveling north from Chicago to the Canadian Arctic. They traveled with the Hudson's Bay Company, following the route along the Mackenzie River to the delta at Fort McPherson on the Arctic Ocean, a journey of almost 2,000 miles. They took a stagecoach on land, and scow and steamboat along the waterways.

The Arctic north of Canada was one of the few still virtually unexplored regions of the world accessible to average Western travelers. Cameron reveled in the journey, meeting Eskimos and their families, watching rafts loaded with precious cargo overturn on the wild rivers, and spending nights under the stars. She took notes for the book she was determined to write about the adventure. She and her niece made careful preparations for their great adventure, which sounds very much like getting ready for a camping trip today, and as modern travel writers do, considered the most precious pieces of luggage to be her two cameras, Kodak film, and a typewriter.

> What Cook & Son failed to supply, the Hudson's Bay Company in Winnipeg furnished. No man or woman can travel with any degree of comfort except under the kindly aegis of the Old Company. They plan your journey for you, give you introductions to their factors at the different posts, and sell you an outfit guiltless of the earmarks of the tenderfoot. Moreover, they will furnish you with a letter of credit which can be transmuted into bacon and beans and blankets, sturgeon-head boats, guides' services and succulent sow-belly, at any point between Fort Chinmo on Ungava Bay and Hudson's Hope-on-the-Peace, between Winnipeg-on-the-Red and that point in the Arctic where the seagull whistles over the whaling-ships at Herschel

.....

By the first day of June we have our kit complete and are ready to leave. We have tried to cut everything down to the last ounce, but still the stuff makes a rather formidable array. What have we? Tent, tentpoles, typewriter, two cameras, two small steamer-trunks, bedding (a thin mattress with waterproof bottom and waterproof extension-flap and within this our two blankets), a flour-bag containing tent-pegs, hatchet, and tin wash-basin, two raincoats a tiny bag with brush and comb and soap—and last, but yet first, the Kodak films wrapped in oilcloth and packed in biscuit-tins.

The greatest of all American adventures of the 19th century was to travel across the unexplored plains in a covered wagon train to find the gold that lined the streets of California. Here's a delightful account of what preparing for a long journey across the country used to be like.

In 1849, Catherine Haun was a young bride in Iowa when she and her husband, a lawyer, decided to follow the path of the gold rush to California. The Hauns were educated and came from middle-class families, so their wagon train was large and well-equipped, and they and those with whom they traveled took the time to make adequate preparations. She dictated an account of the trip years later to her daughter.

Early in January of 1849, we first thought of emigrating to California. Our discontent and restlessness were enhanced by the fact that my health was not good. Fear of my sister's having died while young of consumption, I had reason to be apprehensive on that score. The physician advised an entire change of climate thus to avoid the intense cold of Iowa, and recommended a sea voyage, but finally approved of our contemplated trip across the plains in a "prairie schooner," for even in those days an out-of-door life was advocated as a cure for this disease. In any case, as in that of many others, my health was restored long before the end of our journey.

At that time, the "gold fever" was contagious and few, old or young, escaped the malady. On the streets, in the fields, in the workshops and by the fireside, golden California was the chief topic of conversation. Who were going? How was best to fix up the outfit? What to take as food and clothing? Who would stay at home to care for the farm and women-

folk? Who would take wives and children along? Advice was handed out quite free of charge and often quite free of common sense. However, as two heads are better than one, all proffered ideas as a means to the end. The intended adventurers diligently collected their belongings and after exchanging such articles as were not needed for others more suitable for the trip, begging, buying or borrowing what they could with buoyant spirits started off.

Some half dozen families of our neighborhood joined us and probably about twenty-five persons constituted our little band. Our own party consisted of six men and two women. Mr. Haun, my brother Derrick, Mr. Bowen, three young men to act as drivers, a woman cook and myself. Mr. Haun was chosen Major of the company, and as was the custom in those days, his fellow travelers ever afterwards knew him by this title. Derrick was to look after the packing and unpacking co-incident to camping at night, keep tab on the commissary department, and, when occasion demanded, lend a "helping hand." The latter service was expected of us all—men and women alike—was very indefinite and might mean anything from building campfires and washing dishes to fighting Indians, holding back a loaded wagon on a down grade or lifting it over boulders when climbing a mountain.

Mr. Bowen furnished his own saddle horse, and his services were brought free of expense to himself. His business was to provide the wood or fuel for the campfire, hunt wild game and ride ahead with other horsemen to select a camping ground or go in search of water. He proved himself invaluable and much of the time we had either buffalo, antelope, or deer meet, wild turkey, rabbits, prairie chickens, grouse, fish or small birds.

Eight strong oxen and four of the best horses on the farm were selected to draw our four wagons—two of the horses were for the saddle. Two wagons were filled with merchandise which we hoped to sell at fabulous prices when we should arrive in the "land of gold." The theory of this was good but the practice—well, we never got the goods across the first mountain. Flour ground at our own grist mill and bacon of home-curing filled the large, four-ox wagon while another was loaded with barrels of alcohol. The third wagon contained our household effects and provisions. The former consisted of cooking utensils, two boards nailed together, which was to serve as our dining table, some bedding and a small tent. We had a very generous supply of provisions; all meats were

either dried or salted, and vegetables and fruit were dried, as canned goods were not common sixty years or more ago. For luxuries we carried a gallon each of wild plum and crabapple preserves and blackberry jam. Our groceries were wrapped in India rubber covers and we did not lose any of them—in fact still had some when we reached Sacramento.

The two-horse spring wagon was our bedroom, and was driven by the Major—on good stretches of road by myself. A hair mattress, topped off with one of the feathers and laid on the floor of the wagon with plenty of bedding made a very comfortable bed after a hard day's travel. In this wagon we had our trunk of wearing apparel, which consisted of under-clothing, a couple of blue checked gingham dresses, several large stout aprons for general wear, one light colored for Sundays, a pink calico sunbonnet and a white one intended for "dress up" days.

My feminine vanity had also prompted me to include, in this quasi wedding trousseau, a white cotton dress, a black silk manteaux trimmed very fetchingly with velvet bands and fringe, also a lace scuttle-shaped bonnet having a face wreath of tiny pink rosebuds, and on the side of the crown nestled a cluster of the same flowers. With this marvelous costume I had hoped to "astonish the natives" when I should make my first appearance upon the golden streets of the mining town in which we might locate. Should our dreams of great wealth, acquired over night, come true, it might be embarrassing not to be prepared with a suitable wardrobe for the wife of a very rich man!

When we started from Iowa I wore a dark woollen dress which served me almost constantly during the whole trip. Never without an apron and a three-cornered kerchief, similar to those worn in those days, I presented a comfortable, neat appearance. The wool protected me from the sun's rays and penetrating prairie winds. Besides it economized in laundrying which was a matter of no small importance when one considers how limited, and often utterly wanting were our "wash day" conveniences. The chief requisite, water, being sometimes brought from miles away.

In the trunk were also a few treasures: a Bible, medicines, such as quinine, bluemass, opium, whiskey, and hartshorn for snake bits, and citric acid—an antidote for scurvy. A little of the acid mixed with sugar and water and a few drops of essence made a fine substitute for lemonade. Our matches, in a large-mouthed bottle, were carefully guarded

in this trunk. The pockets of the canvas walls of the wagon held every day needs and toilet articles, as well as small fire arms. The ready shotgun was suspended from the hickory bows of the wagon camp. A ball of twine, an awl, and buckskin strings for mending harness, shoes, etc. were invaluable.

It was more than three months before we were thoroughly equipped, and on April 24th, 1849, we left our comparatively comfortable homes—and the uncomfortable creditors—for the uncertain and dangerous trip, beyond which loomed up, in our mind's eye, castles of shining gold.

The Hauns did reach California, and settled there—a successful adventure trip.

One amazingly successful traveler from the past knew that she always wanted to travel, and explains what drove her on, despite overwhelming obstacles. Ida Pfeiffer (1792-1858) traveled first to the Holy Land, then to Scandinavia, and then around the world twice, and wrote books about her experiences. In recognition of her achievements, though she was not a scientist, she was elected an honorary member of the Royal Geographical Society in Berlin, and presented with a gold medal for arts and sciences by the King of Prussia.

Her life itself was an adventure. Born Ida Reyer in Vienna, she was the only girl in a family of six boys. She dressed as a boy, and described herself as "not shy, but wild as a boy and more forward than my elder brothers." Her father, a wealthy merchant, insisted on a spartan regime for his children. He allowed them only simple food, though they could look at the rich delicacies that the adults ate at the same table. Even reasonable requests were refused in order to accustom them to disappointment, and their father's word was law on all subjects.

Ida seems to have flourished under this treatment; even her father's teasing that he would send her to military school only encouraged her to think of herself as an officer.

Her life changed dramatically after her father died when she was thirteen. Her mother, a strong-willed woman, put an abrupt end to Ida's freedom, making her wear dresses and petticoats. Her education was entrusted to a young tutor, and she credits him as the person who "changed me from a wild hoy-

denish creature into a modest girl." Under his tuition, she chan-
nelled her exuberance into a passion for travel books.

Ida and her tutor fell in love, and when Ida was 17, they
decided to marry. But her mother was determined that Ida
marry someone with money, and chose a wealthy Greek who
had proposed marriage. The battle of wills between mother
and daughter reached a compromise: Ida renounced her tutor,
but refused to marry the Greek. Three years later, when she
saw her tutor by chance in the street, she was so overwhelmed
by her emotions that she fell ill. Her mother still refused to
consent to the marriage so Ida continued to reject all other
suitors.

After months of conflict, Ida agreed that she would marry,
but only—for reasons she never explained—an older man. Dr.
Pfeiffer was finally chosen. He was a lawyer, 24 years older
than Ida, and lived in Lemberg, a hundred miles from Vienna,
which gave Ida an excuse to live away from her mother. Unfor-
tunately, though tolerant and kind, he was never very success-
ful. For 18 years, the family moved from place to place in Aus-
tria and Switzerland, while Ida struggled with poverty as she
brought up their two sons.

After Ida's mother died, the Pfeiffers inherited enough
money to be able to pay their bills. Ida and her two sons stayed
in Vienna, and Dr. Pfeiffer moved back to Lemberg. When her
sons finished school, Ida was ready to do what she had always
dreamed of doing—travel.

In 1842, she set off on a religious journey to Palestine, Egypt,
and Italy. She kept a diary and every evening made notes in
pencil, sometimes using a sandhill or the back of a camel as a
table. Her first German publisher had to persuade her to let
him publish her book, but once it appeared, and went into
four editions, she was delighted with the reaction. She studied
English and Danish and took off for Iceland and Scandinavia
in 1845.

In 1846, she set off for Brazil, and traveled for 30 months
and thousands of miles to circumnavigate the globe. On her
return, she wrote *A Lady's Voyage Round the World*, still in print
today. But despite the book's success, she had no funds for fur-
ther travel. Her admirers in the press wrote about her exploits
and she was awarded a grant of 1,500 florins (about $200) from

the Austrian government. In 1852, she set off again and wrote *A Lady's Second Journey Round the World*, which was published in 1855. In 1856, she traveled to Madagascar, but unfortunately fell ill. When she came home, her health never recovered, and she died of cancer of the liver in 1858. Her son, Oscar Pfeiffer, prepared her papers for her last book in 1861, *The Last Travels of Ida Pfeiffer.*

Here's how she explains what I call "The Itchy Feet Syndrome," the drive that urges her to travel.

> From my earliest childhood I had always the greatest longing to see the world. When I met a travelling carriage, I used to stand still and gaze after it with tears in my eyes, envying the very postilions, till it vanished from my sight. As a girl of ten or twelve, I read with the greatest eagerness all the books of travels I could get hold of, and then I transferred my envy to the grand traveller who had gone round the world. The tears would come into my eyes when I climbed a mountain and saw others still piled up before me, and thought that I should never see what lay beyond.
>
> I afterwards, however, travelled a good deal with my parents, and subsequently with my husband, and did not reconcile myself to remaining at home, till my two boys required my attention and had to attend particular schools. When their education was completed—when I might, if I pleased, have spent the remainder of my days in quiet retirement, then my youthful dreams and visions rose again before my mind's eye. My imagination dwelt on distant lands and strange customs—a new heaven and a new earth. I thought how blessed it would be to tread the soil hallowed for ever by the presence of the Savior.
>
> I thought long: and at length formed my resolution. I had represented to myself first all the difficulties, obstacles, and dangers connected with the undertaking; and endeavored to dismiss the idea from my mind, but in vain. I cared little for privation; my bodily frame was healthy and hardy; I had no fear of death; and as my birth-day dated from the last century, I could travel *alone*. With a joy amounting to rapture, I set out then on my journey to Palestine, and as I came home again in perfect safety, I trusted I had not acted presumptuously in following the impulse of my nature, and I determined to see a little more yet of the world."

Modern travelers today may find it difficult to discover unknown territory and explore unvisited regions, unlike the women travelers of the past. But the thinking, research, planning, decision-making, preparations, coping with family and friends, and attitudes of those women who went before are not that different in spirit from those of today. Women who love to travel are linked by a passion that reaches across time and space. In the chapters ahead, you'll meet a diverse group of women travelers who will share with you the adventures that touched their imaginations.

Chapter Two
BICYCLE TOURING AND HORSE RIDING

"The bicycle is a great comfort; I might not know where I shall find a resting place for the night, but at least I have the means to go off and look for somewhere. When I am afraid or worried, I cycle very much faster." Bettina Selby, *Riding to Jerusalem*

I n the 1890s bicycling became a popular activity for women. Once the new Rover bicycles became available, women discovered how easy it was to balance, pedal, and travel.

Feminists hoped that the new invention would free women from their corsets and burdensome petticoats and allow them to wear bloomers and looser clothing. Women's rights advocates were ecstatic, and one suffragist and temperance leader, Frances Willard, who learned to ride at age 53, called her bicycle "an implement of power." However, medical men warned that bicycle riding was dangerous to women's health because sitting astride on a saddle might arouse them sexually and cause severe distress! One physician complained: "The moment speed is desired, the body is bent forward in a characteristic curve, and is thrown forward causing the clothing to press against the clitoris, thereby eliciting and arousing feelings hitherto unknown and unrealized by the young maiden."

Fanny Bullock Workman

An American couple, Fanny Bullock Workman (1859-1925), and her husband, William, both later renowned as world-class mountain climbers, started out traveling on their bicycles. They explored Europe and Asia on wheels, covering amazing distances. After their adventures, Fanny and William returned to London or Hamburg to put together successful books about their travels.

Merging their identities, they wrote the books as "we," rather like royalty, so that the tone of their books is often pontificat-

ing, without personal reactions or individual details. They were always enthusiastic and energetic and hoped to inspire others, particularly women, to emulate their accomplishments. Their only daughter was looked after by governesses and sent off to European boarding schools while they traveled, while a son died in infancy.

The following excerpt comes from their book about Algeria. They started on the northern coast of Africa, cycled across the Atlas Mountains, and reached the Sahara Desert.

Bicycle Riding in Algeria, 1895,
by Fanny Bullock Workman

The noon of February 21st saw us strapping on the last packages. Salem, the handsome Arab porter, took the final orders about forwarding our trunk, and accompanied by the good wishes of the proprietor and a group of natives and Europeans, who appeared interested in our undertaking, we wheeled the Rovers out of the courtyard and mounted for our journey of over fifteen hundred miles through Algeria.

It seemed a wonderful ride, that first afternoon run of eighty-one kilometers (about 50 miles) from Oran to Perregaux. That was probably because it was the first ride in Africa, for, when analyzed, it was, except for being rather more novel, very like a half-day's spin in France or Italy. The country was rolling, the air mild, trees and flowers in bloom, the roads fine, and offering the advantage of not being cut up by vehicles. After leaving Oran, we met only Arabs and negroes, on foot, or riding on donkeys or horses. We delighted them and they charmed us, and it was with mutual satisfaction that the American and Arab met en route that day.

They were good-natured and orderly, and, when we several times rode through large companies of them, although they laughed and accosted us, they did so civilly, and were neither rude nor coarse. Even when their animals, frightened at the unusual sight, shied up a bank or into a field, they took it in good humor. Once an Arab was thrown from his horse, but he did not seem disturbed by the mishap. We were struck with the difference between the Arab and the Sicilian, as we recalled the various occasions on which, in Sicily, we had been the unintentional cause of unhorsing the latter, who, although not apparently injured by the fall, would usually curse us vociferously with fierce gesticulation, as we rode on.

It has been our experience that horses, oxen and mules are much more liable to be frightened by a woman on a bicycle than a man. Dogs also bark at the former more frequently. It may be that dogs, which seem to regard themselves as a sort of special police, consider women out of place on a wheel, and in need of correction.

In Sicily and Southern Italy, on dismounting in a town, we were immediately surrounded by a motley and noisy rabble, which accompanied us until we left it. On similar occasions, in Algeria, a few Arabs would gather slowly about at a respectful distance, evidently interested, but entirely silent and undemonstrative, never offering to touch the machines. The Arab, as a rule, is lazy and not fond of work or over-exertion, yet he sometimes displays both activity and endurance. On that ride to Perregaux a young man ran along with us for two kilometers or more, as we rode at a fairly rapid pace. We reached Perregaux, a town of fifty-eight hundred inhabitants, about six o'clock, and found a very comfortable inn, where a passable dinner of six courses was served for two francs each

.

We overtook an Arab cavalier on the road, mounted on a short, thick-set, shaggy horse of rather dumpish appearance, and armed with a long, old-fashioned gun. He seemed inclined to try the mettle of his horse against our wheels. The grade at this point was down and the road excellent, so we accepted the challenge. As he increased his speed, we increased ours. Letting our machines out a little more, we left him behind.

A few minutes later, when level ground was reached, the clatter of hoofs was heard behind and we saw he was going to make another trial. We quickened our pace again, but in a twinkling he flew by us like a whirlwind, brandishing his gun in the air, over his head, with his right hand. We shouted "Bien fait" as he passed, which seemed to please him. After two or three hundred feet, he drew in his horse and resumed the customary slow trot.

Bettina Selby

A hundred years later, women bicycle around the world. There are publications and organizations for women cyclists, and a thriving industry of products. An Englishwoman, Bettina Selby, completed an amazing bike trip in the 1980s, riding from London, England, to Jerusalem, Israel. Her background included

service in the Womens Royal Air Corps, a career as a successful freelance photographer, and seven years teaching school. After her three children grew up and left home, she started a new career of writing and traveling.

As a mature student, she attended London University and took a degree in comparative religion. Her decision to ride her bicycle to Jerusalem grew out of her fascination with the Crusades, a religious movement that began in the Middle Ages, in the 9th, 10th, and 11th centuries. Thousands of impassioned Christians left their homes in Europe to join huge groups of pilgrims on treks that sometimes took several years. Their mission was to reach Jerusalem and retake it from the Moslems who ruled there. The Crusade movement attained its highest point in 1095, when Pope Urban II issued a call that all good Christians should help rescue the holy places from the infidels and restore it as a Christian center. Men, women, and children went on Crusades, and their history has marked the routes they took to this day. The last Crusade left France in 1291. Few of the pilgrims who joined Crusades left written accounts of their experiences.

Bettina Selby set out to follow a Crusader's route from England to Jerusalem, curious to see what the pilgrims saw and where they went. She rode a specially made bicycle, which she named Evans, across Europe to Istanbul, through Syria and Jordan, and on to Jerusalem.

In this excerpt she has bicycled through France, Switzerland, and Italy, and taken a boat to Turkey. Planning to ride down the Turkish coast to Syria, she describes her initial feelings of fear at being in Asia.

Bicycle Travel in Turkey, 1985, by Bettina Selby

The countryside I was passing through was not unlike England at first sight; a rural landscape of fields with clumps of deciduous trees here and there. The fields looked bare and dried up, except for patches of tomatoes, glowing redly among the brown stubble of recent grain harvests. I passed patches of melons and red peppers, too; some of these were in small piles by the side of the road, placed there to be picked up later by returning field workers.

After a few miles, tractors carrying the homeward-bound work-

ers began to trundle past in the opposite direction, Women, their heads wrapped around with scarves, were sitting on the mudguards, while their menfolk drove, staring stolidly ahead. The women averted their faces as they passed me but I could see, in my wing mirror, that they turned around to stare at my departing figure. The feeling that I was the only one of my kind in a hostile land steadily increased.

Then a large van passed, going in my direction; it slowed down and stopped and the driver put his head out of the window and indicated that he wished to give me a lift. Suspicion and alarm were my immediate reactions to this probably innocent and kindly gesture. I could think of a dozen reasons for the offer and all of them were unpleasant. Smiling placatingly and waving my hand, in which I hoped would be taken for a polite but firm refusal, I cycled past the van, giving it a wide berth.

At this point I decided I was behaving stupidly. If I was going to regard everyone as a potential enemy, I might as well go home. It is no way to travel, perpetually expecting a knife in the back, or robbers lurking behind every bush. There might well be both these things, but looking out for them all the time meant that I would see nothing else. If someone was determined to rob me, it would happen anyway; there was no question of me being able to prevent it by superior force, since the most lethal weapon I carried was my Swiss penknife and even that was not readily to hand. Nor did I believe that everybody could really be as unfriendly as they appeared. They were probably just struck dumb with amazement at seeing a lone female on a bicycle. Putting thoughts into action, I waved to the very next tractor that passed; the driver responded immediately, and after some hesitation, the women returned the greeting.

Ethel Brilliana Tweedie

In the days before bicycles, the horse was the accepted mode of transportation. Victorian ladies often traveled on horseback to explore the world along a horizontal track, not vertically climbing up mountains. There was one real disadvantage to being a female rider in the Victorian world: they were expected to ride side-saddle, as a sign of good breeding and femininity. It must have been exceptionally uncomfortable and it certainly twisted their spines. The clear moment of epiphany for many of them

is the decision to ride astride like a man, and defy convention in order to continue their travels.

Ethel Tweedie (1860-1940), or Mrs. Alec Tweedie as a properly married English lady titled herself, discovered the joys of traveling after a family tragedy left her a widow without children. Wherever she went, she was interested in everything from etiquette to anti-Communism, and full of energy and enthusiasm. Her ten travel books include *Finland in Carts* and *Mexico As I Saw It*. Her first travel book was *A Girl's Ride In Iceland* and it describes her trip through Iceland with her brother, Vaughan, and a group of friends.

Horse Riding In Iceland, 1889,
by Ethel Brilliana Tweedie

I have often read that it was the custom for women in South America, and in Albania, who have to accomplish long distances on horse-back, to ride man-fashion. Indeed, women rode so in England, until side-saddles were introduced by Anne of Bohemia, wife of Richard II, and many continued to ride across the saddle until even a later date. In Iceland, I had seen women ride as men, and felt more convinced than ever that this mode was safer and less fatiguing. Although I had ridden all my life, the roughness of the Icelandic roads and ponies made ladywise on a man's saddle impossible, and the sharpness of the pony's back, riding with no saddle, equally so. There was no alternative. I must either turn back, or mount as a man.

Necessity gives courage in emergencies. I determined therefore to throw aside conventionality, and "do in Iceland as the Icelanders do." Keeping my brother at my side, and bidding the rest ride forward, I made him shorten the stirrups, and hold the saddle, and after sundry attempts succeeded in landing myself man-fashion on the animal's back. The position felt very odd at first, and I was also somewhat uncomfortable at my attitude, but arranging my dress so that it fell in folds on either side, I decided to give the experiment a fair trial, and in a very short time got quite accustomed to the position, and trotted along merrily. Cantering was a first a little more difficult, but I persevered, and in a couple of hours was quite at home in my new position, and could trot, pace or canter alike, without any fear of an upset.

The amusement of our party when I overtook them, and boldly trotted past, was intense; but I felt so comfortable in my altered seat that their derisive and chaffing remarks failed to disturb me. Perhaps my boldness may rather surprise my readers; but after full experience, under most unfavorable circumstances, I venture to put on paper the result of my experiment. Riding man-fashion is less tiring than on a side-saddle, and I soon found it far more agreeable, especially when traversing rough ground.

Cindy Barrett

Women today ride horses for pleasure and adventure, although they rarely ride side-saddle. The skills of dressage, show-jumping, cross-country, and more are enjoyed by men and women alike. Indeed, Olympic horse competitions are among the few sports where men and women compete equally.

Cindy Barrett is a freelance magazine writer who lives with her husband and two children on seven acres of rural heaven not far from Ottawa, Canada. Before moving to the country, she worked in Toronto as the assistant national editor for *Maclean's Magazine*, Canada's national news magazine. Since she began freelancing, her work has appeared in *Maclean's, Canada Living, Chatelaine, Flare, Cottage Life*, and *Equus*.

The daughter of traveling parents, she confesses to touring Spain and Portugal with them as a sullen teenager. She behaved much better when, several years later, she and her husband joined them for a brief but jam-packed holiday in France. Her current travel plans include parts of Canada she has not yet seen: Prince Edward Island on the east coast, British Columbia on the west coast, and northern Canada. Her favorite vacations include an equal mix of strenuous activity and time to read.

After a long hiatus from horseback riding, she is back in the saddle and taking lessons, spurred on by her young daughter who is as passionate and fearless around horses as she remembers being, and the two of them are dreaming of building a horse stall in their barn. Cindy is currently working on a novel for young adults about a girl and her horse. For women who rode as young girls, the challenge of riding again as an adult demands new skills, as she describes here.

Insights on a Horseback Vacation, 1995,

by Cindy Barrett

When I was only 13, only my horse knew my secret name. That was fitting, because it was with her that I became my true, secret self. Away from the barn I was a mild-mannered bookworm and decidedly unathletic; in the saddle my horse and I were partners in daring, grace, and skill. Whether we were working on a specific manoeuver in the ring or jumping over hay bales as we cantered across a field, she was swift and surefooted, and I was She Who Rides With The Wind.

Today I am not She Who Rides With The Wind. Today I am dead-weight slamming down in the saddle as the horse trots beneath me. My body is desperately trying to remember how to post. The instructor stands in the grassy center of the riding ring as five of us trot round the outside. She calls out corrections: "Adjust your leg, Sherry. Nick, keep your hands quiet." And then to me: "Don't forget to breathe, Cindy." Fear, perched behind me with its arms tightly wrapped around my chest, purrs insistently in my ear.

More than 20 years after any sort of regular riding experience, I am tacking up and bunking down with four other adults for three days. It is the seductive promise of good food and a steady mount that has lured me to the McAlpine Equestrian Center in Eastern Ontario. The Gourmet Horse Lovers' Weekend is the official tag, but I call it adult camp. It promises the same delicious sense of liberation from the camp of my youth—although back then the thrill came from parental emancipation; now it's my children I'm happy to be away from for a few days. But I'm not eager for a complete return to kiddie camp—no latrine duty, please. The only chores I am expected to do here are the more pleasant ones associated with horses; feeding, watering, grooming, and cleaning tack. Someone else will shovel out the aromatic stalls, while I will be maintaining my energy levels with the likes of Apple Chicken and sour-cream cheesecake.

The first thing that guests do after they arrive at the McAlpine farmhouse on Thursday evening is greet the owners: Samme Putzel, who runs the equestrian center, her partner Phil Arber, and Roughie, the Lab-shepherd-collie cross who is the undisputed lord and protector of all 210 acres. The second thing the guests do is examine the menu for the long weekend over amaretto coffee at the large harvest kitchen table by a toe-warming woodstove. It is a relaxing

way to get to know the others, and a mutual love of fine fare and horses produces a quick camaraderie.

The conversation evolves into the weekend's other main topic: horses. I am here with my sister Sherry on our first trip to the farm, but the others have all ridden here before (Samme is certified by the Canadian Equestrian Federation) or on a previous gourmet weekend. Samme describes the horses, their temperaments, and personalities, so we can choose our mounts for the following day. I have already confessed my uneasiness to her on the phone, and she has assured me that she has horses of varying degrees of challenge. I ask her to choose my mount, and she fixes me with a steady, determined eye. "You will ride Skylark. He will take care of you." I think, this is how she deals with a skittish horse. Calmly, and with authority. It works on me, too.

Sherry and I explore the rest of the stone house on our way to bed. Built in 1834, the house has been restored to its former glory with handsome, beaded pine beams, oak and pine floors, and two stone, floor-to-ceiling fireplaces. Upstairs, our bedroom is painted a quiet blue and holds two quilt-covered, white-painted, wrought-iron bed-steads. I feel like I am back in my family's old cottage.

Strains of "Autumn" from Vivaldi's "The Four Seasons" waft up the stairs to awaken us to a golden Indian summer day. Phil and Samme have begun their morning chores—there are sheep and chickens to tend—and after coffee we head to the barn to feed and water the 15 horses. We visit each of them, and everyone coos over the three-month-old colt, a surprise gift from Samme's old Appaloosa stallion, Chief, who a year earlier had enjoyed a stolen moment with a brown mare named Junie.

Finally I meet Skylark. We check out each other over the stall door. He is a neat 15.2-hand bay with a white blaze down his face and a mane that flops randomly down each side of his neck. I am hoping that he will nuzzle my shoulder and blow his warm, grassy breath on my cheek to tell me that he loves me at first sight. Instead he fixes me with a baleful eye and continues chewing a mouthful of hay. Samme watches as I carry a bucket of specially mixed feed into his stall to pour into his feed bowl. "Watch your horse as you're walking by him," she warns me. Despite what I know, I've just hastily exited Skylark's stall with my face averted from his hindquarters because I don't want to see that kick that I'm sure is coming.

Why am I so apprehensive? There is no horrific riding accident in my past that I have never gotten over. Working with horses as a teen I had been stepped on, kicked at, run away with, tossed off, and bitten. But it is ever since I completely lost control of a horse who bolted and took off with me that I've been afraid. My personal mission this weekend is to conquer this semi-rational fear.

After stretching exercises in the warm sun and a lubricating breakfast of berry pancakes with brandied maple syrup, we are ready to groom and tack up. I spend a lot of time with currycomb and brushes on Skylark, massaging him into a blissful state. He's got to love me now, I think. We lead our horses into the ring and I am shaking as I mount. Horses and riders feel each other out as we move around the ring. We're all trotting when I catch sight of my sister in midair. For a moment my own anxiety is suspended as I ride over to her. But she jumps up as soon as she hits the ground, proclaiming she's fine. Belle, her chestnut mare, had been moving in a tight circle and Sherry, who usually rides Western with a larger, bulkier saddle, lost her grip on the small, smooth English saddle. It's her first fall off a horse, so she is roundly congratulated by everyone.

Once Sherry's back on, Samme lines us up to teach us the emergency dismount. "I try to show people this first thing," she says, casting a look at Sherry in mock dismay, "before they need to use it." Then, for fun and to relax us all a bit, she teaches us a few rudimentary circus tricks that reduce us to giggles. We perform 180-degree turns in the saddle, Sherry stands straight up on Belle's back. While I am doing the Flying Angel (one knee on the saddle, the other leg straight in the stirrup, arms outstretched), I realize what a smart woman Samme is. My posting may still be atrocious but I am far more comfortable than when I first mounted.

After a hearty lunch of pesto and penne, we head out of the ring and into the woods for a trail ride. The air is autumn fresh, and the thick carpet of golden leaves underfoot sounds a satisfying, muffled crunch. I am proud of myself for my earlier work. I walked, trotted, and eventually breathed regularly. I have decided that I won't canter, that I have already proven enough to myself. But when Samme asks, I don't want to look like a coward, plus I am starting to trust Skylark a bit. To my surprise I don't pop right out of the saddle and almost enjoy the run. Later as we're walking, we watch a large hawk lazily wheel above us and settle on the tip of a big pine. We are quiet; everyone seems to be drinking in the perfection of the day.

The next day begins with a trail ride. This is video day. We meet up in a field with Samme's friend Harold, who is set up with a camcorder to tape our antics. Samme suggests we try to ride in formation. The Musical Ride we are not. The formation dissolves, and I end up in the center of the field with Skylark, who is patiently trying to figure out what the idiot on his back wants him to do.

We tack up again just as the sun is setting and head out for a night ride. By the time we reach the woods, the nearly full moon is high in the sky. It throws odd dapples of shadows through the leaves, and the horses' ears are all aflicker. I am falling in love with this beautiful animal who not only puts up with my ungainly riding but is teaching me, through his steadiness, to shed my anxieties. We ride for hours under the studded sky, and, as we had for home, the Big Dipper hangs over the farmhouse like a night weathervane. I'll never forget the elegant moon shadow of six riders in single file.

After the horses enjoy a rubdown and handfuls of carrots, we take turns standing under a steaming shower. As we tuck into the herb-scented rainbow trout, I notice everyone is rosy from the outdoors exertion and scrubbing. The best part of camp as a kid was the sense of accomplishment that came from swimming across the lake or learning to shoot an arrow from a bow or simply from thriving in an unfamiliar environment. The glow on my face as we enjoy the feast is also due to the burgeoning sense of accomplishment I feel in overcoming my fear about riding again.

It is on Saturday that I experience two minor epiphanies. We are cantering along a wooded trail when Samme flashes a wide grin over her shoulder and shouts, "Ready to jump?" A small tree has fallen blocking the path. Skylark's beautiful velvet ears prick forward with anticipation when he catches sight of it, and his delight is contagious. We clear it effortlessly, and I pat his neck just like Ian Millar does to Big Ben when they've jumped a clean round. Later, we play canter catch-up. One by one we canter the length of the field. Except I buddy up with Samme because I am still worried that Skylark, most trustworthy of mounts, might bolt if we go alone. We charge up the field, and for the first time I urge Skylark on instead of trying to keep him well under control. Laughing, I sneak a look back—just in time to see Fear bouncing on the ground, coughing in the dust. She Who Rides With The Wind rides again.

Sharlot Mabridth Hall

Sharlot M. Hall (1870-1943) was one of those spunky independent American woman who are often forgotten. She was one of the first people to explore northern Arizona and the area around the Grand Canyon. Her diary is a fascinating description of the area before it became a tourist mecca. She didn't worry about what people thought of her, never mentions what she wore, was the first woman to serve in public office in Arizona, and boldly established her own museum to preserve the artifacts and history she discovered.

She wrote poetry throughout her life, and the two books of her collected poems that were published are kept in print by the Sharlot Hall Historical Society, which she founded. One of her poems provided her epitaph: "O life is a game of poker, and I've played it straight to the end."

She also wrote travel articles, short stories and essays. For almost ten years she wrote extensively for *Out West* magazine in Los Angeles. As a staff writer, she contributed major articles about Arizona as well as her poems. For one issue, she wrote a 68-page study of Arizona's economy to show that the territory was a land of many resources with active communities.

In October 1909 she left the magazine after she was appointed Territorial Historian of Arizona, the first woman in Arizona's history to serve in public office. She was passionately interested in preserving the words and memories of people who had been part of Arizona's history. In order to collect oral history, she spent months out in the field in remote areas. She said she "visited every city and nearly every town and mining camp in Arizona."

Her goal for her 1911 expedition was to explore the Arizona Strip, "that little known region lying north of the Colorado River." The Powell Survey had made geological studies between 1869 and 1880, and the Mormons were the only people who had traveled in the area. The Arizona Strip was cut off from the rest of Arizona by the Grand Canyon, and one man advised her: "Don't go!"

She was accompanied by Allen Doyle, a man who guided tourists in the Grand Canyon area. With their water, food, and belongings in a wagon pulled by two sturdy ponies, they left Flagstaff on July 23, 1911, for the north, and spent two months

in the region. She wrote a diary of her trip, which ran in 11 installments in *Arizona: New State Magazine* from October 1911 to April 1913, with a break when Sharlot's mother died, and she herself was ill.

After that, she resigned as state historian, and wrote very little until 1922, when a state official asked her to put together information about the Indian people, the Smoki. That revived her interest in writing. Her book of poems, *Cactus and Pine*, was reissued in 1924. In 1928, after her father died, Sharlot moved to Prescott, Arizona. She restored the old Governor's Mansion, a large log building, moved into it, and brought with her a large collection of artifacts and papers. She researched additional materials about Arizona's pioneer days and added them to the collection. In the 1930s, she secured funding to construct a fine large stone building, which now houses some of the museum exhibits, the library and research center, and the offices of the Sharlot Hall Historical Society. She died in 1943 at the age of 73.

Here's an excerpt from her Arizona Strip journey to the northern rim of the canyon.

Exploring Northern Arizona, 1911,
by Sharlot Mabridth Hall

August 21, 1911. We are only a few hundred yards from the great northern rim of the canyon but the forest is so dense that our camp seems in a park on a mountain top. All the water here is in little canyons that cut into the rim in ragged notches. Our horses scrambled down over a rough trail to a pool of clear water cold as the snow it had melted from and I went on above by a winding rope of path till the whole southern rim seemed to float out of the distance and the purplish blue vapor that filled the lower gorge.

We could see the trail up from the river to El Tovar and the buildings there and at Bright Angel Camp fourteen miles across on an air line but nearly five hundred miles away by the wagon road which we had been obliged to follow. The smoke from a train on the Grand Canyon railroad drifted out and seem strange enough—"so near and yet so far."

August 23. We rode today to Bright Angel Point on a very fair trail that goes down to the river where Messrs. Rust and Woolley

have a cable and "skip," by which persons and animals are some-
times taken across the river. So far the trip has not attracted a great
number of people, but the cable is being improved each year and it
is only a matter of time until many visitors to the hotels on the
southern rim will cross and spend a few days on the northern pla-
teau and return to leave the canyon by the present railroad.

The roar of Bright Angel Creek comes to the top of the point and
there are several falls along the trail down which the water plunges
and boils in foamy beauty. From the bottom the vast cliffs rise sheer
for a thousand or two feet in one wall and the coloring all along is
almost more beautiful than from the better-known southern rim.

August 24. Today we took a pack outfit of two horses with food
for several days and started for Skiddoo Point, which in spite of its
name is the most beautiful point along this part of the canyon. The
forest too was tall and unbroken except for little natural glades and
shallow canyons with grassy bottoms like the ravines of the plains
country. In these the bracken fern grew in island-like clumps and
asters from palest blue to purple were in full blossom, with many
other flowers. The beauty of the whole was a constant delight.

As we neared the rim, the Painted Desert came into view to the
east and lying some four or five thousand feet lower than this point
which is said to be nine thousand feet above the sea, I almost forgot
the vast and gorgeously colored chasm at our feet, the distant view
was so strange and bewildering and yet so beautiful.

Echo Cliffs along which we had journeyed from Tuba City to Lee's
Ferry and which had towered above us very good-sized mountains
were now in the northern wall of the desert and showed to be the
ragged, broken edge of a fault where the earth had cracked and sunk
and sagged away till it looked like a long piece of broken pie crust—
which may not be a very elegant description but is exactly what it is
like—though burned and browned into the richest reds and purples
veiled over with a haze even more wonderful than that which hangs
always over the canyon.

Rolling westward from the cliffs, the desert dips into rounded
hills and shadowed canyons like the birds-eye view of some gigan-
tic, frozen sea, but a sea of deep reds and blues and streaked with
brighter lines than anything but wet colors on an artist's canvas
could show. No words can tell how weird and unearthly it looks,
much as the moon may be, for to the southern edge the round cra-

ter cone of Black Butte stands out against the brighter color so distinct that the purple mirage around it seems almost volcanic smoke.

Cutting the gorgeous desert clear across, the canyon of the Little Colorado seems another great break in the earth, ready to fall away perhaps and leave another fault-line of peaks and another Painted Desert of rich-colored fragments. But however it seems to waver in the warm, bright haze, it never becomes anything but a bottomless pit with jagged walls and dark side-canyons where at a point or two one may see the river in a silver streak.

By moonlight was it still more wonderful and I could scarcely leave the rim to go to bed, and when I did the forest under the moon was so fine I wanted to stay up to watch it.

Where to Find Bicycle and Horse Riding Vacations

American Dude Ranches
American Wilderness Experience
Bicycle Africa Tours
Experience Plus!
Horse Riding Vacations

 American Wilderness Experience
 Bar H Ranch
 Boojum Expeditions
 Equitours
 FITS Equestrian
 Warner Guiding & Outfitting
Nichols Expeditions
Rainbow Adventures
Wagon Train Trips
 Flint Hills Overland Wagon Train Trips
 Oregon Trail Wagon Train
 Wyoming Wagons West
Wilderness Travel
Womantours
Woodswomen Inc.

Chapter Three
CLIMBING MOUNTAINS

"A more successful ascent of the Peak was never made, and I would not now exchange my memories of its perfect beauty and extraordinary sublimity for any other experience of mountaineering in any part of the world."

Isabella Bird, *A Lady's Life in the Rocky Mountains*

W omen have been climbing mountains successfully for many years, though men have claimed most of the attention. Mountaineering or mountain climbing for sport was invented in the 1800s. Once the middle-class discovered the thrill of climbing mountains, eager men scaled the Alps in Switzerland and the peaks in England, Scotland, France, and rest of Europe. In 1865, the first climber reached the summit of the Matterhorn, the highest peak in Europe at 14,690 feet.

Adventurous climbers moved to India, Nepal, Africa, and South America. The Himalayan peaks drew climbers for the magnificence of the views and the challenge of the climbs. Mount Everest, the world's highest mountain, was finally climbed by Edmund Hillary and Tenzing Norgay in 1953. Junko Tabei of Japan was the first woman to reach the summit on May 16, 1975. From the very beginning of the sport, there have been women climbing, either with husbands or male companions, or on their own. Many have left their mark on the history of climbing.

Julia Ann Archibald

Julia Ann Archibald's description of her journey west in a convoy of covered wagons and her climb of Pike's Peak appeared in *The Sibyl: A Review of Tastes, Errors, and Fashions of Society* in 1859, by J. A. Archibald. She and her husband, James Holmes, set out in the summer of 1858 to climb 14,110-foot Pike's Peak, first climbed in 1818 by Long's expedition.

They traveled across Kansas with a 15-wagon train filled with men looking for gold in the west. Julia, the only woman in the group, was criticized for being "strong minded," and some men objected to her unladylike clothes—a calico dress to the knee, with pants or bloomers. She explained: "I cannot afford to dress to please their taste. I couldn't positively enjoy a moment's happiness with long skirts on to confine me to the wagon."

They met Arapaho and Cheyenne Indians—one offered James two squaws if he would sell Julia! At the fur trading station at Bent's Fort, Julia noted: "The price paid for a buffalo robe at present is ten cups of sugar." About 70 miles from the Rocky Mountains, Julia caught her first glimpse of Pike's Peak: "The summit appeared majestic in the distance, crowned with glistening white." The wagons camped by Boiling Spring river while Julia and James set off on August 1, 1858.

Pikes Peak, Colorado, 1858, by Julia Ann Archibald

After an early breakfast this morning, my husband and I adjusted our packs to our backs and started for the ascent of Pike's Peak. My own pack weighed 17 pounds; nine of which were bread, the remainder a quilt and clothing. James' pack weighed 35 pounds, and was composed as follows—ten pounds bread, one pound hog meat, three fourths pound coffee, one pound sugar, a tin plate, knife and fork, half gallon canteen, half gallon tin pail and a tin pint cup, five quilts, clothing, a volume of Emerson's essays, and writing materials made up the remainder. We calculate on this amount of food to subsist six days.

A walk of a mile brought us to the crossing of Boiling Spring river. It is an impetuous, ice cold stream at this point, about twelve feet wide, knee deep, with a cobble stone bottom. Undressing our feet we attempted it several times before we could cross, the water was so intensely cold we were ready to drop down with pain on reaching the opposite bank.

The first mile or so was sandy and extremely steep, over which we toiled slowly, as we frequently lost all we gained. By persevering, and frequently falling on our backs to rest, we at last reached the timber where we could obtain better footing. We neglected to fill our canteens and now began to feel the want of water. We toiled on

and up in hope of soon finding a spring. At one time we went too far to the left—not knowing the route—and got among some huge boulders which we soon saw the necessity of getting out of the best way we could. After finding the right track we continued, but we had lost so much time in getting among the rocks, and become so hungry, that after proceeding a couple of miles farther, and catching a glimpse of water in a deep canyon, we halted and considered the state of our case.

The question was, should we descend that terrible canyon only to ascend again, or proceed on our journey not knowing when we should reach water? Our longing for water triumphed and down we rushed with such eagerness as is only inspired by suffering.

It is now ten o'clock in the evening, and I am reclining before some blazing pine logs beside a torrent in a mountain canyon several hundred feet deep. The straight, slender, tapering pines that stand around so beautiful in their death, smooth, white and sound, having been stripped of their bark by fire, calmly point to a sky more serene, and to stars far brighter than usual. The trees and the sky almost seem to strive together in preserving a deeper silence. But there is music from the foaming stream, sounds from a dozen little cascades near and far blend together—a thundering sound, a rushing sound, a rippling sound, and tinkling sounds there are; and a thousand shades of sound to fill up between them. The burning pine crackles and snaps, showering sparks, cinders and even coals around and all over the sheet I am writing on, as if to mock the tame thoughts they light me to write.

Aug. 4th. We arrived here day before yesterday about one o'clock p.m. during a little squall of snow. Yesterday we went in search of a supposed cave about three fourths of a mile along the side of the mountain. We penetrated the canyon with much difficulty, being once obliged to take off our moccasins that we might use the toes and balls of our feet in clinging to the asperities of the sliding rock.

We found no cave, but a tremendous amphitheater shaped space, whose perpendicular walls rose seven or eight hundred feet high. Piled around the vast circle at the foot of the walls were granite boulders of all sizes and shapes rising against the walls like the terraced seats of a circus or theater. Deep in the center is a circular spot of green grass, with flowers, and a silvery stream winding through it. We called the place Amphitheater Canyon.

These whole mountains are of a feldsparic formation, with an occasional sample of quartz soil that is covered with vegetation which does not occupy one fourth of the mountain where we are. Granite boulders and stones of every size and shape, with granite gravel, occupy over three fourths. Beautiful flowers, delicate in texture and aroma, grow everywhere, except on the bare rocks, and even within reach of the snow.

Snowdell is the name we have given to a little nook we are making our home in for a few days. It is situated about four or five rods above the highest spring which gushes from the side of the Peak. On the cold moss overhung by two huge rocks, forming a right angle, we have made a nest of spruce twigs. Some smaller rocks form, with the larger ones just mentioned, a trough about three feet wide, and ten feet long. At the outlet of this narrow space we have built up a chimney. When we lie down the fire is burning but a yard from our feet, while we can stretch our hands over the smaller rocks into a large bank of snow. This we call our home.

Eastward, we can look on a landscape of Kansas plains, our view hemmed only by the blue haze of the atmosphere, and extending perhaps two hundred miles. The beauty of this great picture is beyond my powers of description. Down at the base of the mountain, the corral of fifteen wagons, and as many tents scattered around it, form a white speck, which we can occasionally distinguish. We think our location grandly romantic.

We are on the east side of the Peak, whose summit looming above our heads at an angle of forty-five degrees, is yet two miles away— towards the sky.

Aug. 5th. We left Snowdell early this morning for the summit, taking with us nothing but our writing materials and Emerson. We deviated somewhat from our course in order to pass the rim of Amphitheater Canyon. Here on the edge of the perpendicular walls, were poised stones and boulders of all sizes ready to be rolled, with a slight effort, into the yawning abyss. When a stone was started it seemed first to leap into the air, and passing from sight nothing would be heard of it for several seconds. Then would come a crashing, thundering sound from the hidden depths below, which seemed to continue until lost in the distant lower region.

After enjoying this sport a short time, we proceeded directly up towards the summit. Arriving within a few hundred yards of the

top, the surface changed into a huge pile of loose angular stones, so steep we found much difficulty in clambering up them. Passing to the right of a drift of snow some three or four hundred yards long, which sun and wind had turned into coarse ice, we stood upon a platform of near one hundred acres of feldspathic granite rock and boulders. Occasionally a little cranny among the rocks might be found in which had collected some coarse soil from the disintegration of the granite, where in one or two instances we found a green tuft about the size of a teacup from which sprung dozens of tiny blue flowers most bewitchingly beautiful. The little ultramarine colored leaves of the flower seemed covered with an infinitude of minute sparkling crystals—they seemed children of the sky and the snow.

It was cold and rather cloudy, with squalls of snow, consequently our view was not so extensive as we had anticipated. A portion only of the whitened back-bone ridge of the Rocky Mountains which forms the boundary line of so many territories could be seen, fifty miles to the west. We were now nearly fourteen thousand feet above the sea level. But we could not spend long in contemplating the grandeur of the scene for it was exceedingly cold, and leaving our names on a large rock, we commenced letters to some of our friends, using a broad flat rock for a writing desk.

Leaving this cloud-capped bleak region, we were soon in Snowdell, where we remained only long enough to make up our packs. Before we were ready to say good bye, the snow was falling quite fast, and we left our pretty home as we first saw it, in a snowstorm. We pursued our journey in all possible haste, anxious to find a good camp for the night before dark. At last when I thought I could not go further, we found a capital place, a real bears' den it seemed, though large enough for half a dozen. And here we are, enclosed on every side by huge boulders, with two or three large spruce trees stretching their protecting arms over our heads. The next day near noon we arrived at camp.

Mrs. H. W. Cole

Mrs. H. W. Cole, who recommended climbing with rings sewn into the bottom of skirts so they could be looped up if necessary, shows how determined she was to be the equal of the men she traveled with. She started out on horseback, but climbed the rest of the way of her own.

Ascending the Aeggisch-horn, 1859,
by Mrs. H. W. Cole

We were awakened by our alarum at a quarter to four, had a hasty breakfast, and left the hotel by 5:10 am. At 6 am I dismounted, for the horse could go on no farther, and I accompanied the gentlemen on foot the rest of the way, which is excessively steep. The path winds upwards amongst large blocks of stone, which form a kind of staircase to the summit. This I reached at 6:55 am without any assistance. At the top, Mr. F., who was the first to arrive there, offered his hand to assist me up the last few steps over the huge smooth blocks of stone of which the highest peak is composed, but I saucily declined the proferred help, as, had I accepted it, I should not have been able to say that I had ascended without assistance...

I not only climbed up, but also came down again, without any other aid than that of my trusty Alpen-stock and the occasional assistance afforded by my taking hold of the rocks on the side of the path. To my taste, the view from the summit of the horn is so immeasurably superior to what can be seen from below, that no one ought to be content with the view from the lower ridge who has strength to climb for an hour, and has a head steady enough to enjoy the view from this surprising pinnacle.

On reaching the summit, one's first difficulty is to discover a secure resting-place from which to make observations, for there is no level spot on which to stand; but having done this, I found myself poised on a pile of huge, loose rocks, which are heaped together on top of the mountain in so strange a fashion that one wonders the heap does not separate and tumble down on the Aletsch Glacier below.

Valerie Tamis

Valerie Tamis is a contributing editor of *Avenues*, a West Coast AAA magazine with a circulation of 2.5 million, and a frequent contributor to *Walking, Modern Bride, Chevron Odyssey*, and *Westways*. She also writes a weekly column called "Wandering" for several Bergen County New Jersey newspapers.

She chose to climb Flattop Mountain in Colorado for two reasons: to forge a deeper adult relationship with her 23-year-old son Chris, and to prove to herself that she could climb a mountain.

"I achieved both in the Colorado Rockies during the summer of 1995," she notes. "But honestly, what I failed to take into consideration was that chats at 12,500 feet tend to consist of 'Pass the water bottle' and 'My blisters are killing me.' Words, however, proved unnecessary in this rite of passage for us both. Standing atop Flattop beneath an azure sky, I realized I'd raised a sensitive and caring human being with whom I could have fun. He saw that his mother, a recent divorcee, had learned to embrace risk and conquer personal fears. I treasure his words as we huddled on the wind-swept summit: 'I'm proud of you, mom. You set a goal and accomplished it.' Now THAT is a summiting experience."

Mother and Son on Flattop Mountain, 1995,
by Valerie Tamis

A rising sun blushed the scalloped peaks of the Rocky Mountains as my son and I drove toward Wild Basin Ranger Station. Lofty Douglas firs shadowed the bumpy road, and we sipped our morning coffee carefully. Suddenly a large four-legged creature with antlers loped in front of the car.

"Look at the guy in the elk costume!" Chris shouted. "Uh, Chris," I said, "that's the real thing."

My son, obviously, did not major in zoology in college, but his graduation from New York University inspired this trip to Rocky Mountain National Park. Hiking in Colorado sounded "totally excellent" after four Greenwich Village years where elk suits must be the rage. For me, it was a chance to forge a more adult relationship with my 23-year-old son (and truthfully, he negged the idea of a spa).

We weren't concerned that the only prior activity we shared above the timber line was sitting in a Boeing 747. We are not sea level sofa spuds. I walk miles daily along the ocean near my home in Maine, and Chris saved a small fortune on subway tokens biking around New York City. But this vast national park features 355 miles of daunting, altitudinous, often desolate trails. We needed more than spirit and stamina to put our best foot forward, so I had contacted the renowned Colorado Mountain School in Estes Park and arranged for a guide who would teach us skills to summit a mountain. Today that adventure (which Chris labeled "quality mother-son time") was about to unfold.

Jamie Pierce studied us as we walked towards him in the parking lot adjacent to the ranger station. I hoped he didn't consider us potential wimps in the woods despite our new red bandanas and unscuffed hiking boots.

"You guys just arrive last night?" he asked. When we swore we came four days earlier to acclimatize in the thinner air, he smiled and said: "Cool. Most people fly in and think they can do this immediately." I winked at Chris, knowing we passed a crucial test with our veteran guide. Jamie handed us an Acknowledgement of Risk form and my confidence evaporated when the words "accidental death" leapt off the page. "What's this?" I asked. Jamie explained, "There are 350 rescues every year in this park. Hiking is fun but it's serious business." As we signed, he unfolded a large paper that looked like an Arabic mosaic of brown and green squiggly lines.

"This is a topography map," he said. "Oh," I answered. "Right," Chris said. Jamie cleared his throat and continued: "The green lines indicate elevations below the timber line, which is around 12,000 feet, and the brown lines signify heights above that." He pinpointed a spot on the map and said, "The closer the lines, the higher the altitude, so you can see that today's hike to Ouzel Lake will be about 10,500 feet because the lines are tight, but they're still green." "Sure," we responded.

Jamie began rattling on about the importance of pace, but I was more concerned about snakes ("Nope, too high," he assured me) and Chris asked if he'd see the alpine streams depicted in Coors commercials. Jamie said patiently, "We'll talk more about survival skills as we walk."

Chris and I took the lead, striding briskly along the rutted ascending trail that fringed the Saint Vrain River. We passed lush two-foot-high ferns clumped around the trunks of ponderosa pines, and watched a chipmunk scamper behind a profusion of blue columbine.

"Why's Jamie so slow?" Chris asked, looking back at the deserted path. "Let's be polite and wait," I suggested.

Jamie ambled towards us and said, "You guys are on a blistering pace." Somewhat chagrined but definitely flagging, we sat on a log to listen. "A lot of people rush on to the trail without considering the whole journey," Jamie said. "We're going nine miles today through some rough terrain, so it's better to maintain a relaxed gait. As you hike, listen to your body and do what it's telling you. That

means, drink before you're thirsty, eat before you're ravenous, but definitely slow down!"

"I think he's figured out we're not Lewis and Clark," Chris whispered as we followed Jamie, who stopped frequently to munch pretzels and describe trail markers. Three hours later we collapsed on the flat granite boulders that overlook Ouzel Lake. I said, "I understand what you mean about pace. I wouldn't have gotten here at the clip I was going." Jamie pointed to a nearby mountain and said, "Good, because climbing Flattop tomorrow is going to be even tougher."

The next morning I roused Chris at 4:45, who mumbled from beneath the blankets, "Can I have 10 more minutes? I'm preparing myself mentally." The park was eerily silent when we greeted Jamie near Bear Lake trailhead. "Not even the birds are up," I noted. He replied: "It's better to hike early because there's a possibility of afternoon storms. Plus there are fewer people."

The dirt path was Heartbreak Hill from the onset, with numerous switchbacks presenting stunning panoramic vistas of the snow-frosted Rockies. Remembering how sapped we felt after yesterday's hike, we constantly nibbled GORP (good old raisins and peanuts) and apples. All bantering ceased as we trudged higher and higher, and I thought, don't take your son up a mountain and expect to have meaningful conversations.

Dense pine forests yielded to wind-ransacked shrubs as we approached the timber line. Fat brown pikas eyed us from rocky perches, then scurried off through tundra grass. My back and legs throbbed from the unbroken rise. I was short of breath, and needed to rest every 25 feet. "I feel like a new man every time I sip water," Chris admitted. In the distance I spotted ant-sized people on a snowy slope below the summit. "I don't think I can make it," I told Chris. He sat down, handed me the water bottle, and said, "Take as long as you need, mom, but you're going the whole way."

Frigid gusts whipped my nylon jacket as I shuffled through the glacial snowfield that bordered the summit. Ahead lay a chromatic moonscape of gray and black boulders accented with clusters of yellow buttercups. I saw a small sign: Flattop Summit—12,324 feet. Chris and I slapped high-fives and raised our arms skyward in silent celebration. We lunched beneath a Windex blue sky laced with mares' tail clouds. Chris dozed on a lichen-scored boulder while I watched

climbers ascending the rocky cliffs of Hallett Peak. Jamie asked, "Have you thought about the descent?" I gulped. I forgot it was five miles back. "Summits don't come on a silver plate," he said. "You have to work for them up and down, and the descent can be a damn difficult thing."

Ours wasn't, truthfully. We were euphoric with our achievement in Rocky Mountain National Park. We learned that hiking is more than moving from Point A to Point B. It's a journey of risk and challenge, requiring self control, acquiescence to nature's whims, and understanding of other's fragility and limitations. Halfway down Flattop, I reminded Chris of a sign we spotted hours earlier that read: "The Mountains Don't Care." "That's true, they don't," Chris said. "And that's why we have to care." I smiled and thought, oh yes, the son also rises.

Fanny Bullock Workman

Fanny Bullock Workman (1859-1925) believed women could do anything men could do. You met her out bicycling in an earlier chapter. For almost 30 years, she traveled around the world with her husband, Dr. William Hunter Workman. Together they wrote eight books replete with drawings and superb black-and-white photographs about their adventures in Europe, North Africa, India, and the Himalayas. Their climbing achievements and unique explorations of the Himalayas are internationally renowned.

Born in Worcester, Massachusetts, the youngest of three children, Fanny grew up in a wealthy family—her father became Republican Governor of Massachusetts when she was seven. Educated by private tutors, she went to finishing school in New York, and spent two years in Paris and Dresden. At 22, she married Dr. William Hunter Workman, a successful physician, who was 34. In 1884, a daughter, Rachel, was born.

William introduced Fanny to climbing in the White Mountains of New Hampshire, and she climbed Mt. Washington (6,293 feet) several times. In 1888, William became ill, gave up his medical practice, and took Fanny and Rachel to live in Europe, mostly in Germany. Their son, Siegfried, born in Germany in 1889, died in childhood.

Eager for adventure, they bought two new Rover Safety Bicycles and took off to bike through Spain in 1895, Morocco a

year later, the Atlas Mountains, and Algeria. In 1897, they spent three years riding through India, Burma, Ceylon, and Java.

Then they discovered mountain climbing. They climbed several high peaks in the Alps, including the Matterhorn (14,780 feet) and Mont Blanc (15,781 feet). At first, Fanny, a stout, well-built woman, was adamant about climbing in long skirts and keeping her ankles covered. In later photographs she wears a skirt to her knees with thick leggings down to her boots, and a pleated loose-fitting shirt with a high collar and cuffs. She also wore a stylish hat and gloves, and sometimes carried an umbrella.

After each trip, William and Fanny returned to Munich or London and wrote books about their adventures. As they became experienced climbers, their journeys became expeditions, with serious scientific research goals.

In 1899, inspired by the peaks of Everest, K2, and Kanchenjunga, they set out to explore the Karakoram range west of the Himalayas. For the next 14 years, Fanny and William led six major expeditions into the icy wilds of the remote region that few had ever explored before. Mount Bullock Workman is named after them.

In 1902 and 1903, they explored and mapped the Chogo Lungma glacier and the region of northern Baltistan. Fanny climbed Mt. Lungma (22,568 feet) and set an altitude record for women climbers. William, aged 56, scaled Pyramid Peak (23,392 feet) and set a world record for men. In 1906, they explored the peaks and glaciers of Nun Kun, southwest of Srinagar in Kashmir.

In 1912, Fanny led the triumphant expedition over the Sia La pass (18,700 feet), near the head of the Siachen Glacier, and descended through a previously unexplored region to reach the Kaberi Glacier. Fanny wrote the account of this climb herself, and is shown in one photograph reading a newspaper on a summit with the headline, "Votes for Women." As her fame spread, Fanny was given awards and memberships in honorary organizations. Her lecture to the Royal Geographical Society in London in 1905 made her the second woman to address that group since Isabella Bird spoke there in 1897.

Fanny and William moved to the south of France during World War I (1914-1918). After a long illness, Fanny died in Cannes, on January 22, 1925, at the age of 66. William went home to Newton, Massachusetts, and lived to the age of 91. In Fanny's will, she left $125,000 to four women's colleges (Bryn Mawr, Radcliffe, Smith, and Wellesley), and Bryn Mawr still awards the Fanny Bullock Workman Traveling Fellowship.

This excerpt from their Himalayan expedition book is Fanny's personal advice based on her climbing experiences, and is one of the few times that Fanny writes as an individual.

Rarefied Air and Climbing, 1890,
by Fanny Bullock Workman

For the benefit of women, who may not yet have ascended to altitudes above 16,000 feet but are thinking of attempting to do so, I will here give my experiences for what they are worth.

Within four weeks of the completion of a rather exhausting cycle trip in tropical Java, where for six weeks, I had been exercising in a moist temperature varying from 80 to 95 Fahr., I began the march from Srinagar to Baltistan. I had been doing little walking, with the exception of climbing a few Javan volcanoes, which was not invigorating exercise even at heights of 11,000 and 12,000 feet. Two weeks and a half after leaving Batavia were spent in lying around inactive on the decks of steamers, on the train crossing the heated plains of India, in a temperature of 104 to 107 Fahr. for seventy-two hours at Rawal Pindi, and in a 'tonga' from that place to Srinagar. It will thus be seen that, in starting out, I was in no especial training for mountain work.

I am not a light weight and am a slow climber. Still, my powers of endurance on long days of climbing, and in weeks of continued cycle touring have, for a number of years, been good. I had been told by people in England and also in India, that I should not be able to cycle more than one cold weather in the plains, and certainly should not be fit for much in the mountains after a long season of exposure to the sun at lower altitudes. As a matter of fact, my hardest and highest mountain work was accomplished after two seasons, of six months each, cycling in Ceylon, India, and Java. By cycling, I mean touring of a kind quite unknown in European countries, involving a mental tax in trying to control the conditions met with in the East,

in order to reach a desired end, that, very possibly, on a given occasion, might appreciably diminish one's capacity for a long day of physical exertion, or for resisting the effects of rarefied air.

As good a bodily condition as possible is, of course, desirable to enable one to combat successfully the factor 'majeure' in high climbing, diminished oxygen, as well as to endure fatigue and the extreme cold often met with at high altitudes.

On the march to Askole, I experienced much greater difficulty in breathing, when near the top of the Skora La, our first high pass, at about 17,000 feet, than later on at 18,000 and 19,000 feet. The advisability of passing a month, if possible, in valleys 11,000 or 12,000 feet up, and in making experimental higher tours is obvious.

Before making the three principal ascents, I had been for weeks at altitudes varying from 11,000 to 17,500 feet. In the ascent of the Siegfriedhorn, I started from the height of 16,200 feet with a rather severe headache, which, I suspected, came from cold rather than from altitude. This proved to be the case, for it did not increase or diminish, as I went higher. With the exception of the usual quick breathing, which climbing always causes in my case, I noticed no unpleasant sensations from rarefied air either on the ascent or at the top. Neither did I feel the least desire for kola biscuit, peppermint or cognac, whereas I had felt the need of and used peppermint with considerable relief on the Skoro La five weeks previously. My pulse at 17,000 feet, after a few minutes' rest, was ninety; at the summit, 18,600 feet, one hundred and five.

On Mt. Bullock Workman I met with no inconvenience in the way of mountain sickness, although at the summit, after the exertion on the last very steep 'arete', rendered most arduous by fresh snow, I was seized with a violent headache, which became much modified after a substantial breakfast, for which my appetite was good at 19,450 feet. I attribute my slight suffering from rarefied air on these two summits to three causes; first, because I had been living and sleeping at high altitudes for five weeks; second, because my vitality was at no time much impaired by the cold; third, because these climbs were most over snow instead of rock.

I cannot say that I ever slept soundly above 16,000 feet, and at 17,900, our highest camp, my night's rest was often broken in upon by difficulty of breathing. On Mt. Koser Gunge, 21,000 feet, all the conditions were changed. Over the sharp rock 'aretes' and walls to 19,000 feet, I was able to ascend at a rate of 600 feet an hour. From

that point, my chief contention was with the elements rather than with rarefied air. The continued high wind and deep snow reduced our progress to about 300 feet per hour, and much increased, with me, the difficulty of breathing. Towards the last my gaspings for the much required oxygen were most strenuous.

I do not endure severe cold well at any altitude, and at this great height found the chill and numbness produced by the icy wind bitter to bear. I recall no mountain sickness whatever, although the unprecedentedly severe and continued exertion both on the ascent and descent of this peak naturally caused a generally used-up physical condition, before I reached camp at night. No lameness resulted, and the following day I felt perfectly fit and able to attack another mountain had it been necessary.

Sally Wendkos Olds

An award-winning writer of seven books on personal growth and development, intimate relationships, and family issues, and co-author of three college textbooks, Sally Wendkos Olds' publications include *The Complete Book of Breastfeeding*, a classic that has sold over a million copies, and *The Working Parents' Survival Guide*. She has also written more than 200 articles for national magazines. A former president of the American Society of Journalists and Authors, she lives in Port Washington, New York, with her husband Mark, a retired broadcasters. She is the mother of three grown daughters, and is a grandmother.

Sally Wendkos Olds has hiked mountains in the national parks of the United States and Canada and in the Italian and French Alps, but it is to Nepal that she has returned, time and again. Like Fanny Bullock Workman, she often travels and treks with her husband, Mark. She has trekked in this mountain kingdom five times—and expects to return.

In 1993, she and an artist friend, Margaret Roche, were the first western women to visit Badel, a village in eastern Nepal that can only be reached by trekking on foot for three days over narrow trails. Badel has no electricity, telephones, sanitation, or roads, and its people, the Rai, live and work as they have for centuries, following a way of life that will likely disappear soon. The two women stayed with local families, trying to learn about their outlook on life, what they thought, their inner resources,

the secret of their friendliness and joy. She was fascinated by a community that was surrounded by the magnificent beauty of the Himalayas and lived in grinding poverty, struggling in a harsh and primitive land, and is writing a book about her experiences.

Reaching Gokyo Peak, 1994, by Sally Wendkos Olds

From my perch on top of Gokyo Peak in northeastern Nepal, I can see this mountain's taller and more famous neighbor, Mount Everest. On this morning in early May, the filmy white plume of snow that ordinarily blows skyward from Everest's dark crown seems still, suspended in the clear mountain air. Floating just above the mountain's brow against the porcelain-blue sky, it looks like a halo, and I wonder whether it was on a morning like this that the Tibetans named this tallest mountain in the world "Chomolungma," which means "Goddess Mother of the Snows."

It took my husband and me 2 hours and 15 minutes to reach the rocky 17,800-foot summit of Gokyo, bedecked with prayer flags fluttering in the chill morning wind, from our campsite about 2,000 feet below at the edge of Dudh Pokhari, one of the five alpine lakes in the Gokyo valley. The turquoise borders surrounding the lake's frozen center were already wider than they had been the day before. On this first day in May, spring continued coming to this remote corner of the Himalayas.

When Mark and I climbed out of our down sleeping bags at 6:00 this morning, frost sparkled like diamonds on the ground in front of our tent, our canteens were frozen shut and the wash water in the basin by the toilet tent were solid ice. But by 8, after we and our fellow trekkers had breakfasted on porridge and chapattis and were beginning the hard climb up, the sun had come over the mountains to shine on the walled yak pasture where we had camped, and most of us had stripped down to shorts and light shirts.

The two of us and the dozen other trekkers in our group had chosen to view Everest—and several others of the world's ten highest peaks—from the Gokyo lakes area rather than from the more popular viewing sites around Everest Base Camp. We wanted to experience the unique flavor of this out-of-the-way, less-traveled area, with its savage rocky moonscapes and its shimmering lakes. We also wanted to see a part of Nepal that was strewn with huge glacial boulders rather than with the garbage, tin cans, toilet paper (known

locally as "the white man's prayer flags"), and other detritus left along the trails of heavily traveled routes by hordes of trekkers and their retinues.

The Gokyo route fulfilled its promise in every way imaginable. Many visitors, including those who have also been to Everest Base Camp, call the 360-degree panorama at the summit of Gokyo "the finest mountain vista in Nepal." The view from the peak is spectacular. There is the vast Ngozumpa Glacier, the longest glacier in Nepal. Beginning in ice and snow, it grinds down to an immense moraine of rubbly rocks, dotted with small pools—some as bright green as the lakes just below us, some still iced over and glassily reflecting the clear blue sky and long streaming clouds. Then, of course, there's Everest; and the fluted ridge of the vast ice wall anchored at either end by the high peaks of Lhotse and Nuptse; the jutting spires of Makalu; and, showiest of all, the broad crenelated contours of Cho Oyu, the world's ninth highest peak, as it dominates the landscape with its massive bright white, glacier-accented bulk.

This view and the other treasures of the Himalayas had been well worth the long, exhausting climbs and descents over the past two weeks; the cold mornings when we stamped around to keep warm waiting for the sun to warm our campsite; the intestinal bugs and chest colds that had visited all 14 of us trekkers, one after the other; the close quarters inside tents never meant to hold two adults, two lumpy duffel bags, and two backpacks. All these and other minor inconveniences melted away in the face of the splendors we had come so far to experience.

Our trek had begun two weeks before, after a bumpy 9½ hour 118-mile bus ride from Kathmandu, Nepal's capital city, to the bustling little settlement of Jiri. For the next three weeks we would move only on foot, as we followed the traditional walk-in route used by expeditioners for years—until the seductive 40-minute airplane service from Kathmandu to Lukla cut out eight days of trekking for rushed vacationers.

There is a steep price to pay for this airborne shortcut. Telescoping the ascent brings the risk of altitude sickness, which regularly takes the lives of even the fittest—by one estimate, of one in 1,000 Himalayan trekkers. While we were on the trek, a 30-year-old on a nearby mountaineering expedition succumbed; he went to sleep one night at 18,000 feet—and never reawakened. Our trip leader, Peter

Owens, who has led more than 50 treks in the Himalayas (many for the Sierra Club), had planned our route to ascend, on average, only about 1,000 feet a day. We didn't come near Lukla for over a week, and didn't reach Gokyo until our 16th day out of Kathmandu. This gradual acclimatization, as well as a drug, Diamox, that some of us took to prevent altitude sickness, worked well.

The Gokyo trek, including the walk-in route from Jiri, offers many bonuses in addition to being surrounded by these marvelous snow peaks, the youngest, highest, and craggiest mountains in the world. As we hiked up and down, ascending 3,000 feet in a day to the rhythms of aching thighs, or dropping more than 2,000 feet to the sounds of crackling knees, we experienced glories that Lukla passengers miss completely.

We walked through subtropical bamboo thickets, lush with tropical greenery and wild orchids; and in rhododendron forests of 60-foot trees vibrant with red, pink, and white blossoms. At our first campsite, in Shivalaya on the banks of the Khimte Khola river, we shampooed our hair, washed laundry and then dozed in the sun to the soothing sounds of water rushing over rocks.

Among the exotic wildlife of the Himalayas that we saw from trails and campsites were the gorgeous Impeyan pheasant, Nepal's national bird, breathtaking with its nine iridescent colors, some of which show up only when it takes flight; the tiny musk deer, the size of a large dog, valued for the musk gland, the basis for precious perfumes; the barking deer, also small and recognized by its doglike bark; the Himalayan tahr, a large commanding goat at home on the steepest cliffs; and the goral, a wild sheep with short pointed horns.

One morning, alone and relishing my solitude, I walked along the 11,580-foot Lamjura Pass, still and silent except for the trilling of larks, the tinkling of yak bells, and the whistle of a sudden chill wind. In a barren uninhabited area on the ridge was a pile of immense stones. These huge boulders inscribed with the prayer "Om mani padne hum" ("Hail to the jewel in the lotus") reflected the devotion of believers who had either sat alone in this wilderness carving them, or who had carried their heavy weights on their backs.

Just outside of Junbesi, a couple of us stopped in at the Serlo monastery where a young red-robed monk took us into a room filled with hundreds of hand-carved wooden blocks used to print religious books, and then gave us a few rejected pages, smilingly refusing our

offer of money. Another day we all went into a convent populated by bent, wizened, nut-brown women who had fled Tibet after the unsuccessful 1959 revolt against its Chinese conquerors, and now spent their days turning prayer wheels, ringing bells, and subsisting on donations from visitors. In the village of Thamo, we walked up a dark flight of wooden stairs to watch the woman of the house distilling rakshi, the potent liquor made from local grains. Among the Sherpas, the dominant ethnic group in the Khumbu area of Nepal, the woman often runs both household and family business— teahouse, store, or cash crop—while her husband is gone for weeks at a time guiding trekkers or mountaineers.

At the start, our group numbered 50. besides Pete, our leader, we were 14 trekkers of varying ages, 35 to 78, with most in their 30s and 40s. Our professions included emergency-medicine physician, lawyer, botanist, artist, history professor, and computer consultant, and we came from a variety of towns and cities in the U.S. There were an embarrassingly colonial 35 members of staff—guides, kitchen crew, and porters to carry our food, tents, duffels, and everything else that didn't fit into our day packs. As the days went by, porters left, because, as Pete said when a couple of them set out to walk back to their villages, "We just ate up two porters."

We had all trained for weeks before by climbing stairs or jogging or hiking, but even the hardiest among us felt the rigors of the journey. Like Mark and me, nine of us had been in Nepal before. Although only a few had known each other beforehand, after three weeks of trekking we had become a big, close, temporary family, sharing intimate physical and emotional details of our lives, as well as our medicines, our equipment, and even our scarce toilet paper.

Before Mark and I left for Nepal, puzzled friends asked us, "With all the places in the world that you haven't seen, why are you spending all this money and time to go back to one that you have—and to be tired and uncomfortable in the bargain?" We did our best to explain the appeal of being among the most spectacular scenery in the world, with some of the friendliest, kindest people we have ever encountered. But after all our explanations, a mystical element remained; we had heard a call that we couldn't put into words. The best answer we could give—if it were only possible—would be a magical transport to the top of Gokyo Peak.

Effie Fletcher

For those of you considering a trip to the Himalayas, take the advice of an expert. Effie Fletcher is director of Himalayan High Treks, and this is what she tells people interested in joining one of her trips.

Preparing for the Himalayas, 1996, by Effie Fletcher

One of the most frequent questions I'm asked is what it takes physically to go on a trek. Trekking is an activity that almost anyone can enjoy at some level. I've taken people from ages 12 to 77 on my trips. Many people who think backpacking would be too much work love trekking. On Himalayan treks, staff members cook for you, put up your tent, guide the way, and explain the sights. We also provide an American group leader trained in First Aid. On the popular Annapurna and Everest routes, you stay at comfortable guest houses.

With such an investment of time and money, most people are better off if they put some into training. This is especially important if you are older, have less than perfect health, or haven't been exercising regularly for some time. Start as soon as you decide you want to go trekking. Incorporate aerobic exercise into your schedule at least two or three days a week. Stairclimbing is especially good training. So is fast walking. As soon as you can, buy the boots you plan to wear on the trek and start breaking them in.

After about two months of regular exercise, begin hiking one day a week. Start with about five miles with a climb of about 1,000 feet or less, and try to do a little more each week. Join your local branch of the Sierra Club or a hiking club. Two months before the trip you should be able to do the hike for your trek. For a moderate trek, you should be able to complete an eight mile hike, gaining 2,000 feet of elevation without becoming completely exhausted. In other words, if you have to take a bath, a dose of ibuprofen, and still feel too exhausted to go to work the next day, you aren't ready. Change to an easier trip or one that will give you more time to train.

If you are on track, switch into high gear! Try to exercise almost every day and focus on those weekly hikes. Try one of the hikes from the beginning. It should be fairly easy now. All this hard work will really pay off on the trek. You'll feel more energetic and be able to fully enjoy all there is to see and explore.

Almost anyone, anytime, can enjoy hiking in the Himalayas!

Where to Find Mountain Climbing Vacations
Call of the Wild
Himalayan High Treks
Journeys International
Myths and Mountains
Overseas Adventure Travel
Rainbow Adventures
Wilderness Travel
Wilderness Women
Woodswomen Inc.

Chapter Four
HIKING AND WALKING

"The only use of a gentleman in travelling is to look after the luggage, and we take care to have no luggage."
Emily Lowe, *Unprotected Females in Norway*

H iking and walking are easy. You can skip the years of training, avoid expensive equipment, and walk almost anywhere. Comfortable clothes, a good pair of shoes, and a light bag to carry the essentials are all that's necessary, and the energy and will to keep walking. It just depends how far you want to travel and how long you can go on putting one foot down in front of the other.

Walking takes you anywhere you want to go. Unlike the mountaineers and climbers, the women in this chapter follow more horizontal routes. Their footsteps take them across a variety of terrain, from walking over a burning volcano to strolling with a llama through fields of alpine flowers. They choose to walk for a variety of reasons, and their journeys lead them along their individual paths.

Alexandra David-Neel

The life of Alexandra David-Neel (1868-1969) was an extraordinary adventure. The daughter of a French journalist and his wife, she had an unhappy childhood. In her early 20s, fascinated by Buddhism and the East, she used money her grandmother left her to travel to India and Ceylon to study Buddhist writings and teachings. Unable to pay for further travels, she returned to Paris, became an opera singer, and traveled with operatic touring companies to Vietnam, Greece, and Tunisia. In 1902, she left the opera in Tunis and started writing magazine articles. In 1904, she married a distant cousin, Philippe-Francois Neel, and though they never lived together, she wrote him let-

ters constantly. Philippe served as her business manager and agent; when he died in 1941, she said: "I lost the best of husbands and my only friend."

In 1911, Alexandra went to India, where she had a rare interview with the Dalai Lama, who told her to learn the Tibetan language. She crossed illegally into Tibet from India and spent the first winter of 1914 studying in a monastery. But the British authorities demanded her deportation. Furious at their action, she traveled to China, arriving in Peking in 1917, determined to reach the city of Lhasa and study at a renowned Tibetan Buddhist center.

After a 2,000-mile journey across China, she spent four months traveling to Lhasa in the winter of 1923. Accompanied by a young Tibetan monk, Yongden, whom she called her adopted son, and with her hair and face darkened, she and Yongden posed as Tibetan beggars on a pilgrimage. When they reached Lhasa, her achievement was publicized throughout the world. The Geographical Society of France gave her its Gold Medal, and she was made a Chevalier of the Legion of Honor. Her book about her trip, *My Journey to Lhasa*, published in 1927, was immensely popular and is still widely read today. The following excerpt describes a typical day of her astonishing trip.

The Trail to Kongbu, 1927, by Alexandra David-Neel

A number of trails crossed near the river. One led north toward the upper country of Potod where it joined tracks that allowed one to reach the grassy northern solitudes. Another went down toward the Brahmaputra, and a third one led to the Kongbu province.

We started off correctly on the Kongbu track, but hesitated when it branched off into a short cut and a main path. We decided in favor of the former, following mere intuition, without suspecting that the two would join later on. This short trail was a true masterpiece of the Public Works engineers. It was cut by perpendicular rocks against which ladders of a peculiar pattern had been placed to enable one to climb up and down. At other places it ran like a balcony on branches thrust horizontally into the ground, and the whole device was built for tall Popas, with much longer legs than ours. Our feet were left waving in the air on the primitive staircases, whose steps were shaky stones or the notched trunks of trees. What we could not do with

our feet we had to perform with the help of our hands, hanging in the air until we touched a point of support, and relying on our strength to raise ourselves when climbing. Had we not carried baggage on our backs, we should have enjoyed the sport, but we were heavily laden. Knowing that no food would be available on our way, which lay through uninhabited forests, we had provided ourselves with a full supply of 'tsampas,' which weighted heavily on our backs and put our acrobatic feats of equilibrium in jeopardy.

But worst of all, we feared missing our road. Such a trail might lead to some forest village, but it could scarcely be the main highway from Kongbu to Po, followed, as we knew by loaded horses and mules. We also failed to discover any trace of the party of pilgrims. Thirty men would have left the imprint of their feet in the soft mud. It was most certain that our former companions had not passed this way. Yet, as we were proceeding in the right direction, I ventured to continue. After all, we were again alone. It would be enough for our own enjoyment if we reached Lhasa, the Lamaist Rome, in time to witness the various New Year festivities. We therefore had time to loiter over the country. Fresh meetings with robbers were the only serious annoyance we had to fear.

This most uneven trail, on which we had expended so much exertion, ended near a beautiful tree dedicated to some sylvan deity. And here also it joined the main track. Happily, we had not missed our way. This spot broke the monotony of the jungle in a pleasant way. The giant tree, from the lowest branches of which hung countless tiny paper flags bearing spells meant to protect travelers, appeared to be a mighty guardian against the dangers that lie in the gloomy forest.

Our progress became more rapid now that we were treading a tolerably good path, and I regretted having taken the difficult short cut. I ought rather to have blessed the very friendly sylvan deity of that road who had perhaps suggested the choice to me. A little further on I found in the middle of the road a long shoot of wild orchids in full bloom and quite fresh, as if it had just been plucked. I relate the fact because, as we were then in January, it shows that the whole of Tibet is far from being an icy-cold bleak country, like the region which extends from the south of Lhasa to the Himalayas.

At the end of the afternoon we overtook the party of pilgrims, who were camped in a pretty clearing near the junction of the Po river and one of its tributaries. Our arrival caused some commotion,

and our new friends rushed toward us to ask if we had met any robbers. We were astonished, and replied that we had not seen a single human being on our road. They could not understand how this could be, for they had met a gang of about thirty men who had tried to extract some presents from them. As they refused to give the least thing, a fight followed in which the robbers had been defeated and some of them wounded. Two of the travelers had been wounded with swords and had lost a quantity of blood. Another, who had been pushed violently and had fallen on a rock, complained of internal pain.

At last, when we had explained that we had come by the narrow short cut, our new friends congratulated us on having escaped the robbers on the main path. For, angered as they must have been after their defeat, they would certainly have stripped us of all our belongings. After hearing this news, I ceased completely to regret my tiring exertion on the short cut. Once more I had been extremely lucky.

Isabella Bird

Isabella Lucy Bird Bishop (1831-1904) was one of the most adventurous of the Victorian lady travelers. She became the outstanding explorer-writer of her day, and gallivanted around the world with unprecedented audacity. Frequently ill and suffering from a bad back, her doctors prescribed "a change of air," so she took off for Australia, New Zealand, the high mountains of Tibet, Hawaii's volcanoes, unexplored Japan, China, Korea, and more. Her superb books about her experiences were bestsellers, and many of them are still in print today.

In Colorado, her daring travels and anguished romance with Rocky Mountain Jim are described in *A Lady's Life in the Rocky Mountains*. Her books are filled with humor, excitement, adventure, and lively detailed descriptions that make you feel as if you are standing next to her.

Her journeys were always dramatic. In Persia, she rode through wild snowstorms accompanying a dashing British officer on a secret government mission. In Tibet, she climbed 12,000-foot mountains and crossed glaciers with ease. Astride a camel, she survived the burning desert on a pilgrimage to Mount Sinai.

She was deeply attached to her younger sister, Henrietta, who died in her 40s. At 50, Isabella married a doctor, John

Bishop, who died five years later. Aa a widow in her 60s, she set off on her most daring adventures. She photographed the dangerous rapids from her boat on China's Yangtze river, trekked through the Himalayas, rode across Turkey, and—at 70—galloped through Morocco's Atlas Mountains on the Sultan's black horse.

Honored as the first woman Fellow of the prestigious Royal Geographical Society, and a member of the Royal Scottish Geographical Society, she was presented to Queen Victoria. She addressed members of the British Parliament about her travels in Armenia and the violence of the Kurds. Her charitable efforts helped set up medical missions in India. She died peacefully in Scotland at 73.

Here's a typical expedition for Isabella—investigating a Hawaiian volcano. You can almost feel the heat of the lava!

Discovery of a Volcano, 1872, by Isabella Bird

As we ascended, the flow became hotter under our feet, as well as more porous and glistening. It was so hot that a shower of rain hissed as it fell upon it. The crust became increasingly insecure, and necessitated our walking in single file with the guide in front, to test the security of the footing. I fell through several times, and always into holes full of sulphurous steam, so malignantly acid that my strong, dog-skin gloves were burned through as I raised myself on my hands.

We had followed a lava-flow for thirty miles up to the crater's brink, and now we had toiled over recent lava for three hours, and by all calculation were close to the pit, yet there was no smoke or sign of fire, and I felt sure that the volcano had died out for once for our especial disappointment. Suddenly, just above, and in front of us, gory drops were tossed in air, and spring forwards we stood on the brink of Hale-mau-mau, which was about 35 feet below us. I think we screamed, I know we all wept, but we were speechless, for a new glory and terror had been added to the earth. It is the most unutterable of wonderful things. The words of common speech are quite useless. It is unimaginable, indescribably, a sight to remember for ever, a sight which at once took possession of every faculty of sense and soul, removing one altogether out of the range of ordinary life. Here was the real "bottomless pit"—the "fire which is not quenched,"—"the place of hell"—" the lake which burneth with fire

and brimstone"—the "everlasting burnings"—the fiery sea whose waves are never weary.

There were groanings, rumblings and detonations, rushings, hissings, and splashings, and the crashing sound of breakers on the coast, but it was the surging of fiery waves upon a fiery shore. But what can I write! Such words as jets, foundations, waves, spray, convey some idea of order and regularity, but here there was none. The inner lake, while we stood there, formed a sort of crater within itself, the whole lava sea rose about three feet, a blowing cone about eight feet high was formed, it was never the same two minutes together. And what we saw had no existence a month ago, and probably will be changed in every essential feature a month hence.

What we did see was one irregularly-shaped lake, possibly 500 feet wide at its narrowest part, and nearly half a mile at its broadest, almost divided into two by a low bank of lava, which extended nearly across it where it was narrowest, which was raised visibly before our eyes. The sides of the nearest part of the lake were absolutely perpendicular, but nowhere more than forty feet high; though on the far side of the larger lake they were bold and craggy and probably not less than 150 feet high. On one side there was an expanse entirely occupied with blowing cones, and jets of steam or vapor. The lake has been know to sink 400 feet, and a month ago it overflowed its banks.

The prominent object was fire in motion, but the surface of the double lake was continually skinning over for a second or two with a cooled crust of a lustrous grey-white, like frosted silver, broken by jagged cracks of a bright rose-color. The movement was nearly always from the sides to the center, but the movement of the center itself appeared independent and always took a southerly direction.

Before each outburst of agitation, there was much hissing, and a throbbing, internal roaring, as of imprisoned gases. On our arrival, eleven fire fountains were playing joyously round the lakes, and sometimes the six of the nearer lake ran together in the center to wallowing down in one vortex, from which they reappeared building upwards, till they formed a huge cone 30 feet high, which plunged downwards in a whirlpool on to reappear in exactly the previous number of foundations in different parts of the lake, high leaping, raging, flinging themselves upwards. Sometimes the whole lake took the form of mighty waves, and surging heavily against the partial barrier, with a sound like the Pacific surf, lashed, tore, covered it,

and threw itself or it in clots of living fire. It was all confusion, commotion, force , terror, glory, majesty, mystery, and even beauty. And the color! Molten metal has not that crimson glean, nor blood that living light! Had I not seen this, I should never have known such a color was possible.

During three hours, the bank of lava dividing the lake rose considerably, and a cavern of considerable size was formed within it, the roof of which was hung with fiery stalactites, more than a foot long . . . The heat was excessive. We were obliged to stand the whole time, and the soles of our boots were burned, and my ear and one side of my face were blistered. Although there was no smoke from the lake itself, there was an awful region to the westward of smoke, sound, and rolling clouds of steam and vapor.. We were able to stand quite near the margin, and look down into the lake, as you look into the sea from the deck of a ship, the only risk being that the fractured ledge might give way.

Diana Somerville

Diana Somerville's two daughters were grown but had not exactly left home, when she decided to spend her 50th year living in Australia. She arrived in Beechworth, a small town in northeastern Victoria, sang in a local Gilbert & Sullivan production, wrote voluminous letters, kept an idiosyncratic diary, and journeyed over thousands of miles of the Australian landscape, from the last spit of land before encountering the polar ice caps to the deserts of the back of beyond. Her journey to the Red Center was inspired by Ronnie Jensen, a seasoned world traveler and outback aficionado, her tentmate for the journey who became a lifetime friend.

Diana Somerville was born in Lincoln, Nebraska, because that's where the train stopped, according to family myth. A life on the move ended in Boulder, Colorado in 1968 when she arrived with a university professor husband, two daughters, a Pomeranian dog and a Siamese cat. Soon afterwards, she became the first woman in her neighborhood to get a divorce, and embarked on several careers simultaneously—as a single working mom, a writer, a teacher, and an active feminist. None paid particularly well, but all offered unlimited learning opportunities.

After spending her 50th year in Australian dreamtime, she resumed life in Boulder. She now teaches, writes a regular newspaper column, contributes articles to national and international magazines, and travels whenever possible. She's probably the only person to have taught both science writing and women's studies at the University of Colorado. After 30 years in Colorado, she relishes hiking, still refuses to ski, and considers herself more a writer who travels than a travel writer. She enjoys spending time with her three grandchildren and a like number of cats.

Walking the Earth in Australia, 1994,
by Diana Somerville

A bit of rain has turned the ground in Curdimarka, South Australia, into a sea of gluey mud. The mud sticks to my shoes so determinedly that the farther I walk, the taller I grow. Returning from the bush latrine I am a clumsy, lead-footed giant, my right eye swollen from bug bites.

"Welcome to bush camping," laughs my tentmate.

My companions and I are on the fourth day of a 19-day journey that began in Albury, Victoria, in the gentle, temperate country along the Murray River just north of the Australian Alps. We have already moved west and north through the mountains of the Flinders Range and into the Great Artesian Basin. In the coming weeks, we will follow the unpaved Oodnadatta Track deep into Australia's interior, past Ayers Rock, Alice Springs, Palm Valley, Kings Canyon and numerous points I'd never heard of. Then we will return to Albury through the deserts that lie to the east. Altogether, our tour will trace a rough circle of more than 4,000 miles through stone, dunes, and sand. This adventure was organized by one of Australia's legendary old bush hands, Jean Whitla, who grew up in the Red Center of the continent, where her father served with the Royal Flying Doctor Service. Jean, with botanist Judy Frankenburg and geologist Morrie Godz, provide on-the-road tutorials to the group of 29 Australians, and me, interested in outback history.

It's nearly impossible to discuss the monolith—Uluru or Ayers Rock—without touching on the issue of names. Many places have two names, one given by Australia's indigenous peoples and one by the European invaders. The Australian government ducked the naming

issue by proclaiming it "Uluru National Park and the Ayers Rock Resort." "Welcome to Aboriginal Land" says a sign noting the park is open from 6 am to 7:30 pm. Built in 1984, and modeled after U.S. national parks, Uluru has all the amenities; three hotels, facilities for disabled visitors, campgrounds, art galleries, a swimming pool, a museum, and its own fire department, police station, and Flying Doctor base. Although we are camping out, this is not exactly a wilderness experience.

My cynicism drops as an evening squall provides a breathtaking sight—Uluru highlighted by a rainbow. It's impossible not to be moved by the enormousness of the Rock, a looming presence that seems to create a low-level hum. A subtle spectrum of colors appears on the rock's sculpted surface. Like everyone else at the park, come dusk we head for the view area, called Sunset Strip for the Rock Show. More than 20 buses disgorge German, Japanese, Danish, Italian, and English tourists as well as throngs of Australians. Lightning crackles, a helicopter and a plane drone by. Kata Tjuta—or the Olgas—miles away appear a ghostly, distant Stonehenge shrouded in mist and rain.

From this vantage point, the chain that guides climbers up Ayers Rock is visible only with binoculars. The road to Uluru curves round the dunes, insinuating itself into the landscape, a modern replacement for the old straight-line scar across the plains. A chain threaded through posts hammered into the rock marks the trail to the top, 1,141 feet above the desert floor. By 9 the next morning, thousands of people swarm around, most determined to haul themselves up hand over hand. A sign saying the Anangu people do not climb the Rock makes my decision for me. Following the path of those who have lived with Uluru for more than 20,000 years, I opt to walk along the base of this massive oval some four miles long and a mile and a half across. The base has been fluted and scalloped by wind and water, leaving countless caves, some smaller than a fist, others large enough for a tribal gathering. Some of the caves reveal white walls or golden interiors, the result of subtly varying composition of the rock. Others have structures hanging from the ceiling, more rounded and delicate-seeming than stalactites.

To the Koori (aboriginal) people, the land represents the power of creation they call the dreaming. Every geographic feature has meaning and importance. Uluru records the activities of Mala, the first hare-wallaby, at the time of creation. The tourist route up the rock

crosses Mala's fabled path. One bell-shaped opening, a sacred site for women, is called the pocket of the hare-wallaby. Such especially sacred sites are off-limits to visitors.

With scarcely a breather, it's off to Kata Tjuta—the Olgas. Covering about 22 square miles, the beehive-shaped domes are also anomalies that survived the forces of erosion. Many people find Kata Tjuta less overpowering than Uluru, the winding trails more entrancing than the straight climb up The Rock. Only the bases of the "heads" are fringed with vegetation. There is no water here, no springs or standing pools. Acacia and cassia trees line the trail, but few are large enough to provide shade. A wildflower, Ptilotus, blooms a brilliant purple, rooted in a handful of orange sand, evidence of recent rainfall. A patina of desert varnish makes the stone surfaces appear polished smooth, their colors changing with the angle of the sun from mahogany to bleached orange. It seems any trace of water would dance like droplets in a hot skillet.

When we reach Palm Valley, it's so hot that a chameleon-sized lizard dances from one foot to the other on a sizzling rock. One side of the valley is a steep rocky cliff, the other a more gentle hill. Palm Valley is a spectacular biological refuge for 333 plant species, many considered rare. Granite boulders and sandstone lie jumbled on the valley floor, creating pockets and pools of water. The pools teem with strange reeds and bulrushes. Short, palmlike cycads seem to burst out of the rock. Gently chattering and swaying, thousands of Livistona Mariae palms soar straight up, some reaching more than 30 feet above the broad valley floor. The forest is a breathtaking relic of a time 10,000 years ago when Australia supported palm forest through much of its interior. Since then, as the continent slowly dried, the palms have retreated into this last refuge where high valley walls protect them from fire while porous, gently sloping rock creates seepage along the valley floor. The nearest other stand of Livistona is 600 miles to the northeast, in a tropical rainforest.

Nothing prepared me for the spell of these stately, elegant anachronisms, Touching their rough bark and looking at the massive, matlike root systems of a few that toppled removes none of their improbability. Palm Valley is awesome—in the original sense of the word.

Geologists and biologists consider Kings Canyon, 200 miles southwest of Alice Springs, more significant. Our visit takes place on a hot and sunny day, with a few tiny clouds hanging high in the sky. A park entrance fringed with ghostly white gum trees and cypress pines

gives no clue to the spectacular cliffs and weathered sandstone domes beyond. Towering red sandstone cliffs rim a gorge notched into the westernmost mountains of the George Gill Range. Along the rim of the canyon, the vegetation is remarkable for its endurance, sprouting from fractures in the rock that have trapped smidgens of sand.

I opt for the low road, an easy path along the canyon floor, past 200-foot-high red rock walls of sandstone so brittle that it easily shears off. The trail ends at a grove where I can identify cycad palms, native figs, and river red gums, all sustained by water trapped by the stones. Kings Canyon's towering walls protect nearly 600 plant species, many found only here.

It's also sandstone heaven. Carmichael sandstone, deposited approximately 440 million years ago, forms the lower, rubbly part of the cliff face. Over that is an almost vertical face of Mereenie sandstone, which was deposited about 360 million years ago and then folded and faulted during the MacDonnell Orogeny.

Scattered on the canyon floor are slabs of honey-hued, quartz-rich sandstone. Examining the rocks more closely, I can hardly believe my eyes but there are fossil ripple marks and water patterns on the surface. As I prepare to leave in the dimming light, a small, shy wallaby peers out from a safe vantage point high up a sandstone wall. The Matilda Highway beckons. There's more than 2000 miles of hard desert driving before we're back to Victoria.

Kathryn Black

Like many travelers, Kathryn Black admits to enjoying a dollop of comfort as part of the outdoors experience. She has been a freelance writer, journalist, and editor for more than 20 years, including ten years as articles editor in New York at *Woman's Day* magazine, and later for *Better Homes & Gardens*. She traveled for personal pleasure, mainly to Europe where she went at least once a year. She also traveled to Scotland, Italy, and France on assignments, and began exploring the western United States. Later she moved to San Francisco and worked as a freelance writer, publishing articles on a wide spectrum of topics in *Glamour, Working Woman, Redbook, Food and Wine,* and others.

In 1987 she moved to Boulder, Colorado, where she had grown up and attended university. She married photographer

Jens Husted in 1991, and continued writing. Now that they have two young sons, a large old house, a garden and a dog, her solo travels have ended, but she enjoys family trips in the minivan exploring Colorado.

Her books include *In the Shadow of Polio: A Personal and Social History* (Addison-Wesley, 1996) and *Sweet Success* (Macmillan, 1986), later published in paperback as *On Your Own Terms: A Woman's Guide to Working With Men* (Vintage Books, 1987). She has also taught writing classes and workshops at the University of Colorado and elsewhere. She looks forward to collaborating on travel books with her husband when he will take the photos and she will write the text.

Llama Trekking, 1985, by Kathryn Black

What appealed to me about llama trekking in Colorado was that it seemed to take the pain—and the bulk—out of backpacking, and leave only the fun. I had done enough sleeping in the woods and eating by a campfire to know that "luxury camping" is an oxymoron. But the trip brochure emphasized comfort and—here's what won my heart—included a menu. The llamas would carry the packs.

My friends were skeptical. Llamas spit, they said. I had heard that too, but how bad could llama spit be? I had lived in New York City where officials find it necessary to put up signs admonishing the public against spitting. I figured nothing a llama could do would be worse than what I had seen there.

On our first meeting one July day at a trailhead outside Steamboat Springs, a colorful ranching town 170 miles northwest of Denver, llamas revealed themselves to be docile, nonthreatening, predictable animals—and none of them spit. They seldom do, I learned later, and only when they rile one another. When that happens, they spray each other with semi-digested grasses.

Joining the nine llamas at the trailhead was a group of six hikers; plus two llama packers, Cheryl Wiles and Bonnie Lyttle; and company owner, llama breeder and trek leader, Peter Nichols. Nine llamas were more than necessary, but Peter brought along some young ones who needed the practice. Though most trips run for five days, our was a special three-day trip, and our mission was to climb 1,500 feet to a base camp at 10,300 feet, covering five miles of varied terrain in the Mount Zirkel Wilderness Area, a corner of the Rocky

Mountains. This region is part of the Routt National Forest and, like all federally designated wilderness areas, is off-limits to anything motorized. Even the forest service travels through on horseback and maintains the trails with bucksaws. The forest borders the Continental Divide, the ridge of peaks (some over 14,000 feet) that make up the backbone of this country.

The area is virtually empty of human visitors for nine months of the year—the 300 inches of snowfall discourage even the most stalwart—and it's that as much as anything that preserves the land. Llama trekking goes on there for just ten weeks, July to mid-September, which pretty much encompasses spring and summer at those heady altitudes. The thin air and the long winters discourage ticks, venomous snakes, and poison ivy. Sounded good to me.

We were each assigned a llama for the trip, for no better reason than that Peter had found that people like getting to know one llama. Our responsibilities for the llamas weren't great. Peter's instructions boiled down to: Hang on to the tether as you walk along, and if you get tired of that, tie the llama to the one ahead. I was given Dr. Pepper. He talked—in the llama way of emitting a scratchy, tuneless humming sound—almost nonstop while walking. Eventually, one of us asked: "Why do llamas hum?" And Bonnie—someone had to— answered: "I guess because they don't know the words."

As we headed up the trail, Dr. Pepper's breath warm and regular on my neck, his humming sporadic. I began to imagine a communion between us. He nuzzled me occasionally and kept a firm pace close behind me. But I soon learned another characteristic of llamas. They're intensely social animals. An untethered llama doesn't bolt for home as a horse would; he sticks with his buddies. When I stopped to take a photograph, Dr. Pepper walked on by me without a backward glance, intent on keeping up with the group.

Two hours into the trip we had covered little ground. Fully loaded llamas are slow moving, even though they are well suited for lugging supplies and trudging up mountains. And true to their group instincts, they do everything together. When one stopped to urinate, they all did, which ensured a leisurely pace. Slowing us down as well were the younger llamas. One, like a recalcitrant first grader, couldn't be hurried. Then there was Lucky. He was inclined to lie down in the trail without warning. He refused to grasp the truth; we expected him to walk all the way, uphill, and carry a load, too.

Admittedly, our hike was made even slower by the human trek-kers. Enthusiastic photographers in the group, myself included, made frequent stops to snap one breathtaking vista after another. We lin-gered for a long time at a broad mountain meadow, spring green with wild grasses and lush with wildflowers. The lea was bordered on one side by a steep, wall-like rock cliff, on the other by a fast-moving stream. Douglas and alpine fire and Colorado blue spruce added shades of green. We finally were urged on by Bonnie, who told us that early spring wildflowers, which were past blooming in the meadow, would be out at the higher altitudes.

Five hours into the hike we arrived at the base camp, and that was when the pleasures of trekking with an outfitter were most ob-vious. Our tents were already pitched, the dining and cooking tents stocked, the campfire ringed with stones, and wood gathered. While we settled in, Bonnie and Cheryl made lemonade to clear the trail dust from our throats. Clearly, once in camp, our comfort rested on the able shoulders of the staff, not on the llamas. The llamas may have carried the gear, but Bonnie and Cheryl cooked.

For the rest of the evening, the llamas grazed in a nearby meadow, needing no care. They eat the native high-altitude vegetation, with eliminates the need to carry feed. Llamas also have no more impact on the trails and pastures than deer. Cheryl pointed out a tree circled by bare dirt and churned up ground where some horses had been tied more than a year ago. The ground had still not recovered.

When we gathered for dinner that first night, each of us perched on a stool made from an upturned log, I could see this wasn't like any camp food I had ever had before. The menu: pork tenderloin (which had marinated all day in a cooler carried by the llama named Bucky), spinach salad garnished with marsh marigolds, broccoli with cheese sauce, wild rice, sourdough bread, and bananas Foster. A bouquet of wildflowers and candles made up the centerpiece. Each placed setting included a wine glass. The meal was delicious—and not just because anything in the out-of-doors tastes better.

The next day I awoke to the sweetest sound know to campers— that of a fire popping. It meant that someone else had braved the morning chill to get a fire going and all we had to do was find our way to it. As it turned out, the indefatigable Bonnie and Cheryl team had been up long before the rest of us, heating water for coffee and washing up and preparing a breakfast of link sausage, blueberry pan-cakes, and melon slices.

After a lazy, carefree morning spent exploring the camp area, watching Bonnie bake banana bread and breadsticks, fly-fishing in the lake, and cheering on one brave Minnesotan who swam in those icy waters, we decided to hike to the top of the Continental Divide.

We brought along the llamas, mostly for the fun of it. One llama would have been enough to carry lunches, jackets, and camera equipment, but as we were on a llama trek, we wanted llamas along. Following Peter, we climbed until we reached a deep bowl on top of a mountain that was dotted with rock outcrops and small snowfields. Streams and rivulets cut creases in the valley, and deep-green marshy growth drew patterns in the meadow. The green was broken with tiny spots of color: the pale blue of columbines, deep-purple penstemons, and yellow, black, and gray moss on speckled granite boulders. Traversing the valley, we climbed the other side and were then above the timberline. At our feet was tundra vegetation, and before us bare, cinnamon-colored cliffs, which Peter said were in the direction of Utah, and the jagged sawtooth outline of Mount Zirkel itself. We stood at 11,000 feet in the barren terrain and felt ourselves on top of the world.

It was exhilarating—and the strongest reminder during the trip of why one bothers to get to the back of beyond. We lingered, trying to ignore the wind and the clouds, which had been rumbling in the distance and were now gathering in earnest. While the rest of us examined the miniature flowers and tufts of grass the size of pincushions, and contemplated the significance of the Continental Divide, Peter kept an eye on the impending storm. When one heavy cloud circled back and let loose a bolt of lightning, he insisted on a quick descent.

As we charged down the mountain, I kept reminding myself of what Peter said about llamas; "A llama can go anywhere you can, as long as you don't use your hands." As it turned out, it was Dr. Pepper who might have been wondering whether I could follow him—he nimbly jumped the four- and five-foot drops along the rough trail, leapt over logs, and trotted easily behind the others. I was more hesitant. In front of me I could hear a fellow trekker muttering directions to llama Hahns. "Rock" he said, or "Watch your step, guy," and "Slippery here." I don't know whether Hahns was listening, but I was.

Just as we barreled across a marshy meadow, I spotted the blue tarps that covered our tents and the rain began in earnest. For a

moment I thought a rainstorm would take the fun out of a camping trip, but in fact it added excitement. Besides, Bonnie had turned back before the rest of us, and she had a fire and hot drinks waiting. We collected around the campfire to dry out our socks and felt cozy under the huge tarp.

Our trip ended all too soon the next day as we traced our steps in a leisurely hike out of the wilderness. On this high-mountain excursions I discovered what for me was just enough roughing it. I like a good hike, sitting by a campfire, the night noises and wildlife, the stars and the other wonders of being in the outdoors. But I'm not keen on being uncomfortable or cold. I have a friend who calls it "camping" anytime she has to sleep on the first floor. She wouldn't have liked this. But I did. And next time I go camping, I'd be happy to have Dr. Pepper along. Mostly, however, I'd like to have Bonnie and Cheryl with me. I can still smell Bonnie's banana bread.

Where to Find Hiking and Walking Vacations
Adventure Alaska Tours
Alaska Wildland
American Wilderness Experience
Archaeological Tours
Call of the Wild
Country Walkers
Crow Canyon Archaeological Center
Earthwatch
Experience Plus!
Explorations, Inc.
Himalayan High Treks
Hurricane Creek Llama Treks
International Expeditions
Journeys International
Myths and Mountains
Nature Expeditions International
Nichols Expeditions
Outdoor Vacations for Women Over 40
Overseas Adventure Travel
Rainbow Adventures
Vermont State Parks
Wilderness Travel
Wilderness Women
Wildland Adventures
WomanTours
Woodswomen Inc.
Yellowstone Llamas

Chapter Five
ON THE WATER

"There are only certain windows of opportunity in your life when you can travel for extended periods of time with few responsibilities."

Marybeth Bond, *A Woman's World*

In the old days, superstition held that it was unlucky to
have a woman aboard any ship. Those few women who
traveled by sea in the 17th, 18th, and 19th centuries were
courageously independent, and most were accompanied by men.
These pioneering women travelers sailed across oceans, up riv-
ers, and across great lakes to reach far-distant places and find
adventure.

Today, more women take cruises on luxury liners than men.
What's more, the active women of today have acquired the
skills of sailing, rowing, canoeing and rafting. They can steer
their own vessels and travel by themselves. These stories are
about women who have braved stormy waters in their quest
for adventure.

Leonie D'Aunet

Leonie D'Aunet (1820-1860?) was French, though little is
known about her upbringing or education. She lived in Paris
most of her life, and was about 20 years younger than her
husband. She accompanied him on several trips abroad, and
wrote enthusiastic reports of their travels in Europe and
Scandinavia. Her accounts are vivid, personal, and entertain-
ing, and she clearly enjoys the adventure of traveling to differ-
ent places. Later in her life, she returned to Paris and edited
several journals for women.

This excerpt comes from her book describing a journey to
the Arctic regions of the North Pole. She has traveled through
Norway to Hammerfest, the northernmost town in

Scandinavia, and sailed with an expedition for several weeks to reach the ice-bound island of Spitzbergen.

Icebergs in Spitzbergen, 1845, by Leonie D'Aunet

These Polar ices, which no dust has ever stained, as spotless now as on the first day of creation, are tinted with the vividest colors, so that they look like rocks composed of precious stones: the glitter of the diamond, the dazzling hues of the sapphire and the emerald, blend in an unknown and marvelous substance. Yonder floating islands, incessantly undermined by the sea, change their outline every moment; by an abrupt movement the base becomes the summit; a spire transforms itself into a mushroom; a column broadens out into a vast flat table, a tower is changed into a flight of steps; and all so rapidly and unexpectedly that, in spite of oneself, one dreams that some supernatural will presides over those sudden transformations.

At the first glance I could not help thinking that I saw before me a city of the fays, destroyed at one fell blow by a superior power, and condemned to disappear without leaving a trace of its existence. Around me hustled fragments of the architecture of all periods and every style: campaniles, columns, minarets, ogives, pyramids, turrets, cupolas, crenelations, volutes, arcades, facades, colossal foundations, sculptures as delicate as those which festoon the shapely pillars of our cathedrals—all were massed together and confused ins a common disaster. An arrangement so strange, so marvelous, the artist's brush is unable to reproduce, and the writer's words fail adequately to describe!

This region, where everything is cold and inert, has been represented, has it not, as enveloped in a deep and sublime silence. But the reader must please to receive a very different impression; nothing can give any fit idea of the tremendous tumult of a day of thaw at Spitzbergen.

The sea, bristling with jagged sheets of ice, clangs and clatters noisily; the lofty littoral peaks glide down to the shore, fall away, and plunge into the gulf of waters with an awful crash. The mountains are rent and splintered; the waves dash furiously against the granite capes; the icebergs, as they shiver into pieces, give vent to sharp reports like the rattle of musketry; the wind with a hoarse roar, scatters tornadoes of snow aborad. It is terrible, it is magnifi-

cent; one seems to hear the chorus of the abysses of the old world preluding a new chaos.

Never before has one seen or heard anything comparable to that which one sees and hears there; one has conceived of nothing like it, even in one's dreams! It belongs at once to the fantastic and to the real; it disconcerts the memory, dazes the mind, and fills it with an indescribable sense of awe and admiration.

But if the spectacle of the bay had something magical in it, ominous and gloomy was the scene on shore. In all directions the ground was white with the bones of seals and walruses, left there by the Norwegian or Russian fishermen, who formerly visited these high latitudes for the purpose of collecting oil; for some years, however, they have abandoned a pursuit which was much more dangerous than profitable. These great bones, bleached by time and preserved intact by the frost, seemed so many skeletons of giants—the past dwellers in a city which had finally been swallowed up by the sea.

The long fleshless fingers of the seals, so like to those of the human hand, rendered the illusion singularly striking and filled one with a kind of terror. I quitted the charnel-house, and directing my steps very cautiously over the slippery soil, penetrated inland. I found myself very speedily in the middle of a cemetery; but this time, the remains lying on the frozen snow were human. Several coffins, half open and empty, had formerly been occupied by human bodies, which the teeth of the white bear had recently profaned. As, owing to the thickness of the ice, it is impossible to dig graves, a number of enormous stones had, in primitive fashion, been heaped over the coffin-lids, so as to form a defence against the attacks of wild beasts; but the stout limbs of "the great man in the pelisse" (as the Norwegian fishers picturesquely call the polar bear) had removed the stones and devastated the tombs; a throng of bones strewed the shore, half broken and gnawed, the pitiful remains of the bears' banquet. I carefully collected them, and replaced them piously in their proper receptacle.

In the middle of this work of burial, I was seized with an indescribable horror; the thought came upon me that I was doomed, perhaps, to lay my bones among these dismembered skeletons.

I had been forewarned of the perils of our expedition. I had accepted the warning and fancied that I comprehended all the hazard; yet these tombs made me for the moment, shudder, and for the first

time I dwelt with regret on the memories of France, my family, my friends, the blue sky, the gentle and serene life which I had quitted in order to incur the risks of so dangerous a voyage.

Ida Pfeiffer

Here's an excerpt from the travels of Ida Pfeiffer (1792-1858) which exemplifies what a good traveler must do—make the best of catastrophe and laugh in the face of danger. Pfeiffer, born in Vienna, was one of the most astonishing women travelers of her day (see Chapter One). After an initial trip to the Holy Land, she went to Europe and Scandinavia, and then traveled round the world twice. She fell sick on an expedition to Madagascar, and, returning home, died two years later. Her son, Oscar, prepared her last book for publication. On this journey she deals cheerfully with the storms of Cape Horn.

Around Cape Horn, 1851, by Ida Pfeiffer

The dangerous part of the passage round Cape Horn begins in the opinion of navigators with the Strait Le Maire, and ends on the west side of America, in the latitude of the Straits of Magellan. Near this point I found myself on the 3rd of February in the fine English barque *John Renwick*, Captain Bell, with whom I had engaged for twenty-five pounds to carry me to Valparaiso.

The extreme point of Cape Horn is a mountain about 600 feet high, but before it, and separated only by a narrow strip of sea, likes a magnificent group of black basaltic rocks. Near it we saw some whales and albatrosses, but no icebergs. We thought when we had passed this cape, and fairly entered the Pacific Ocean, it would have brought us weather that would credit to its name, but for fourteen days we had to struggle with storm and sea, with rain and cold, before we reached the latitude of the Straits of Magellan, and after this came a tempest that last four and twenty hours, and had carried away four of our sails. We shipped two such tremendous seas that a plank in the deck got loose, and the water penetrated to the cargo of sugar.

The deck was like a lake, and it was necessary to make great openings in the bulwarks that the water might run off the quicker, and in the mean time we had got two inches of water in the hold. No fire could be made, and we had to content ourselves with bread

and cheese, and raw ham, which indeed we had no little difficulty in carrying to our mouths. The last cask of lamp oil too became a sacrifice to the storm; it broke loose and was dashed to pieces, and the captain began to be apprehensive that we might not have oil enough to light the compass till we reached Valparaiso. All the lamps in the ship were therefore replaced by wax lights, in order to save what remained. In spite of all these disagreeables, however, we kept up our spirits, and during the gale could not help laughing at the comical positions we involuntarily assumed whenever we attempted to rise.

Amelia B. Edwards

British women have proved themselves indefatigable travelers; it may be a reaction to the perennial damp gray weather that drives them to more exotic climates. Amelia Edwards (1831-1892) found her calling in Egypt, far from her birthplace in London. The daughter of a retired army officer and an Irish mother, she was educated at home, and soon showed a talent for writing. Her first novel, *My Brother's Wife*, was published when she was 24. She wrote articles for popular English magazines such as *Household Works*, *The Saturday Review*, and the *Morning Post*, and also wrote ghost stories for Charles Dickens' publications.

When her parents died in 1860, she was 30 and unmarried. She continued to support herself by her writing but longed for adventure. She decided to travel in Europe and write books about her experiences. Her walking trip in the largely unexplored Italian Dolomites in 1873 was described in *Untrodden Peaks and Unfrequented Valleys*, a delightful account of two women riding and walking in the mountains, which is still in print.

The turning point of her life was her journey to Egypt to voyage up the Nile in 1874. Fascinated by the scenery and the fantastic ruins of pyramids and historic sites, she was also appalled at the decay of such splendid antiquities. On her return to England, she studied Egyptology and wrote articles about the disastrous state of Egyptian artifacts. In 1882, together with the eminent archaeologist Reginald Poole, she established and organized the Egypt Exploration Fund, dedicated to organizing and funding expeditions to Egypt. It became her life's work.

Amelia visited the United States in 1889-90 to give a lecture tour about Egypt, and traveled as far west as Milwaukee. She was awarded honorary degrees by Columbia University and Smith College. Her book, *A Thousand Miles Up The Nile*, is still an excellent introduction to Egypt and its history. She toured England in 1891, after her book was published. The British government awarded her a small pension "in consideration of her services to literature and archaeology."

Amelia died of the flu in 1892. She left the Egyptian section of her considerable library and a collection of antiquities to University College, London, along with a bequest of £2,500 to establish the first English chair in Egyptology. The following excerpt from her book on Egypt is typical in its detail, scholarly knowledge, and enthusiasm.

Sailing Up the Nile, 1874, by Amelia B. Edwards

We now had the full moon again, making night more beautiful than day. Sitting on deck for hours after the sun had gone down, when the boat glided gently on with half-filled sails and the force of the wind was spent, we used to wonder if in all the world there was another climate in which the effect of the moonlight was so magical. To say that every object far or near was visible as distinctly as by day, yet more tenderly, is to say nothing. It was not only form that was defined; it was not only light and shadow that were vivid—it was color that was present.

The amber sheen of the sand-island in the middle of the river, the sober green of the palm-grove, a lady's turquoise-colored hood, were clear to the sight and relatively true in tone. The oranges showed through the bars of the crate like nuggets of pure gold. A crimson shawl glowed with a warmer dye than it ever wore by day. The mountains were flushed as if in the light of sunset. Of all the natural phenomena that we beheld in the course of the journey, I remember none that surprised us more than this. We could scarcely believe it at first that it was not some effect of afterglow, or some miraculous aura of the East. But the sun had nothing to do with that flush upon the mountains. The glow was in the stone, and the moonlight but revealed the local color.

At a point about ten miles below Denderah, we saw some thousands of fellaheen at work amid clouds of sand upon the embank-

ments of a new canal. They swarmed over the mounds like ants, and the continuous murmur of their voices came to us across the river like the humming of innumerable bees. Others, following the path along the bank, were pouring towards the spot in an unbroken stream. The Nile must here be nearly half a mile in breadth; but the engineers in European dress, and the overseers with long sticks in their hands, were plainly distinguishable by the help of a glass.

The tents in which these officials were camping out during the progress of the work gleamed white among the palms by the riverside. Such scenes must have been common enough in the old days when a conquering Pharaoh, returning from Libya or the land of Kush, set his captives to raise a dike, or excavate a lake, or quarry a mountain. The Israelites building the massive walls of Pithom or Rameses with bricks of their own making, must have presented exactly such a spectacle.

At the Temple of Denderah

The effect of the portico as one stands at the top of this staircase is one of overwhelming majesty. The immense girth of the columns, the huge screens which connect them, the ponderous cornice jutting overhead, confuse the imagination, and appear perhaps even more enormous than they are. Looking up to the architrave, we see a kind of Egyptian Panathenaic procession of carven priests and warriors, some with standards and some with their musical instruments.

The winged globe, depicted upon a gigantic scale in the curve of the cornice, seems to hover above the central doorway. Hieroglyphs, emblems, strange forms of kings and gods, cover every foot of wallspace, frieze and pillar. Nor does this wealth of surface sculpture tend in any way to diminish the general effect of size. Every group, every inscription, appears to be necessary and in its place.

Most of these details are as perfect as on the day when the last workman went his way and the architect saw his design completed. Here at Denderah we have an example of Graeco-Egyptian work, and early Christian fanaticism. Begun by Ptolemy XI, and bearing upon its latest ovals the name and style of Nero, the present building was sill comparatively new when, in AD 379, the ancient religion was abolished by the edict of Theodosius. It was then the most gorgeous as well as the most recent of all those larger temples built during the prosperous foreign rule of the last 700 years. It stood, surrounded

by groves of palm and acacia, within the precincts of a vast enclosure, the wall of which, 1000 foot in length, 35 feet in height, and 15 feet thick, are still traceable.

Dora Birtles

Amelia Edwards sailed down the Nile with a crew of men, but in this century many women are taking charge of their own boats. The number of women sailors has increased tremendously, particularly in the last 20 years. In 1932, Dora Birtles was an experienced sailor. At the age of 28, looking for adventure, she decided to sail around the world. She left the port of Newcastle on the east coast of Australia, with a group of friends—Ruth and Joan, two women friends of hers from university, Joan's husband, Henery, and Sven, a professional sailor. Dora's husband, Bert, a journalist, found their boat, the Skaga, but did not want to join the trip. The Skaga was a Swedish-built 34-foot vessel, had a comparatively small sail area, heavy gear, and a delayed reaction to the tiller. Because this was the first time women had undertaken a trip like this, the newspapers were interested in the journey, and the women wrote articles along the way.

Sadly, personal conflicts disrupted the trip. A major disagreement in the first days spoiled the entire experience for Dora. She had sailed for years with her uncle and her brother, and was accustomed to strong leadership, as well as the companionship of her husband. She felt isolated on the Skaga, and was astonished when Ruth expressed anger at Dora's warm relationship with Sven, the only professional sailor aboard with enough expertise to cope with daily crises. Joan was cold and critical towards Dora, always agreeing with Henery's suggestions though he was an inept leader. The journey ended in Singapore eight months later, after sailing some 5,000 miles by way of New Guinea and the Java Sea.

After the voyage, Dora went to England where she and her husband stayed in London for several years. Her book about the voyage, *North-west by North*, was published in 1935. Later, she and her husband returned to Australia with their two sons, and she wrote children's fiction as well as adult fiction and non-fiction. Her novel, *The Overlanders*, became a successful

movie. She lived in Sydney, and was active in the yachting world.

This excerpt describes the first day of the voyage, a nightmare experience that might have persuaded less dedicated adventurers to call the whole thing off. A violent storm blows up, and Dora, Joan, and Ruth, overcome by seasickness, lie helpless in the cabin, while the men sail the boat.

Sailing from Australia to Singapore, 1932, by Dora Birtles

What a night! A night of strange noises, incredible nerve-wracking new noises, watery noises most of them. The snarl of the water slapping on the deck exactly four inches above my nose, the hiss of its indrawn breath serpenting alongside us, the funny little squeaks of the timbers of the boat 'talking' to each other. All good vessels 'talk' like this, the Swede who had sold Skaga to us had said. There was the rattle and strain of the tackle and ominous creaking from the mast. Was it safe, that mast? A spruce mast. The natural crack in it was very wide. Every now and then came the crashing immediately on top of me of the heavy block through which the staysail sheet ran. The reverberation below of that horrible impact was a Vulcan's hammer descending. I though it would pound the deck to pieces.

Sometimes there was a tremendous wallop as an extra big wave jolted the bow, the ocean giving her a straight left on the nose, and I wondered how the shipwrights managed to fit timbers to the stempost that they stood it at all. Once or twice Sven came down from the tiller and consulted a chart. Water was streaming form him, it was raining up there. His eye-sockets were red with salt; he manipulated the parallel rulers, measured, and twirled the dividers about. We were going to run in for shelter. I noticed his short blunt fingers, everything he touched he left wet, his hands were cracked and blackened from the ropes and the sea. He had lit the small kerosene lamp; its smoky glare shut us all in tightly, a little close world of light in a roaring chaos of water and wind outside. He took no notice of Ruth and me, said nothing at all, but rose from the table and swung up out of the high hatched, giving us for a moment an eddy of fresh air.

From inside the boat there had been a steady lap, lap, lap in the darkness, exactly the kind of lapping a slobbering big dog makes when he drinks thirstily. Now I leaned over, peered down the steep side of the bunk and saw in the lamplight that the floor of the cabin was gone and in its place was a slopping lake of viscid black; greasy, slimy, and with strange objects, bits of cork and paper, and the poor unwritten-in diary, floating about in it. As Skaga rolled this noxious liquid slapped and splashed viciously up the sides of the water tanks on top of which were our two bunks, one on each side of the cabin. It was the bilge that had risen, augmented by frequent cascades of sea water down the steering cockpit aft. The black color came from the preparation the bilges had been painted with, terrible stuff.

It was a new situation for me. I had never felt the presence of so much water, for so long, and so close to me before. The ocean pressed in on us, it weighted the air in the cabin, there was a watery pressure in every breath we took, the timbers of the Skaga strained outward resisting it; it possessed a limitless force that it had not yet exerted fully, there was always behind it the hint of further power held in reserve. The ocean would never tire; it might give up, but it would never tire. The water washed over the deck just above my head, I could almost feel the waves break round my pillow, every little noise was so closed; from the water tank below me came animal gurglings with every change of level; it was only half full and every roll sent it shifting. From the shut porthole above my head came an intermittent spatter of drops, wetting the pillow. Into every tiny crevice the water forced a way.

When morning came with the sea settled to a moderate gale and a gray light coming through the slightly slid-back hatch, I got up. Oh the relief of it! The triumph of being well and able to get about. Floating in the cabin was an apple. I was hungry, my middle felt like two sheets of brown paper flapping together. I picked up the apple and wiped it. It was impregnated with kerosene to the core. I ate it all. "If that doesn't make me sick, nothing will," I thought. Nothing happened, so out came the plum cake. For breakfast we had slabs of it with a cold drink of limejuice cordial.

My first twenty-four hours at sea. Nobody had slept. It had been a noisy, smelly, anxious nightmare. But it was over. I was never again to experience that desolate amalgamation of incompetence and sea-sickness.

Gail Goldberger

Few people experience seasickness on a river raft, and it is unlikely that rafters get tossed around overnight in a violent storm. But there's certainly excitement. Having rafted the American River in California, the Green River in Utah, and the Yampa and the Arkansas in Colorado, I know that one of the most dramatic experiences is the 13-day terrifying, thrilling, and amazing trip through the Grand Canyon. This piece by Gail Goldberger, a freelance writer and fundraising consultant living in Chicago, Illinois, captures the feeling with compelling accuracy.

Gail Goldberger was born in 1951 and raised in Chicago. She first developed an affinity for the outdoors summering in Michigan in her grandparents' home on Lake Michigan, where she swam nearly every day. She especially enjoyed overcast days when the water was choppy so she could take her inner tube out and bounce around in the waves.

In 1971 she took her first trip out West and passed through the Grand Canyon. Walking a mile down the Bright Angel Trail she saw the ribbon of Colorado River and it called to her. Back in Chicago, she planned her own canoe trip in the Boundary Waters of Minnesota. Tired of portaging a heavy canoe and equipment, she and a friend began running small rapids; Gail experienced a thrill she had never known before.

After moving to California in 1975, she took her first whitewater rafting trip in 1976 on the Rogue River in Oregon, and another on the American River. She quit a management consulting job in San Francisco and began two years of wilderness immersion by working at a Sierra Club Lodge in Tweedsmuir Provincial Park, British Columbia. That summer she also rafted the Colorado River for the first time. In 1978, she trained on rivers in California and Oregon, and graduated to whitewater canoeing. In 1980 she returned to the Midwest and flatwater canoeing.

For 12 years, she enjoyed a successful career as a fundraising and marketing professional, and then in 1991 began a career change to writing. She has had articles published in magazines and newspapers, and recently put together a collection of essays and poems. She wrote her first poems in 1977, and feels the outdoors inspired her to begin laying down words.

During her training as a river rafting guide, she took a 13-day trip down the Colorado River through the Grand Canyon. The route winds through 276 miles of the most dramatic scenery and down 161 of the most challenging rapids in the country. The rapids are all named—Nankoweap, Hermit, Zoraster, and the biggest of all—Hance, Horn, Granite, Crystal, and Lava Falls. Rapids are rated—depending on the speed of the water flow at a specific point—from Class 1 (easy) to Class 6 (most difficult). Hance, Horn, Granite, and Crystal rate between 6 and 8; Lava Falls was rated Class 10.

This excerpt, from a much longer account of Gail Goldberger's Grand Canyon trip, was first published in an excellent women's travel magazine called *Maiden Voyages*.

Flipping on the Colorado River, 1978, by Gail Goldberger

Day One. Shoving our raft off from Lee's Ferry, Arizona, were three other trainees besides myself. Kim and Mary Lou had been down the river many times; this trip would earn them their certification. Ken, a college student, was a novice like myself; we'd both been down the Rogue River in Oregon, where we had met our friend and guide, Tom.

Since it was our first trip on really big water, Ken and I took turns rowing with other guides who taught us the ropes—how to navigate rapids and how to read the water. There are many ways to get through a rapid, and even well-trained, expert guides learn to expect surprises.

I will never forget the first person on our trip to "take a swim." Halfway through Sockdolager, a long and snarling rapid, Ken and I turned around and noticed that Kim was no longer at the oars. No one was pulling us through! Shocked, we glanced at each other and then at the oars flopping behind us. Swiftly, Ken jumped back, grabbed the oars and began to row. I looked around frantically for Kim, who fortunately was hanging onto the back of the raft and continued to do so as we made our way down the rest of the rapid. After she pulled herself back in, she told us that the first wave had rolled into the raft, and knocked her off the wooden seat into the water.

These "adrenaline-producers" punctuated our journey, and alternated with peaceful, breathtaking experiences of nature. The river

mirrored the sometimes mile-high canyon rising on either side of it, through which it has carved a wondrous course. The walls are a geologic amphitheater, showcasing the evolution of life with layers of limestone, sandstone and granite. At night, in shadows cast by the moon and the river's ceaseless murmuring, ancient faces emerged from rock columns and ledges to tell stories of their own. And, each day we talked about the rapids to come, and about Lava Falls. Late on the afternoon of the eleventh day, we arrived.

Day Eleven. It had been long and hot with the Santa Ana wind blowing hard from the direction into which we were heading. For most of the afternoon we turned our boats around and back-stroked. A mile before the rapid, we passed Vulcan's Anvil, a tall chunk of lava jutting out like an evil finger warning us away. The river narrowed. The canyon walls changed from soft pinks and tan to black. We tied our boats off to the right of the thundering roar of the water. Other groups were ahead of us, on the left and right hand sides of the river, scouting and waiting to go. Our crew climbed to a black rocky rise. We looked down upon an extremely long stretch of river that dropped 37 feet in a few hundred yards. We studied the river. We stared down the whole gnarly run of it.

A few motorized rubber rafts went first, having a buckaroo ride. People whooped and hollered, some holding on for dear life, some falling into the boat, some leaning over the side with raised beer cans.

We watched as six wooden dories went through Lava Falls. The last dory entered the rapid just a little too far to the right, and careened toward rock-litter at the bottom. The dory collided into a steep rock, spilling people and gear into the river.

Seeing a boat turn over like that put us deeper into our fear. Ken left the group to walk up a rise to the right of the beginning of the rapid. When I went to look for him, I found him scrunched under a scrubby tree starting at the rapid and the boat down river.

"Thinking about going down there to help?" I asked.

"No," Ken said, "I'm too nervous to help."

Together we contemplated the water. The most difficult thing about Lava was the point of entry. If you entered too far to the right, the river drew you into rocks at the bottom. Entry to the left of center was not possible. An enormous curling wave dropped 10 to 12 feet like a waterfall. An equally high wave curled back into it, and stretched 30 feet across the river. Ken and I started at the hole,

leering at us like a sinister mouth. Just to the right of the trough was a narrow slot, a straight-away of sorts, and the safest entry to the rapid.

"See that trough?" Ken asked, as though I could miss it. "If I saw my boat go in there, I'd jump out to the right to avoid it. I don't think you can get out of that hole."

Oh great, I thought to myself. We slowly headed back to our boats, feet pressing into the black gravel trail. It was 6:00 p.m., over 100 degrees. Even our strong, amazingly capable crew must have been tired. Earlier that afternoon, under the slim shade of a tree, Tom confided to me that he hated running big rapids late in the day after oaring hard for so many hours in the heat.

"I'm already worn thin," he said. "And I don't like looking at the rapid with the sun at horizon level either."

We were the second of our group to pull away from shore. Sam, the trip leader, yelled back, "Tom, make sure those folks have their life jackets on good and tight." Tom leaned forward and checked us one by one, pulling back straps to see if they were tight enough. Our boat swung around and moved into the smooth wide tongue of water that was the approach. Tom spouted instructions about what to do in case we flipped. "Feet out, take deep breaths when you surface, back-paddle, get away from the boat." I'd never heard him sound so serious before.

We moved ahead very slowly into broad, quiet water. And then, I heard rushing sounds. I looked over my shoulder at Tom, whose eyes strained fixedly ahead. They looked wild, opened extra-wide. I felt fear. I held the ropes of the raft tighter than I'd ever held anything in my life.

Tom yelled, "There's our first mark!" We sailed over a trail of little bubbles and a smooth edge of water and then... we were sliding down a chute at a 70-degree angle...face to face with a massive wall of water curling back on us. Were we in the trough? In a fraction of a second I realized there was no way we were going to punch through the wave. It was higher than our boat was long, and way too wide. Our angle was too steep. We had entered the rapid too far to the left. We were in the trough!

In a moment that stretched before me like an hour, the boat flipped, over my shoulder, left to right. Swearing to myself, "Oh shit!," I kicked away from the boat hard, with a presence of mind that surprised me. My leg grazed something, and then I was free, away from

the boat. I tumbled over and over. I had swum rapids before, and usually felt in control. But not there. Not then. I came up for air and was immediately dashed underwater again, tossed this way and that. I was unaware of forward, backward, right side up or upside down. I though about thrusting my legs forward like I was supposed to, but couldn't.

I emerged a second time and got ready to gulp. I opened my eyes and was horrified to see a 15-foot wave curling over my head. Oh God, I screamed. Brace yourself! I don't remember getting a breath. I was too stunned by the sight of the wave coming down on me. I was shot straight down like a cannonball in reverse. I was fortunate that this was a deep river and a deep rapid. I hit no rocks, encountered no obstacles, though later I learned that the rapid was strewn with huge boulders. I was shoved straight down. It was black all around me and still. Well, this could be it, I thought. I might die in this rapid.

I had no idea how far down I'd been pushed. I was in the bottom of the worst navigable rapid in North America, I could drown. The feeling sunk in and I gave in to it at some level. I relaxed. I was not breathing, nor was I struggling for air. I was calm. For the first time, I straightened out my body. I put my feet in front of me, and felt that I was on my back being carried swiftly forward. Mercifully I had hit a straight-away in the rapid. No longer was I being tossed this way and that. I imagined myself coursing down river, like flying. I opened my eyes, and spread my arms out wide. I felt very free.

And then, the blackness of the water became brown. I moved through lighter and lighter shades. I became excited. I was getting nearer the surface. Suddenly I was aware of tremendous pressure on my chest as though two enormous clamps were pulling me up. The power of the swiftly flowing water had met the buoyancy of my life vest. Oh, my sweet life jacket!

I popped out of the water, slicing through the surface at 20 mph. Ahead of me was a line of choppy standing waves. Although each crest and trough were six to eight feet high, I'd swum rapids like these before, feet out in front of me, and I knew I could do it. I was moving fast, dropping down into the bottom and up over the crest of each wave. No one was in front of me and no one could hear me, but every time I slide down and rose over a wave I bellowed, "I'm alive, I'm alive, and I'm swimming Lava Falls!"

Tom was behind me, shouting the name of one of our passengers, "Dale, Dale!" I twisted around and yelled back, thinking he was calling my name. I could see him and Mona hanging from the sides of our upside-down raft. Off to our right and a little in front of us was Chris, bobbing pale green and not looking good. Dale was nowhere to be seen. Tom continued to call out her name.

I could see people running and boats being hurled into the water to try and get us before we were swept into Little Lava Falls, another big rapid, right below Lava! The current was strong. Oars churned and bodies pitched and flailed as they hurried out to catch us.

The rapid carried me right up to a raft. Someone grabbed me under my arms and yanked me in. I was soaked, chilled, and crazed with an odd mixture of fear, gratitude, and exultation. I yelled: "Swimming at the Y will never be the same!" Thank God!

One by one, we all ended back on shore and most of the gear was still roped in place. Mona and Chris were pulled from the water. It turned out that Dale had gone to the right of the rapid, unlike the rest of us who went left, and got picked up by another boat company.

Around the campfire, Tom, Mona and Dale told how they were trapped beneath the raft. Tom recalled feeling his body graze against boulders as he was being trundled down the rapid. He shivered in the telling.

Day Twelve. All of us from the flipped boat were exhausted. Though Tom could have used a lighter load, we clung together, the five survivors, huddled next to each other, taking comfort in the nearness of our still intact selves.

I never did become a river guide. It was too physical and too intense for me in the end. But I learned to read water and steer boats, and later, canoes, all over the Midwest. That was more my speed.

Where to Find On the Water Vacations
Adventure Alaska Tours
Adventure Bound
Alaska Wildland
American Wilderness Experience
Annapolis Sailing School
Colorado River Outfitters Association
Echo: The Wilderness Company
Explorations, Inc.
Hawk, I'm Your Sister
International Expeditions
Journeys International
National Women's Sailing Association
Nature Expeditions International
Nichols Expeditions
Northern Lights Expeditions
Offshore Sailing School
Outdoor Vacations for Women Over 40
Rainbow Adventures
Rocky Mountain River Tours
Victory Chimes Windjammer
Wilderness Travel
Wildland Adventures
WomanTours
Woodswomen Inc.

Chapter Six
SPORTS OUTDOORS

"I suppose, if there were a part of the world in which mastodon still lived, somebody would design a new gun, and men, in their eternal impudence, would hunt mastodon as they now hunt elephant."

Beryl Markham, *West With the Night*

There are few stories about women hunting, fishing, or shooting, or playing football, baseball, or ice-hockey, which is often what people think of when you say sports. More and more women are beginning to be active in team sports and outdoor activities, and there has always been a minority who enjoyed going out to hunt, fish, and shoot with men.

Traditionally, female players have excelled in individual sports such as tennis, swimming, and skating because there was little support for many team sports. Women chose to focus on sports they enjoyed and were permitted to play. Today, there's been a dramatic change, with Olympic competitions that highlight women gymnasts, runners, basketball players, skiers, and more, which inspires the next generation of young girls to emulate their idols and take up a new sport.

This chapter brings you a varied selection of women writing about what they love, ranging from a 15th-century fishing expert to a 20th-century one-legged skier.

Dame Juliana Berners

Dame Juliana Berners was a prioress in St. Albans, England. She was renowned in her day for her wisdom, scholarship, and charm. She was also passionately interested in fly fishing, and wrote a comprehensive guide called *The Treatise of Fishing with an Angle*, published in 1450. It has become the classic guide to fly fishing, and her advice is still sound, some 500 years later. She gave detailed instructions on how to build a rod, construct handmade hooks, make fishing lines from braided horse hairs,

tie flies, and which was the best fly for different months of the year. She also explained how the weather affected fishing, and recommended good places and the best time of day to fish. Here's an excerpt from her philosophy about fishing—still relevant to today's ecological concerns.

The Treatise of Fishing with an Angle, 1450, by Dame Juliana Berners

What are the means and the causes that lead a man into a merry spirit? Truly, in my best judgement, it seems that they are good sports and honest games in which a man takes pleasure without any repentance afterward. Thence it follows that food, recreation, and honorable pastimes are the cause of a man's fair old age and long life. And therefore, I will not choose among four good sports and honorable pastimes—to wit, among hunting, hawking, fishing, and fowling. The best, in my simple judgment, is fishing called angling, with a rod and a line and a hook.

If the angler catches fish, surely there is no man merrier than he in his spirit. Also whoever wishes to practice the sport of angling, he must rise early, which thing is profitable to a man in this way. That is, to wit: most for the welfare of his soul, for it will cause him to be holy; and for the health of his body, for it will cause him to be well; also for the increase of his good, for it will make him rich.

You that can angle and catch fish for your pleasure, as the above treatise teaches and shows you; I charge and require you in the name of all noble men that you do not fish in any poor man's private water (such as his bond, or tank, or other things necessary for keeping fish in) without his permission and good will. And that you be not in the habit of breaking any men's fish traps lying in their weirs and in other places belonging to them, nor of taking the fish away that is caught in them. For after a fish is caught in a man's trap, if the trap is laid in the public waters, or else in such waters as he rents, it is his own personal property. And if you take it away, you are robbing him, which is a right shameful deed for any noble man to do, a thing that thieves and robbers do, who are punished for their evil deeds by the neck and otherwise when they can be discovered and captured.

And also if you do in the same manner as this treatise shows you, you will have no need to take other men's fish, while you will

have enough of your own catching, if you care to work for them. It will be a true pleasure to see the fair, bright, shining-scaled fish outwitted by your crafty means and drawn out on the land. Also I charge you, that you break no man's hedges in going about your sports, nor open any man's gates without shutting them again. Also, you must not use this aforesaid artful sport for covetousness, merely for the increasing or saving of your money, but mainly for our enjoyment and to procure the health of your body, and more, especially, of your soul.

Also you must not be too greedy in catching your said game, as in taking too much at one time, a thing which can easily happen if you do in every point as this present treatise shows you. That could easily be the occasion of destroying your own sport and the other men's also. When you have a sufficient mess, you should covet no more at that time. Also you should busy yourself to nourish the game in everything that you can, and to destroy all such things as are devourers of it.

Marilyn Stone

Marilyn Stone is the founder and director of Wilderness Women in Denver, Colorado, a new organization that is introducing women to sports and activities they have never tried before or long to try again. This comment comes from her newsletter.

Do you know what you are fishing for?, 1996
by Marilyn Stone

When you listen to someone describe why they are passionate about a particular outdoor activity, they will most likely emphasize being out in nature, the peaceful surroundings, the spirituality they feel, comradeship, and other reason too numerous to list here. To someone outside looking in, the obvious goal or most salient portion may be working up a sweat at cross-country skiing, making machines overcome obstacles as in four-wheeling, killing a trophy buck, or catching a monster fish. It is important for the uninitiated to talk with and listen to the true motivations of the devotees of these sports in order to understand.

Understanding what different sports and activities have to offer can open up options. For many years, I felt that something was

missing in my life—and there was! I knew that I enjoyed being outdoors, but I didn't know what I wanted to do out there. It was not until I was 28 years old that I was introduced to my passion. I simply did not know that it was an option nor was I able to articulate whether I was looking for an opportunity for companionship, spirituality, or some other elusive quality. I needed the experience to know what I wanted and why I needed it. Age and experience helped me to find the words to tell other people.

Do you know what you are fishing for? Can you let yourself find it? Do you feel that you have deserve to have it? Or can you have it only after everyone else has gotten what they are fishing for?

Claire Walter

Scuba diving is becoming more and more popular, and women find they are on an equal footing—or flippering—with men under the water. The thrill of seeing wonderfully colored fish shimmering close by while you float through turquoise light is exhilarating.

Claire Walter is an expert skier, who recently discovered the joys of scuba diving. She's an award-winning freelance writer, Western Editor for Skiing Magazine, and travel columnist for Cross Country Skier. She has been the author, co-author or a contributor to a dozen books, including *Skiing on a Budget* (Betterway Books), *Buying Your Vacation Home for Fun and Profit* (Dearborn Financial Publishing), and the second edition of *Rocky Mountain Skiing* (Fulcrum), which won the Harold Hirsch Award for the best ski book of 1992-94. She also won the prestigious Lowell Thomas Award for guidebook writing in 1988, and was named Colorado Freelance Writer of the Year in 1991.

She has skied the major resorts of North America and many of the lesser ones. She has summited Tanzania's Mt. Kilimanjaro and hiked many of the high peaks of Colorado and the Swiss Alps. She also holds Advanced Scuba Certification. A native of Connecticut and long-time resident of the New York metropolitan area, she now lives in Boulder, Colorado, with her husband, Ral Sandberg, and her son Andrew Cameron-Walter.

Scuba with Sea Lions, 1995, by Claire Walter

I pressed my mask against my face, jumped into the water and floated until the group assembled. It was just like every other dive—

until I submerged. Before I could orient myself, I was nose to nose with a sea lion. It hurtled toward me like a furry brown torpedo, peered into my mask and veered away just short of contact. Before the dive was done, I saw sea lions twist like corkscrews or do submarine flips to induce divers to do the same. I watched them swim through a divemaster's upraised arms, and I lured one with a stream of bubbles from my upended spare regulator.

The dive site was Seal Island, midway down the Sea of Cortez. This 900-mile-long body of water, also called the Gulf of California, is the world's richest sea; 3,700 square miles are now a Mexican Biosphere Reserve. Like the girl with the curl, when the diving is good, it's very, very good—an underwater array of sea life that is unsurpassed in this hemisphere for abundance and variety. And when the diving is bad, it is horrid—wind-whipped seas, cold-water surges, and minimal visibility.

In spring, whales and dolphins migrate to the Sea of Cortez, as do sea lions moving from winter waters to bear their young, and that's sufficient reason to dive there, cold water and dense plankton notwithstanding. The bulls arrive first. The strongest males secure the best beaches, and like the guy with the great car, the bull with the best beach attracts girls. A dominant bull with a terrific beach may have 40 or 50 cows in his harem, while a weaker or very young male may occupy only a small ledge with room for just two or three females and their pups.

When I dived there in May, Seal Island was on the schedule every day, and the excursions never got old. This granite outcropping off the mainland's central coast, officially San Pedro Island, is a major sea-lion rookery. When one buddy team was late in returning to the boat, a divemaster hopped into the water to look for them through his mask. Half a dozen sea lions joined him, first trying to draw his attention with their gymnastics. Soon the animals 'helped' the search. When he raised his head to breathe, they did too. When he put his face down, so did the sea lions. And when the divemaster called out that he saw the divers swimming back to the boat, the sea lions let out short barks of confirmation.

Until the pups are born in June, both males and females cavort with divers, but after that, swimming with all sea lions is replaced by swimming near male sea lions. Cows and their young mostly stay on the island, while bulls patrol the water. It's all right to dive outside of what the males have decided is their territory, but they

will bark warnings to divers who get too close. Bulls have even been known to charge persistent divers crossing the invisible line drawn in the sea by these clever mammals.

Scuba season cranks up in spring when quarter-inch wetsuits are necessary. As the water warms, plankton blooms, and visibility is miserable. In summer, the plankton disappears and the sea offers clement temperatures, good visibility, and a variety of fish. Fall is the kindest season. The water has been warming all summer, but the desert air cools from stifling daytime to delightful moderation. Best of all, the big cetaceans are on the move once more, presenting the possibility of whale and dolphin sightings with each boat ride. Come November, the plankton returns and the scuba season winds down. You can dive the Sea of Cortez in May, July, and October, and return with completely different memories from each trip.

Sally Wendkos Olds

This next story about running in Bangkok is particularly appealing because it captures so well the sensation of being a foreigner in a strange place, and of doing something you love despite the new location.

Thirty years ago it was rare to see a woman out running, or competing in races. Today you see women runners in every competition, including marathons and triathalons. Their visibility and success has inspired amateur women runners to put on sneakers and take off from suburban homes and city apartments at home or abroad to experience the joy of running.

Sally Wendkos Olds, whose climbing adventures you read in another chapter, is an award-winning writer of seven books on personal growth and development, intimate relationships, and family issues, and co-author of three college textbooks, Sally Wendkos Olds' publications include *The Complete Book of Breastfeeding*, a classic that has sold over a million copies, and *The Working Parents' Survival Guide*. She has also written more than 200 articles for national magazines. A former president of the American Society of Journalists and Authors, she lives in Port Washington, New York, with her husband Mark, a retired broadcaster. She is the mother of three grown daughters, and is a grandmother.

She recently won an award for her article about running the New York City Marathon to celebrate her 60th birthday.

Running in Bangkok, 1994, by Sally Wendkos Olds

The roseate glow in the sky over Bangkok divided into long slender wisps of coral in front of a misty pearl-gray wash. Almost immediately the pastel tones began to deepen and dip into other tints until, paling again, the thin stripes evanesced into a tranquil blueish-gray canopy, and day broke above the gleaming golden temples of this ancient "City of Angels." But of the hundreds of people in Bangkok's Lumpini Park on this morning in early May, I seemed to be the only one who was at all interested in the spectacular sunrise.

All the others were pursuing business as usual. The concierge at the Oriental Hotel had been right. When I had asked him early that morning, as I came down to the sumptuous lobby in my running shorts and Nikes, whether it was safe to run in the streets around the hotel, he had told me, "Yes. But you really want to go to Lumpini Park. The doorman will get you a taxi, and your driver will wait for you while you run. You will see many other people there." "This early?" I asked incredulously. He smiled benignly, his eyes crinkling behind his round glasses.

I didn't realize what a treat I was in for until I reached this enormous leafy square, its 52 acres making it the city's largest green oasis. Named after Lumpini in Nepal, where the Buddha was born from his mother's side as she rested her arm against a tree in her garden, this tree-rich Thailand park opens at 5 a.m. every day and is open free to the public until 6 p.m.

After the ten-minute ride to the park, my slim, mahogany-hued driver silently pointed me toward the entrance, guarded by an impressive military statue, and then turned to chat with some of the dozens of other drivers congregated outside the gate. I memorized the number on the side of his car, and I walked a few yards to a neatly ordered phalanx of fifty or so exercisers of disparate ages, shapes and levels of fitness. They were doing calisthenics to the lively music coming from loudspeakers hidden among the trees—palmettos with their leafy fronds; flame trees with their vivid blossoms in scarlet, tangerine, lemon; giant palms reaching up to rival the skyscrapers that bordered the park.

I thought I'd warm up along with the crowd, but no matter how closely I tried to copy the simple movements demonstrated by the slender young man leading the exercises, my western body couldn't get into the rhythm that seemed to come so effortlessly to everyone

else. Anyway, I shrugged to myself as I made my way into the park, I'd come here to run.

I threaded my way along the paved pathways, through crowds of Thais using their bodies, using their park. A group of some twenty young men and women, all dressed in identical white shirts and navy shorts, ran in rhythm along the wide avenue. (Except for this group, every female over 8 years old—except me—wore long pants despite the steamy temperatures, already sending rivulets of perspiration down the faces of the exercisers. Apparently, only men and tourists dared to bare their knees, but although I was clearly the object of interested stares, any disapproval melted away in warm smiles that acknowledged the strange ways of foreign women.)

An old man in a gray cotton tunic and trousers used his cane to trace graceful, slow-motion lines in the air during his tai chi routine. Two round-faced women in purple jogging suits bent, stretched, jumped and panted together. A slim young man dressed all in white sat cross-legged on a rock, lost in a trance. A middle-aged man in a business suit, bald head shining, stood beneath a tree and softly chanted from a prayerbook. Two couples held each other lightly, doing ballroom dancing under the tutelage of a watchful teacher. Three- and four-generation families, from infants in arms to ancients in wheelchairs, consumed breakfast banquets at marble-and-granite picnic tables from which the aromas of their spicy exotic fare wafted out invitingly. Birds warbled overhead. Lush tropical flowers perfumed the air.

I followed the road as it wound by a lake where ducks and swans floated and dipped down for breakfast and small boats waited to be hired. I passed statues, a pagoda-shaped gazebo offering shade and shelter, a restroom where users were lining up to buy tickets to enter. Had I been in the park a few years earlier, I might have seen former president Jimmy Carter, who jogged—and sweated—on these same paths, flanked by both Thai and American bodyguards. But this morning, among the hundreds of Thais, I passed only two other westerners; one man was running, one woman enjoying a morning stroll.

From time to time I mentally rehearsed my taxi's number and congratulated myself on my prudence in anticipating my eventual reunion with "1-1-1-6-6-2-2" and its driver. After about twenty minutes, however, I realized that I would have done well to apply

the same foresight to memorizing my route. Even though I had thought I was following a simple, straight path, my dependably defective sense of direction had marooned me in uncharted territory, along the two-mile perimeter of the park. I had no idea where I was. Then, when I thought I had turned back to retrace my steps, I found myself looking at unfamiliar buildings, new sculpture, strange plantings.

Finally I approached a pleasant-looking elderly walker, rotund in her balloon-shaped trousers. "Excuse me," I said slowly in English. "Where is the gate with the statue?" First she looked at me in bewilderment, then smiled ruefully and shook her head. No matter how I pointed or sculpted the air with my hands, I couldn't break through the language barrier.

I kept running, although I was now in a less populated part of the park—its maintenance area, I judged from the look of the buildings. Three fresh-faced teenage boys sauntering along with their school books stopped politely in response to my wave, but when I asked, "Do you understand English?" they shook their heads, looked at each other and guffawed like teenagers anywhere in the world.

I silently berated myself for not having studied my Thai phrasebook, and kept running along what seemed like the outside of the park. And then as I turned off onto a little path, I was relieved to spot a pagoda I had seen before, a little bridge I had crossed before, a line of new people waiting to go into the restroom I had passed earlier. Within minutes, much to my relief, I found the great gate through which I had entered the park and my patiently waiting driver. I rode back to my hotel feeling that I had gained an intimate look at the Thai people. Of course, it's arguable that anything done at 6 o'clock in the morning is intimate.

Ida Pfeiffer

In 1848, Ida Pfeiffer found herself in India, and like all good travelers, was determined to see and do everything she could, including an unscheduled tiger hunt. Earlier, you read her philosophy of travel, and an exuberant account of being at sea in a storm.

Ida Pfeiffer (1792-1858), born Ida Reyer in Vienna in 1707, was one of the most astonishing women travelers of her day. After an initial trip to the Holy Land, she went to Europe and

Scandinavia, and then traveled round the world twice. After an expedition to Madagascar, she fell sick, and, returning home, died two years later. Her son, Oscar, prepared her last book for publication (See Chapter One).

Tiger Hunt in India, 1848, by Ida Pfeiffer

March 6. Adjunta, India. Early in the morning I mounted my horse, to visit the rocky temple of Elora; but, as it often happens in life, I was reminded of the proverbial saying, "Man proposes and God disposes," and instead of the temple I saw a tiger hunt. I had scarcely turned my back on the town where I had passed the night, when I saw advancing towards me several Europeans, sitting upon elephants. We stopped on coming up with each other, and began a conversation, from which it appeared that the gentlemen were out on a tiger hunt, as they had information of some being in the neighborhood, and they invited me, if such sport did not terrify me too much, to join them.

I was very glad of the invitation, and soon found myself in company with two of the gentlemen and one native, seated in a box about two feet high, which was placed on the back of a very large elephant. The native was to load the guns; and they gave me a large knife to defend myself with in case the tiger should spring up to the edge of the box.

Thus prepared, we set off for the hills, and after the lapse of some hours thought we had come, probably, pretty close to the tiger's den, when suddenly one of our servants exclaimed, "Back! Back! That is Tiger!" Glaring eyes were seen through the bushes, and at the same moment several shots were fired. The animal was soon pierced by several bullets, and now dashed at us full of fury. He made such tremendous springs that I thought he must infallibly soon reach our box, and choose himself a victim out of our party.

This spectacle was terrible enough to me, and my fear was presently increased by the sight of a second tiger. I behaved myself, however, so valiantly that no one of the gentlemen suspected what a coward I was. Shot followed shot. The elephants defended themselves very cleverly with their trunks, and after a hot fight of half an hour's duration we remained victors, and the dead animals were in triumph robbed of their beautiful skins. The gentlemen were so courteous as to offer me one of them, but I declined accept it, as I

could not have delayed my journey long enough to have it dried and put into a proper state.

I got a good deal of praise for my courageous behavior, and I was told tiger hunting was really extremely dangerous were the elephants were not very well trained. If they were afraid of the tigers, and ran away, one would very likely to be dashed off by the branches of the trees, or perhaps left hanging upon them,and then would infallibly become the prey of the enraged animal. It was of course too late for my visit to the temples of Elora this day, so I had to put it off to the following morning.

Carolee Boyles-Sprenkel

As women move into the mainstream of adventure travel, they also move into the fields of traditional male sports, including hunting, fishing, and shooting. Denver's Wilderness Women offers archery and shooting courses for members. Here's a comment from a woman hunter.

Boar Hunting, 1996, by Carolee Boyles-Sprenkel

I'm writing this during the first week of March 1996 at a ranch in (way) upstate New York, after hunting for the past two days in several feet of snow. It's been an entirely new experience for me, since the most snow I've ever seen in Florida was about an inch. I have hunted in a small amount of snow in Colorado a few times, but never anything like this! Once you get away from New York City, there are a lot of places to get away and go hunting or fishing.

The upshot of my trip was a nice, though small, European boar. It's the first European I've ever shot, and I had to stalk it with a bow across a big open field. Fortunately, I have a good set of snow camo, so I blended in nicely with the field and was above to get a twenty-yard shot on him. Besides boar, the ranch also has a beautiful herd of fallow deer, as well as mouflon and red deer. Just a reminder: we have a feral hog hunt planned for early December.

Cale Kenney

Women skiers have a long tradition. Because skiing demands not just brute strength, but coordination, stamina, balance, and skill, women have been schussing down slopes since the early days of the sport.

I met Cale Kenney at a writer's group in Denver, where I spoke about my biography of Isabella Bird, and she joined in the lively discussion about writing and historical research. Wearing a long skirt, Cale was masterfully getting around with a crutch. She gave me a copy of her magazine, *Howlings*, with writings by western women, and I discovered she was a skier.

In 1971, at the age of 19, Cale Kenney was gravely injured in a motorcycle accident in which she lost her left leg, hip, and pelvis. She says she was quite devastated until she became active again. She attended the National Handicap Ski Championship at Winter Park, Colorado, and decided to improve as a recreational skier by becoming a racer.

Realizing she had lost her heart to the mountains, Cale moved to Winter Park after graduation from college: "I skied almost every day, like skiing was an act of holiness. And I became whole again."

There Cale began a career in journalism as a reporter, columnist, feature writer, and sports editor for the *Winter Park Manifest*. In 1983, after a knee injury, she moved on to Colorado State University, where she got a master's in English and began teaching. Eight years later, while teaching "Writing the Wild Woman" at Colorado Free University, she got the idea that led to her present career as an editor and publisher. She said: "I couldn't believe the good writing and important stories these women had to tell; there had to be a public for this."

So, in June of 1995, she launched the quarterly 'zine called *Howlings: Wild Woman of the West*, a 48-page collection of poetry, short stories, essays, and autobiographical sketches up to 1,500 words, which she selects. She looks for women with unique, authentic voices who write from a place of passion in their lives. She is writing an autobiographical novel, titled *Miss American Pie*, and crossing her fingers that one of her projects will lead to an income she can live on and continue to be creative.

Today Cale exercises, walks, and swims to keep in shape "for skiing and the active life I want to live, despite the limitations disability and age have put on my body."

Après Ski, 1996, by Cale Kenney

I would never have thought I'd lose a leg to become athletic, but that's what happened after a new friend, herself a new amputee, asked me if I'd like to go skiing.

"What? And break my one and only leg?" What is she, a masochist, I wondered. That was before I learned masochism is a prerequisite for being an athlete.

"Cale, most people break a leg because they cross their tips. We can't do that." I forgave her good attitude; however, I saw I had to be more sophisticated in my excuses.

"Skiing is an elitist sport," I sniffed. "You have to have money."

"It's free if you're disabled," she volleyed.

"But I don't know how," I said like the stubborn coward I was.

"They teach you," she said like the stubborn advocate she was.

"Where I am supposed to get the equipment?" I didn't really want an answer.

"They loan it," she said. "Free!" We both recognized that we'd been through a major life crisis, her having all the right answers to both of our excuses.

After the success of several years of gracefully mastering crutches, I was to be humiliated by both the laws of physics and the athletic challenge of learning to ski with a body still a stranger to me.

In the parking lot outside the lodge, my new friend and I sat for several hours telling our stories inside her car. I told her: "When I was in high school I was a 'hoodsie'. The most athletic thing I ever did was run—and that was from the cops." I didn't mention I had been a bowler, since I only did it to wear the shoes and be ogled by boys. She was a swimmer, played tennis and lacrosse. She had also skied before. I asked her if that was an advantage, and she said she was willing to find out.

When we entered the lodge, I felt like Ann Boleyn heading for my beheading, until I saw a gathering of guys lounging at the fireplace drinking Schnapps and hot chocolate. Social life! Now that I could relate to. Jane steered me away and took me to the handicap skier station where we stood on platforms, sat on benches, and by the time I got all my gear, I was exhausted.

"Okay, let's hit the bar," I said cheerily. Instead we were led out into the frigid air to the hilltop where our teacher, Fran, a large 30-something three-tracker, instructed us how to put our skis on and take up our outriggers.

Outriggers are crutch-like poles with a 12-inch ski tip at the bottom that rides over the snow, making a platform of three skis instead of two, thus the expression three-tracker. Once you become a really good skier, like Fran, you ski with your one leg and use the outrigger to balance every once in a while. That first day, though, three skis weren't enough.

In the two years I had been an amputee, I had never worn pants. My vanity required long dresses which flared at the waist so I could also hide my loss of a hip. With these ski pants I felt like a dorky stork standing over the ski as I readied to put my food into the binding. My balance was good, but it did call for the earth to stand still.

With my crutches gingerly gripping the snow, I leaned down. The ski flew backwards, and I flew forward. Fran caught me right in time from falling flat on my face. She held me around the waist while I got the ski on. I stood like a perturbed flamingo while Fran handed me the outriggers, and the principles of friction vs. sliding demonstrated themselves. The first thing I did was treat the outrigger like a crutch and put some weight on it. Like a banana peel it slid out from beneath me. I was on my butt before my ski had even moved. I was stunned. Fran didn't offer to help me up. I hardly had strength to lift myself, but I had also to lift the fool outrigger at the same time.

Oh, my. I was most unhappy, and the cheerfulness around me made my mood more foul. My friend was already several hundred feet down the hill, a natural kinesthetic learner. "You can do it, Cale," someone gushed. Right. Each time I tried to get up, the ski slipped downhill, me laying on its tail.

"Lay your ski across the fall line," yelled Fran. The fall line she had explained earlier was the path a ball would take if dropped down the hill. Fran side-slipped down to me, stopped my slide, and then lifted my ski—with my leg attached—up into the air, turned me around on my back and headed my ski up the slope. "You want to get up with your ski across the fall line and use the uphill outrigger to push up off the ground," she said.

"No, I don't. I want to go in and have some hot chocolate now," I mumbled. My crutches, however, were ten feet above me, my ski having slipped that far down the hill as I was just trying to get up. I knew Sergeant Fran would never bring them down to me. I was in for the duration. Her duration.

The day was a nightmare. My ski pants kept falling off me, and I couldn't pull them up without letting go of the outrigger and falling down myself. Those moments when I would get set upright, point downhill and start to get some speed, I'd instinctively lean back to keep the ski from going further down hill. *Boom!* Skiing taught me another law of physics; if you lean back, the ski goes forward faster; if you don't stay over it, you're down. "Bend your knee," she instructed, and I looked down to see what part of my body my knee might be.

The concept of turning was never introduced that day because I used up a flotilla of instructors trying to teach me to merely stay up. I could hear voices from uphill calling, "Kyle, get up!" and I thought, "I'm glad I'm not this Kyle guy because I gotta sit down and rest." When I realized they were actually yelling at me, I was genuinely puzzled. "Why should I rush to get up if I'm just going to fall down again?"

When I finally got to the bottom of the hill, I collapsed in relief like a snow angel. I didn't care if I embarrassed the other gimps. When I looked up into the blue sky, I saw a circle of trees, and I realized I wasn't even cold. I was exhilarated. I looked uphill to see how far I'd come, and I felt a bolt of happiness. It wasn't that hard! As long as I didn't have to do it again real soon.

I was next introduced, however, to the converse of Newton's Law of Gravity: What goes down must come up again. At Haystack you skied down and took a T-bar up. A T-bar is a rope tow with an iron piece shaped like an upside down T. A skier holds on to the stem with one hand, tucking the T under her butt, and is towed to the top.

This assumes you have not only balance, but a butt. No one made the connection that my pants were falling off because, not only had I lost a leg, but half my derriere. So no one could figure out why I was such a terrible spaz on the T-bar. But it took the rest of the day to get me up it. Eventually one of the instructors skied me between his legs, his butt on the T, and my back leaning against him.

"If I get to the top," I asked him, "can I stay there?" He offered to buy me that hot chocolate himself. My hero!

The thing that was most exciting about that first day of skiing was that it was over. I came a few times more that winter, and even conquered the T-bar, and by my last lesson could traverse across the

slope and stay up. The next year I discovered paradise at Sunapee, New Hampshire, where they had a chairlift. It would take at least one more season before I was strong enough to stand up from a sitting position, balance my body over the center of the ski, and turn with enough finesse to completely control my speed.

In five years I would be competing regionally and nationally, and in 1979 become the Women's National Three-Track Champion. In 1980 I represented my country in Olympic Games for the Disabled in Norway. All that for a hot chocolate après ski?

All that because skiing gave my body back to me.

Where to Find Sports Vacations

American Wilderness Experience
Annapolis Sailing School
Colorado River Outfitters Association
Echo: The Wilderness Company
Expeditions, Inc.
Experience Plus!
Hawk, I'm Your Sister
National Women's Sailing Association
Nichols Expeditions
Northern Lights Expeditions
Offshore Sailing School
Outdoor Vacations for Women Over 40
Overseas Adventure Travel
Rainbow Adventures
Rocky Mountain River Tours
Victory Chimes Windjammer
Wilderness Women
WomanTours
Woodswomen Inc.

Chapter Seven
OFF THE BEATEN TRACK

"I confess I am malicious enough to desire that the World should see to how much better purpose the Lady's Travel than their Lords. A Lady has the skill to strike out a New Path and to embellish a worn-out Subject with a variety of fresh and elegant Entertainment."

Mary Astell, *Introduction to a Book of Travel Letters*

When women travel, they often see things differently from men, and notice different things along the way. Their interests go beyond the immediate scenery to the people and customs that make up the fabric of daily life in another part of the world. They have the interest and the patience to examine unusual aspects of traveling that others may ignore.

The writers in this chapter are all modern women and experienced travelers. These are stories that rarely get published because they're distinctly unusual.

Penguins in Antarctica, 1994, by Evelyn Kaye

The penguin waddled up to me as I sat on a rock, and stood by my foot, peering at my yellow boots out of round beady eyes. About as high as my knees, his front was a freshly washed white, his back a smooth gleaming black, and he had a white splash across his head. His webbed pink feet clung to the rock as he turned his bright orange-pink beak, in which he held a stone, this way and that inspecting me. Not dangerous, he decided. He waddled past me toward the nest of stones by a rock where two fluffy gray baby chicks huddled under a penguin. He carefully dropped the stone beside the nest, and waddled back past me.

This is Antarctica, the untouched fifth-largest continent that covers the southernmost parts of the earth in a glittering, dazzling feast of snow, icebergs, mountains, seals, unique seabirds, and penguins who are absolutely unafraid of people. It takes a while to get there from anywhere else. I flew from Miami to the southern tip of Argen-

tina, and boarded a boat that headed through some of the roughest seas in the world. Yet compared to the hardships endured by the early explorers, the crossing on a modern Russian research vessel was luxurious.

My first view of Antarctica was tantalizing. After two days at sea, fog hung over the ocean when suddenly someone spotted a whale spouting and a penguin swimming in the water. In the distance through the mist loomed huge cliffs covered with snow; it was Deception Island, the first landing!

Dressed in all I'd brought—polypro underwear, turtleneck, sweater, jeans, warm jacket, pull-on hat, waterproof gloves, two pairs of socks, and fur-lined boots—I added a yellow slicker, rainpants, waterproof boots, and the essential orange life jacket. I was warm and ready. With my camera tucked in my pocket, I clumped on to the deck, climbed down the narrow metal ladder on the outside of the ship, stumbled into the bouncing dingy, and sat on the edge with eight other excited travelers. We roared over the gray waves to the beach at Deception Island. When the boat stopped, we climbed out one at a time ("swing both legs over") into Whalers Bay. I waded through the shallow water to stand on the sandy gravel of my first Antarctic beach. It was about 40 degrees Fahrenheit, calm and still. Only when the wind came up did it feel really cold.

Penguins! Five perky penguins waited to greet us! One preened by the water, bending his head backwards and sideways as he polished his coat, and reaching down to smooth his chest and round tummy. Another stared, took a few steps on his pink feet toward his friend who flapped his flippers, gave a loud squawk, and waddled off. One lay on his round, white stomach on the ground, his head and feet up at either end so I wondered if you could tip him up. The fifth one paddled into the shallow water and watched the cameras with curiosity.

It's hard not to smile at penguins. You can't take them seriously, like polar bears or crocodiles or African elephants. Maybe it's the way they look, neatly dressed in elegant black and white, the quintessential evening dress for formal occasions. Or maybe because they are so small, they seem endearing and entrancing, not fearful. These first penguins were chinstraps, scrappy noisy fellows with white fronts, black backs, dark gray beaks, and a distinctive thin black line under their stark white chins. I watched them walk about and cavort in the water, my camera clicking photo after photo.

Walking along the beach, I passed several large rocks. When I came back, one of them raised its head and gave a huge yawn. It was a bulbous, mottled beige Weddell seal taking a nap with his buddies. After one quick glance, it went back to sleep. Further along the beach, I met three Gentoo penguins with red bills and feet, a white ring around their eyes, and a white band across the top of their heads. They ran along the sandy gravel on their pink feet, squawked indignantly, and jumped into the water.

It's light all the time in the Antarctic summer. From my cabin window I watched icebergs floating in the water nearby. One, about 20 feet long and 8 feet high, resembled a small mountain; another was about half that size and pyramid-shaped; the third looked square with an uneven top. White and tinged with a pale fluorescent green, they floated eerie, silent, unreal in the ocean. I slid open my window to take a photo and little dry snowflakes blew in. As we steamed steadily on the water, more and more icebergs came into view, stretching toward the horizon.

Our next landing was spectacular. The Zodiac zoomed over to Paradise Bay on the Antarctic continent. We came into a sheltered cove surrounded by high rocks. Huge icebergs soared out of the water through the mist, like mythical creatures rising from the sea. Later, when the sun came out, we admired them as dazzling marble sculptures set against the brilliant blue water. The Zodiac puttered around the bay slowly. Perched on the perilously steep cliffs were nests of blue-eyed shags, or Antarctic cormorants. On untidy nests of twigs and sticks I saw the soft gray down of the chicks as we floated past. Birds flew up in the air, their long necks stretched out, their wings beating over the water. They flew back to feed the chicks with regurgitated food from deep down in their gullets. It was exhilarating to see so many birds, so free, so wild.

We passed a huge iceberg shaped like a piece of modern sculpture with high curving walls, and round holes. It glowed a pale phosphorescent blue from beneath, and the patterns of light and shade turned it blue, green, gray and white. I asked if we could turn the motor off for a moment. In the silence, it was eerie to be so close to the giant iceberg, its unique shape looming over the rubber dinghy. The only sounds were birds calling and screeching, the water rippling, the sudden splash of a penguin in the water, and the voices of the group on shore.

Coming in to land, I climbed over the rocks, and up a hill into deep snow. Around the rocks, dozens of penguins sat on round stone nests, guarding balls of gray fluff that occasionally poked their heads into the air to look around and open their tiny beaks.

Watching the penguins in the snow was hilarious. They took tiny determined steps on their webbed feet, sometimes slipping and falling down on their round stomachs, or scooting themselves down a snowy slope, or scrambling up again to stagger on until they reached gravel or rocks. Penguins look awkward on land, but once in the ocean they swim like dolphins, speeding under the water and "porpoising" in a curve above the waves before plunging down again. Their amazing speed and the distances they cover reminded me sadly how confined captive penguins are in zoos.

Aboard the boat later, I watched dozens of black and white Cape petrels flying alongside like a flock of beautifully poised butterflies, soaring and floating in formation against the blue sky and the gray rolling sea. When I looked through my binoculars, it was like watching fish swimming through clear water, silent, smooth, elegant, their wings outstretched and heads into the wind. As more and more of them flew along, it was an unending chain pattern in the air.

The voyage up the Lemaire Channel was most dramatic. It's a narrow opening between high mountains, like a canyon or fjord, blocked with ice most of the year. Standing on the bridge looking out of the big windows, I watched as the Russian captain carefully plotted the course and directed his crew to steer the ship between giant turquoise icebergs and the floating ice. A moving panorama of snowcovered peaks unfolded on both sides, brilliantly white in the sunshine. As the ship moved slowly up the channel, I saw seals lounging on icebergs, whales spouting in the water and breaching into the air, penguins scampering over icefloes and leaping into the water, stunning views of mountain peaks against the immaculate blue sky. For hours I stood mesmerized by the view, taking photographs, unable to tear myself away for even a moment.

We reached Peterman Island and went ashore to walk among hundreds of Gentoo penguins sitting on their nests built of mounds of stones, busy looking after their newly hatched chicks. The noise of squawking and squeaking was deafening. Curving waves crashed on the rocks. Icebergs loomed in the ocean. Above, dozens of skua birds wheeled and screeched, waiting to attack. Suddenly, two skuas flew

down and pecked at a penguin sitting on its nest, while a third snatched the fluffy chick and flew away with its prey amid furious squawks from the entire penguin colony.

The day we landed on Wencke Island it was cold but calm, like a pleasant winter day. We'd started walking along the trail to the penguin colony when a storm blew up. The temperature dropped and the air turned frigid. Thick gray clouds swept across the water, completely hiding our ship moored nearby. A fierce wind whipped the sea into white-tipped waves, and dry snow hit our faces. Within minutes, visibility dropped to zero. "Back into the Zodiacs!" came the call, and grabbing our lifejackets, we scrambled aboard as quickly as we could. The dinghies bounced high over the rising waves. We hung on to the ropes as the spray drenched us. Around us the wind whistled, snowflakes whirled, and thick mist blotted out the landscape. We could see only an angry sea and wild waves. It was with relief that the looming side of the ship came into view, and we climbed up the swaying ladder to safety. The weather in Antarctica can change as swiftly as that, and the old hands are always on the alert for unexpected developments.

I traveled with a group of about 80 people through Overseas Adventure Travel. We were an eclectic bunch. There were six French people who avoided speaking English, a group from Canada, and another from Hawaii. The Americans included teachers; a recently liberated New York editor; a travel agent; an engineer; retired couples from New Jersey, Chicago, San Francisco, and Florida; a young woman photographer and her boyfriend; a TV producer; and three professors. We had comfortable cabins, most with shared bathrooms, ate our meals in a one big diningroom, walked around the decks, played card and board games, and talked.

Brad Rhees, an American, was our leader. Alan the Australian was the most entertaining guide and did a hilarious imitation of a penguin, and Canadian Geoff was the best-looking. They, and other experts from Chile and Argentina, gave us daily lectures on the geology, animals, birds, and plants of Antarctica, showed videos, and recommended things to read. We pored over nautical maps to follow our route. We learned about early explorers, watched videos, saw slides, and read books and magazine articles in the library. The Russian Captain welcomed visitors to the bridge at any time of day or night. We were reminded to respect the environment, keep a safe distance from wildlife, and take only photographs.

The Antarctic Treaty, signed in 1961, dedicated the vast region to scientific and peaceful investigation, with no one country owning the area. Today, Antarctica is dotted with research stations. The Argentinean station at Paradise Island was a hut with two researchers who offered t-shirts, patches, and souvenirs for sale. Other countries with stations are the United States, Britain, Brazil, Poland, France, Norway, New Zealand, Australia, Chile, South Africa, Belgium, Japan, and Russia. The facilities vary from a simple hut to a complex of buildings, including a coffeeshop and offices. On Couverville Island, a British group studies the effects of tourist activity on penguins. Researchers videotape visitors as they stroll among the colony of penguins while a control group of penguins on the other side of the island never sees the tourists.

On the last afternoon, I sat by a sheltered bay on a rock, watching the penguins. They trotted down from their stony nests on the top of the cliffs to the edge of the water. Standing close to each other, they stared at the splashing waves until one of them jumped in. He actually fell in, landing flat on his stomach and paddled off, head sticking up above water, looking around. Then he'd dive below and disappear. Another penguin followed him, and then another, until the whole group was in the water, little heads bobbing and disappearing.

Nearby, a group of penguins in a shallow pool played what looked like tag, swimming and splashing each other. When they scrambled out on to the rocks, they preened themselves carefully. With their beaks, they smoothed their black and white coats, twisting and turning to make sure they didn't miss a spot. Satisfied, they stood for a moment looking around. The first one set off waddling over the gravel and stones to the narrow path that led up to the nests on the rocks. As the last one passed me, he stopped and turned, gave a loud squawk, as if to say goodbye, and waddled off. It was an Antarctic moment.

Barbara Alpert

One of the people I met on the Antarctica trip was Barbara Alpert, whose energy, travel stories, and quick wit livened up mealtimes and evenings. She's a writer, editor, and college professor. A veteran traveler whose favorite adventures include a Tanzanian safari, a ramble through the Orkney Islands and

Scottish highlands, and a dream trip to Antarctica, Barbara Alpert hopes to add China, Australia, and the Galapagos Islands to the list of places she's been.

An honors graduate of Brandeis University with a degree in theatre arts, Barbara Alpert spent three years working as a stage manager and tech staffer for Joseph Papp's New York Shakespeare Festival and Public Theatre. She launched her publishing career with early stints at Avon and Ballantine Books, then rose to executive editor at Bantam Books, where she worked with such authors Louis L'Amour, Barbara Mandrell, and Shirley MacLaine.

She is the author or co-author of seven books, including *No Friend Like A Sister*, *HELP: Healthy Exchanges Lifetime Plan* (with JoAnna M. Lund), and *How to Be A Christmas Angel* (with Scott Matthews). Her articles have appeared in *Cosmopolitan*, *ParentSource*, and *New York Running News*, and she has lectured on book publishing at dozens of conferences nationwide. Currently she teaches book editing at Hofstra University, where she is an adjunct professor of English. She's also volunteered as a finish-line supervisor for the New York City marathon for 15 years.

Barbara calls her travel philosophy "wild goose chasing," pointing out that every destination seems to lead somewhere else. A chance visit to the Actors' Church in Covent Garden, London, found her in the midst of the annual garden party held by actors of the West End to raise money for charity; and a quick stop at a roadside rock shop in Montana produced an encounter with a woman who'd dug up the first baby dinosaur bones there!

Antarctica, 1994,
by Barbara Alpert

I went to Antarctica because I wanted to go to the ends of the earth.

I went to Antarctica because until 1947, women weren't allowed.

I went to Antarctica because a book I treasured called it *The Last Continent of Adventure.*

I went to Antarctica because I'd had a life-long love affair with penguins.

I went to Antarctica because the old mapmakers had called it "Terra Australia Incognita"—the Unknown Southern Land.

I went to Antarctica because I was between jobs and I'd never have enough vacation time again.

I went to Antarctica because I'd dreamed of icebergs and glaciers and all those snow-covered peaks.

I went to Antarctica because it was as close as I could get to following in the footsteps of my heroes—Captain Cook, Magellan, Drake, Roald Amundsen, Lincoln Ellsworth.

I went to Antarctica because I could.

Sally Wendkos Olds

This next piece I couldn't resist including. Sally Wendkos Olds is the award-winning writer of seven books on personal growth and development, intimate relationships, and family issues, and co-author of three college textbooks. Her publications include *The Complete Book of Breastfeeding*, a classic that has sold over a million copies, and *The Working Parents' Survival Guide*. She has also written more than 200 articles for national magazines. A former president of the American Society of Journalists and Authors, she lives in Port Washington, New York, with her husband Mark, a retired broadcaster. She is the mother of three grown daughters, and is a grandmother.

The View from the Charpi, 1996,
by Sally Wendkos Olds

I have never been reticent about regaling my friends about my adventures in Nepal. After coming home from a trek, I would go on and on about sunrise over majestic Himalayan peaks, about beautiful Sherpa and Rai and Tamang and Newari people, about Eastern spirituality, about the excitement that is Kathmandu. Friends would listen—at first eagerly, then politely—before their eyes inevitably glazed over. But somewhere in my recital everyone—everyone I spoke with—would rouse themselves and ask the universal question: "But how did you, um, er, uh, go to the bathroom?"

"Very carefully," I would answer. And then as I would describe the usual "bathroom" routine, of finding a relatively private spot behind a tree or in a clump of bushes or on the side of a hill to do what I needed to do, I would almost always hear: "The trip sounds wonderful—but I could never do that."

But Nepal is changing. Impressed by health workers' pronouncements about the dangers of eliminating in the fields and the practice's contributions to parasitic infections and child mortality, prosperous farmers in small villages have begun to install *charpis* (latrines) behind their houses. On increasingly trafficked tourist routes, lodge owners, catering to western notions of sanitation and privacy, have improvised a range of ingenious structures to meet bodily needs. So a friend and I instituted a rating system, 1 star up to 5, based on:

Accessibility (A)
Efficiency (E)
Comfort (C)
Fragrance (F), and last, but far from least,
View (V).

Here's a sampling of what we found.

1) We are staying in the home of the richest man in the hill village of Badel. This is how I find the *charpi* in the dark: I walk straight through the yard, and when I see two curved white horns and two shiny round black eyes, I know I have reached my land-mark—the *baisi*, the female water buffalo that the woman of the house milks every morning.

Holding my flashlight in one hand, I turn right and use my other hand to steady me as I climb up a slippery little embankment that's hard enough to manage by daylight. It goes up about 5 feet, and while going up is a challenge, coming down the zigzag scramble constitutes serious risk to life and limb—especially after a pelting rain slicks the rocks and mud even more.

I softly call, "Is anybody here?" before pulling aside the blue plastic curtain over the door. (No one ever is there.) Then, looping the flash-light cord around my wrist so I won't drop it into the trench dug in the dirt, I pull my underpants way in front of me, anchor my feet as far apart as I can and squat. (One night I forgot my flashlight. No problem: I found my way by the light of the moon and the gleam of the baisi's eyes.)

There's no odor at all. Fresh air drifts in between the woven bam-boo walls. More important, ashes from the family's cooking fire are deposited here every morning, creating a chemical substance similar to lime. Coming out of the charpi, I smile as I see the sunburst of wild marigolds at the top of the embankment by the bamboo enclo-sure. A cheerful greeting from the morning!

RATING: A - **; E - ****; C - ****; F - *****; V - *

2) At the Pasanga Lama Teahouse in the shadow of the Khumbu Himalaya, I get directions to the charpi in the back. I walk a few feet in front of the teahouse, turn left, climb over a narrow wooden log marking the edge of the porch, balance along a 9-inch-wide stone

wall with no railing, go up a few earthen steps and just make it inside without having to go on hands and knees through the tiny opening.

The three wooden slats that form the floor are placed so far apart from each other that I have to perch carefully, back and knees deeply bent, to avoid falling through to the unsavory pile below. Since I can't stand erect inside (even though I'm only 5'2"), I have to step outside to pull up my underpants—in full view of God, Mount Everest, and any interested passerby. (Underpants are part of the problem; they're another idiosyncrasy of western women.) How to protect my privacy? In the time-honored tradition of feminine modesty, I avert my face.

Once my skirt has redescended to respectable Nepali length, just above my ankles, I climb over the fence to take a photo of this remarkable structure—and then get stuck. I'm afraid of climbing back over this side, for fear of sliding into the muck, but what choice do I have? No one else is likely to appear to pull me over. The picture snapped, the camera hanging around my neck, I manage to hike up my skirt, tuck it into my underpants (which do prove practical, after all), and clamber over the side.

RATING: A - *; E - **; C - *; F - *; V - *

3) At the Kwangde Hotel in Thamo: Night has fallen. The darkness here is blacker, denser than any I have ever seen—or not seen. By the dim beam of my battery-dying flashlight I make my way to the back door and remove the wooden stave that fits into two cutouts on either side and serves as a bar against intruders. I'm grateful the yard is on this level, so I don't have to descend the shaky ladder leading down to the front entrance. In the yard I walk a few feet to a neat little stone building. A curtain weighted with a wooden rod at the bottom hangs over the front for privacy, and a little metal gate inside keeps the animals out.

I push in the gate, being careful not to fall into the neat rectangle in the wooden floor. And squat, holding onto the stone wall for support with my left hand, and with my right, holding back both underpants and long johns. And people don't want to come to Nepal because of going to the bathroom—when it's such an adventure!

RATING: A - **; E - ***; C - ***; F - ****; V - *

Barbara Alpert

Barbara Alpert took a safari to Africa. Here's her comment on a similar topic.

Basic Bush Bathroom Technique, 1994,
by Barbara Alpert

Except for a week at Girl Scout Camp when I was nine and visited the outhouse by flashlight, I'd never gone to the bathroom outside. But the African safari I'd chosen meant I'd be pitching my own tent nightly and going to the bathroom in the bushes. Could I handle it? I'd have to!

First night in Tanzania, and determined to be an intrepid traveler, I headed for a big stand of shrubbery on the outskirts of our camp-site. I'd stuffed a wad of biodegradable toilet paper in one pocket, tucked a bottle of water under one arm, and carried a toothbrush smeared with toothpaste in one sweaty hand. Spitting a mouthful of Colgate and bottled water on the African landscape seemed a kind of sacrilege, but I quickly realized I had no choice.

Now the tough part—dropping my pants in the open. I peered through the branches, trying to determine if my chosen spot was safe from the eyes of my fellow campers, decided it was, and pre-pared to do the deed. Then it hit me. By facing the camp, I was exposing my naked backside to any creature creeping around in the stand of trees nearby. The choice was clear; better to risk displaying my bare tush to the humans nearby than offer a plump, pale target to a passing lion!

Paulette Cooper

When travel writers get really wild ideas about adventurous travel, they often suppress them reasoning that they're illegal, dangerous, or downright impossible. This next story is one of those, except she did it. Paulette Cooper is a full-time author and journalist, and has written more than 1,000 articles, which have appeared in *The New York Times, The Washington Post, New York, Parade, Cosmopolitan*, and other national publications. She is the author of nine published books, including *The Scandal of Scientology, 277 Secrets Your Dog Wants You To Know, The 100 Top Psychics in America*, and *The Medical Detectives*. She still loves cruise

ships, but now gets to sail them free by writing about them rather than stowing away on them.

Confessions of a Cruise Stowaway, 1971,
by Paulette Cooper

Admit it. If you've ever been on an ocean liner, the thought has crossed your mind at least once that it would be so easy to stow away. You could go aboard as a guest, eat from all the free buffets, sleep in the lounge like the occasional drunks you see who pass out there. After all, a stowaway doesn't have to worry about whether to get an inside or outside cabin. he doesn't have to fight for the first or second sitting. He has no problems with silent tablemates who order every course on the menu and then wash them down with his wine. Yes, the life of the stowaway would be such fun...

The truth is—it's hell! I once succumbed to the fantasy rather than leave it to some other crazy kid to do.

Every stowaway has some trick that he thinks will enable him to get away with it. One man used to board a ship with a phony letter allegedly authorizing him to stowaway to write about the experience. A group of West Indians got on a ship as a band and delighted the passengers with their medleys. No one meddled with them. But they got caught when they all foolishly slept in the same lounge.

I decided that my trick was to be me. I wouldn't hide. I wouldn't try to be inconspicuous. I would make a point of meeting every person on the ship—except, of course, the captain, purser, and master of arms, who have a sharp eye for stowaways. I would wear big fake eyelashes and little low-cut dresses in the hopes that everyone would notice me, and no one would think that I didn't belong there.

Why shouldn't I make it, I reasoned? Even Balboa, who discovered the Pacific Ocean, once stowed away in a crate with his dog in order to escape his creditors. It's true that over a thousand stowaways a year are caught, and they're subject to a fine and/or a year in jail. Stowaways in the dim past have also been flogged, tortured, raped, thrown overboard, left on islands to die, or turned over to sailors to devise their own devious punishments.

This is all I thought of for seven miserable days. Exciting, glamorous, carefree vacation? Forget it! You disintegrate every time someone taps you on the shoulder. You cringe very time someone calls out your name. When an officer looks at you, you know that he

knows—or at least that he may be wondering. There was another stowaway on our Caribbean cruise who was caught three hours after we put out to sea. Unfortunately, I didn't know it. The first day all I kept hearing was the dreaded word "stowaway" and I thought the officers were talking about me.

Delicious free food? Don't count on it. The 10 o'clock bouillon and 4 o'clock tea and pastries were too meager to make a meal, and the buffets were so badly spaced out that you could starve to death in between. (In between, I was forced to eat the setups from bars, and found myself munching onions, olives, orange wedges, maraschino cherries. One starving day, I ate the lemon wedges.)

Restful, relaxing vacation? I slept three hours a night, fully dressed, in a lower deck lounge with all the lights on and with a bumpy patent leather purse for a pillow. My attache case—all the luggage I had—was stuffed in a piano. I almost slept through the movies, but they kept playing a shoot-em-up and I kept waking up during the gunfire.

Lots of fun and games? I joined the ping pong contest to give me something to do besides worrying. I knew, of course, that I would have to be careful not to win, since prizes are delivered to your cabin. Still, I wasn't worried, because it's easier to lose a contest than win one. Unless, of course, you turn out to be the only person who signs up—which happened to me on this trip—and you are declared the winner by default. I refused to accept the prize—a bottle of champagne.

Romance? Yes, I met dozens of men, perhaps because of those low-cut dresses, but they would invariably ask me for my cabin number (maybe because of those low-cut dresses) and I would have to scurry away quickly. Still, I felt it wasn't a total waste socially because I told a few of the men to look me up in the phone book when they returned home. But after I got home, I realized that while I'm listed, I'm not listed under the phony name I used on the ship.

True, I became the only woman I know of to have successfully stowed away in recent times on an ocean liner (a very large, well-known one, which I can't name because I am still open to action). My friends were terribly impressed. My parents were slightly horrified. I was invited to appear on several television and radio programs, but I've noticed that the editor of the Guinness Book of Records has not called me to get the correct spelling of my name.

Still, even though it was a pretty awful experience, it didn't sour me on cruises. In fact, I've been on three of them since I stowed away. But I paid for every one of them!

Claire Walter

The very thought of a spa conjures up images of warmth, comfort, pampering, and plenty of rest and relaxation—hardly an adventurous vacation. Go with Jana, and spas will never be the same.

Claire Walter is an award-winning freelance writer, Western Editor for Skiing Magazine, and travel columnist for Cross Country Skier. She has been author, co-author, or a contributor to a dozen books, including *Skiing on a Budget* (Betterway Books), *Buying Your Vacation Home for Fun and Profit* (Dearborn Financial Publishing), and the second edition of *Rocky Mountain Skiing* (Fulcrum), which won the Harold Hirsch Award for the best ski book of 1992-94. She also won the prestigious Lowell Thomas Award for guidebook writing in 1988, and was named Colorado Freelance Writer of the Year in 1991.

She has skied the major resorts of North America and many of the lesser ones. She has summited Tanzania's Mt. Kilimanjaro and hiked many of the high peaks of Colorado and the Swiss Alps. She also holds Advanced Scuba Certification. A native of Connecticut and long-time resident of the New York metropolitan area, she now lives in Boulder, Colorado, with her husband, Ral Sandberg, and her son Andrew Cameron-Walter.

Jana & Her "Mountain Vimmen", 1994,
by Claire Walter

"Ve are mountain vimmen!" declared the lanky redhead, as we shifted our legs and lungs into overdrive for the march up Ptarmigan Peak. It is nearly five-and-a-half miles each way with a 3,500-foot elevation gain—a good first-day hike for the dozen participants in the four-day Women's Mini Spa at Keystone in Colorado.

The spa director, Jana Hlavaty, bounded up the mountain. Her long lean body was a bundle of energy and athleticism. On her face was etched the big smile which greets strangers. "Hi, I'm Jana" she beams with each introduction. No-one who's met her, watched her, or followed her is likely to forget her.

Jana, an athletic defector from Czechoslovakia when there still was a Czechoslovakia to defect from, was on her native country's cross-country team in 1964, and became the oldest member of her adopted country's Olympic squad at the 1976 Winter Games. A special act of Congress granted her citizenship so she could compete for the US, but nothing could tame her accent or dampen her enthusiasm for getting and staying in shape. She celebrated her 50th birthday by running the Pikes Peak Marathon.

"When we're young, we sacrifice health for wealth," she observes. "When we're old we sacrifice wealth for health. We need to maintain what we have." She dreamed up the notion of a high-energy outdoor-oriented program to preach the healthy lifestyle she espouses: consistent exercise, no red meat, and an otherwise healthy diet. Now in her mid-50s, she is a role model for all of us who are no longer in the full flower of youth. Jana is the essence of a "mountain voman" and she wants each of us to "be vun too."

And so there we were - twelve women from all over the country, ranging in age from early 30s to late 50s, and in shape from very good to nearly sedentary. Joanne, a corporate promotions manager from St. Louis, rollerblades and does aerobics. Terry, a North Carolina real estate agent, works out regularly and was three months pregnant. Mimi, a Connecticut homemaker, plays tennis. Peggy is a California podiatrist, Karen a Salt Lake City insurance agent, and all wanted to rev up their regular fitness routines. Judy had never exercised much but wanted to jumpstart a regime with the Womens Mini Spa. The format caters to each woman's pace, because Jana brings in one or two colleagues each day. With hiking and biking at two or three different levels, everyone's needs can be met. Mimi dropped out after just a day. Judy struggled with the altitude and her own lack of conditioning but continued gamely. She always brought up the rear, but her attitude matched Jana's philosophy.

"You can't expect to drop five pounds in four days," Jana cautioned us at the Wednesday evening orientation session, "but we have to find a way to change our lives. It's important to get started. We'll use every minute of the program. We don't need a Stairmaster. We have the mountains. Rain is no excuse. We are going to make you mountain women." Or, as Jana pronounces it, "mountain vimmen."

Reveille was early—a daily 5:45 wake-up call followed by a fruit-and-carbo breakfast, warmup and stretch, and then on to the day's

activities. Details differ from week to week, but the mix of hiking, biking, and enrichment is similar during each session. Thursday's Ptarmigan Peak hike was especially grueling for the sea-level dwellers and not an easy morning stroll for anyone, and that set the tone. The trail begins with a steep, take-no-prisoners approach, climbs steadily through a great aspen grove and up a series of switchbacks to timberline where the wildflowers show off their summer splendor. From there, it's a long uphill on an intermittent trail.

With only two brief rest stops, the fastest of us reached the top in just under three-and-a-half hours. We unloaded our healthy box lunches from our packs and sat in a hollow just below the summit with a lingering snowfield sparkling just below, and a glorious panorama of the Mosquito and Tenmile Ranges splayed before us. The descent took two-and-a-half hours, but the only rest we got was the short van ride back to Keystone.

We hustled to our rooms for a quick cleanup before a yoga class, and finally a sauna, the steam, or the hot tub to turn that yoga-induced relaxation into absolute enervation. Before we sat down to a low-fat candlelight feast, we had a cooking class under chef Bob Burden, whose healthy recipes sacrifice nothing in refined taste or exquisite presentation. Sleep came easily, as it would every night.

Friday featured a 28-mile bike ride over Swan Mountain Road, up to Copper Mountain, to Frisco for lunch, and back to Keystone. Jana's "vimp alternative" merely eliminated the grind over Swan Mountain. Three of us elected to go easy. It's one thing to power your own body up and down a mountain on a hiking trail. It's another on a bike. You have gears on your side while climbing and gravity on the descent, but you are also muscling the weight of the bike. The optional massage that evening felt like a necessity.

On Saturday morning, we shouldered our packs in Montezuma, a funky mining town up the road from Keystone, for the hike to the ghost town of St. John, a one-and-a-half mile, 500-foot warm-up. We climbed quickly to a vast bowl ablaze with wildflowers and then up a steep-flanked mountain, past summer snowfields, up a gully, and over a saddle between two sky-scraping peaks. Our reward was lunch at a mountaintop lodge. By this time, not even the most committed carnivore would have dared order a burger. We carried our salads and pasta to the sun-dappled deck. The "vimp route" was returning via the gondola. The hardcore elected to walk down.

Sisterhood, camaraderie, and even friendships develop quickly in groups like this, and the parting becomes bitter sweet. On Sunday, after a short morning hike, we had a light lunch at a cafe. As we nibbled on the healthiest offerings, we gazed up at the mountains we'd conquered, and, dare I say it?, looked rather condescendingly at the tourists huffing and puffing after walking up a single flight of stairs. We cast smug glances at each other, exchanged addresses, promised to keep in touch, and swore to Jana that we'd live right and stay in shape. And to a degree, we've done so. After all, "ve ARE mountain vimmen."

Reed Glenn

This last story is for travelers who really hate to go away. Every travel writer experiences at least one trip from hell, when everything that can go wrong does go wrong, several times, and even the occasional bright spot cannot obliterate the awfulness of what's happening. The only thing to do is keep remembering that it will make a great story.

Reed Glenn, a freelance writer and photographer, specializes in travel, especially to Mexico, outdoor recreation, and the environment. She writes a biweekly, nationally distributed column, Earthright, for Knight-Ridder News, and travel stories for such newspapers as the *Denver Post, Dallas Morning News, New York Newsday*, and the *Los Angeles Times*. She has been a writer and columnist for the *Daily Camera* newspaper in Boulder, Colorado since 1985. Her writing and photography have also appeared in *Outside, Esquire, Runner's World, Diversion, Triathlete, Rodale's Scuba Diving, Caribbean Travel & Life*, and other major magazines.

She is the author or co-author of five books, including *The Insider's Guide to Boulder and Rocky Mountain National Park* (now in its third edition), *Frommer's Mexico '92 on $45 A Day, Frommer's Puerto Vallarta, Manzanillo & Guadalajara '92-93*, and *The 10 Best Opportunities for Starting a Home Business Today* (1993). She was awarded the Lente de Plata (Silver Lens Award) by the Mexican Ministry of Tourism for photos and stories on Mexico's people. The 1994 anthology *Travelers' Tales Mexico* includes one of her non-fiction stories. She enjoys cross-country skiing, windsurfing, hiking, scuba diving, world travel, and exploring Colorado. She did not enjoy this trip to Russia.

A Marathon Trip to Siberia, 1993, by Reed Glenn

Steam poured out of the overhead vents and dripped onto the floor of the Aeroflot Ilyushin-86 cabin. I was careful not to trip over the loose carpet balling up in the aisle. The worn seats had little padding and no magazine, emergency instructions, nor sick bag. Everything normally light and plastic on an American plane was heavy metal: tray tables, locks, and air blowers—all old, chipped and repainted metal, giving everything a shabby and oppressive feel. Emergency instructions on the door were in Cyrillic. I sat wreathed in smoke. Because my original window seat was so cramped, I had moved to the roomy bulkhead seat in the smoking section where there was lots of room to stretch—until a group of Mongolian-looking teenagers started a card game on the floor at my feet.

I had been invited as a guest journalist to cover the Siberian International Marathon in Omsk. When I boarded the plane in New York, exotic-looking Slavic and Asian types had waited at the Aeroflot gate. Next to me, two older women with lined faces chatted in Russian. Some women were actually wearing babushkas. I felt superior to all the squeaky-clean American tourists lined up next door at the Delta Airlines flight to Moscow. I was going to Russia with the Russians.

I had decided not to even think about my luggage, which for some reason had never been put on the plane back in Denver. It was to go on another flight that would arrive in New York five minutes after I left for Moscow, to arrive the following day. Unfortunately, that was when I'd be leaving for Siberia.

We arrived in Moscow on the dot of 2 a.m. MST, which was sometime in the Russian afternoon. It was a scene of chaos. Mobs of people were backed up in the customs lines with huge dollies full of suitcases and boxes of appliances, window fans, and toaster ovens. My guide, Sasha (short for Alexander) stood holding a sign with my name on it. He was a handsome, young gynecologist, practicing in a Moscow hospital, and a native of Omsk, Siberia. Then we had to wait three hours to meet Hugh, a British runner, who would compete in the marathon.

Hours later, arriving at the hotel, it seemed we weren't expected. Sasha spent another hour making phone calls as we waited in the lobby, decorated with bad 1960s-style abstract metal art. Two hours later, we checked into one room—only one was ready. I was beginning to understand the origins of Russian Roulette. In the hotel's

restaurant, Hugh and I enjoyed a good meal and relaxed after 36 hours of travel. The meal check came itemizing almost everything separately: two dinner rolls (3 rubles), five radishes in the salad (5 rubles), six cucumber slices in the salad (6 rubles), and so on.

Though our Siberia flight left after midnight, we had to be at the airport at 9:30 p.m. to confirm our flight with "the chief." We arrived at the airport on the dot of 9:30 p.m. and went to a remote area. "The chief," of course, was not there. Finally, a large, mafioso-type car pulled up. It contained "the chief." We got the OK and settled back to wait some more—the ubiquitous Russian pastime. Around midnight, another car took us to a paved field where a few other people sat waiting in their smoke filled cars while an ancient army propeller plane was being loaded.

A jeep was being winched up the rear ramp into the body of the plane. Inside, men were busily loading boxes of Mars and Snickers bars, dining room chairs, mattresses, bed frames, and finally, the very car that had driven us there. With much winching and wedging, the car was finally crammed into cargo hold, which now resembled someone's basement. They finished loading at 2 a.m.

We climbed up a ladder into the plane. The passenger section was an 8-by-10 room. Two bench-like arrangements sat opposite each other, one with two seats, the other with three. They were covered by a white sheet—no seat belts. Three older people sat knee-to-knee across from Hugh and me. Against the plane's other side wall was a cot. Sasha took a spot on it and was soon joined by six others. The entire loading crew filed into the tiny space left, and as the plane taxied down the runway, some of the men standing brought chairs and gasoline cans from the back and sat two to a chair, or one to a can.

Though the outside door to the cargo hold kept popping open, the plane continued to taxi. Faster and faster we sped down the runway. Lights whizzed by, but we never took off. I assumed the plane was too old and too heavy, and we'd just crash in a heap at the end of the runway. Instead, the plane slowed and turned around for another shot. We gained speed and actually took off. I tried to sleep, but flies kept landing on my hands and face, and the roar of the uninsulated plane was like being inside of a vacuum cleaner. One bare light bulb hung from the ceiling, and a procession of flies marched around it, casting shadows on the walls that looked like huge rats. I felt like a

prisoner being sent to exile in Siberia. The cabin grew colder and colder as we flew over the treeless steppes of Siberia. We finally arrived in Omsk after almost seven hours—it was supposed to take three. Because of the Siberian time change, we had missed breakfast and lunch was not for a couple of hours. Dimitri, our host, greeted and welcomed us, and I forced a hello.

Things improved after a few nights' sleep. I learned to ignore the brown water in my bathtub. Everyone I met in Siberia was really friendly. The weather was actually hot—it was August. Because my luggage still hadn't arrived, Dimitri's wife, Ludmilla, lent me a whole bag of clothes, which made me feel like a real Russian. The marathon itself was fascinating, with runners from all over the new republics, some wearing exotic traditional hats. The festivities finally ended with good international relations prevailing. We returned to Moscow on a regular Aeroflot plane, which now seemed like first-class after the cargo plane. By then, I'd had enough of traveling like a Soviet citizen. Unfortunately, I still had a return flight from St. Petersburg, so I decided to change my ticket and go directly home from Moscow.

In Moscow, Sasha and I went first to an Aeroflot office, waited for an hour, and were told there were no seats from Moscow to New York for a month. We rushed to the national travel agency, only to find it closed for lunch with a long line forming outside. We spent an entire day on the subways and trams, going from agency to agency, where we stood in line for an hour only to be told after finally reaching the disinterested agent that we were in the wrong line, they couldn't help us, or to go somewhere else. We even made the arduous journey to the airport—where, at last, I found my luggage—but I still couldn't change my ticket. At this point, Russian Roulette was starting to sound like fun.

Sasha joked: "Would you like to become Soviet citizen? It seems you cannot leave." Something I had read in a guidebook before the trip kept flashing back: "Travel only in organized tour groups in Russia. Individuals receive no attention. Don't try to do anything spontaneous in Russia."

The Muscovites seemed a grim and corrupt lot who had given up on their own system but had no hope of improving it. It was impossible to get anything done. Phones and computers didn't work, so everything had to be done in person. But once you arrived—after

riding crowded buses and subways and walking miles—no one could help, much less care. Most agents seemed concerned only with filing their nails or smoking their cigarettes. Those few who did try to help were faced with the rest of the hopeless system. Finally, we gave up. We took several more subways, trams, and a train, then a mile walk to Sasha's apartment outside Moscow. He and his wife graciously put me up for the night on the sofa bed, and fed me chicken soup and caviar.

The next day Sasha found a policeman friend to drive me to the airport, where I would camp out to try to go standby. At my suggestion, Sasha, a doctor, wrote me a note in Russian saying that I was called home for a family medical emergency. It worked. I got on the plane, which had lots of empty seats. When I arrived back in New York City, I wanted to kiss the ground. Everyone seemed so nice and helpful—even the taxi and bus drivers.

Where to Find Off the Beaten Track Vacations
Adventure Alaska Tours
Alaska Wildland
Archaeological Tours
Bicycle Africa Tours
Call of the Wild
Earthwatch
Expeditions, Inc.
Experience Plus!
Explorations, Inc.
Hawk, I'm Your Sister
Himalayan High Treks
Horse Riding Vacations
Hurricane Creek Llama Treks
International Expeditions
Journeys International
Myths and Mountains
Nature Expeditions International
Nichols Expeditions
Northern Lights Expeditions
Outdoor Vacations for Women Over 40
Overseas Adventure Travel
Victory Chimes Windjammer
Wilderness Travel
Wildland Adventures
WomanTours
Woodswomen Inc.
Yellowstone Llamas

A-Z WHERE TO FIND ADVENTURE VACATIONS

The companies listed alphabetically in this section are qualified adventure companies carefully selected for inclusion because of the high standards they maintain. They have replied to a questionnaire, supplied printed materials, and provided the names of two recent participants, whom I have contacted about their trips. Every organization listed in the book has met specific criteria for quality, experience, and reliability. They:

- offer quality outdoor adventure programs;
- provide qualified leaders;
- have been in business for a reasonable period of time;
- have run successful trips before;
- provide helpful informational material;
- describe exactly what their prices include;
- welcome inquiries and respond promptly;
- list an address and phone in the United States;
- provide names and addresses of recent participants.

ADVENTURE ALASKA TOURS

Discovering Alaska's unspoiled beauty away from crowds of tourists is the goal of this company. You travel in groups of no more than eight people, mingle with the local residents, camp out or stay in cabins, enjoy bed-and-breakfasts and family hotels, and admire some of the most spectacular scenery in North America.

"80% of the time there are more women on the trips than men, whether it's wilderness travel to general sightseeing," notes Todd Bureau, director. "Age range of participants is from 14 to 84, from many countries, all curious to learn why these lands have captured the hearts and imaginations of so many."

The Marine and Mainland Tour visits Anchorage and Fairbanks, with a tour of Denali Park and Wrangell-St. Elias Park, plus a ferry ride to Childs Glacier, and a walk through a ghost town. The Yukon Canoe Adventure spends nine days paddling the river with visits to Dawson City of Klondike Gold Rush fame and the frontier outpost of Eagle. You camp at the base of a glacier and on river islands. The 17-day Overland and Marine Adventure includes hiking, kayaking, and canoeing, as well as travel by van, boat, and train.

Special trips include a winter stay to watch the Iditarod and go dogsledding, sea kayak tours to spot whales, porpoises, and marine birds, and an exploration of untouched Siberia rafting down the Katun River.

Price includes:
Accommodations, equipment, guides, instruction, all meals, pre-trip material, land transportation.

Most popular:
Interior and Coastal Tour, 7 days, $1,925.
Marine and Mainland Tour, 9 days, $2,125.
Inside Passage and Yukon Tour, 10 days, $2,695.

Contact:
Todd Bureau, Director
2904 West 31st Avenue
Anchorage AK 99517
Tollfree: 800-365-7057
Phone: 907-248-0400
Fax: 907-248-0409
e-mail: advenak@aol.com
Women: 80% of time more women than men.
Children: Over 14 only.

Comments:
"Great time on the Iditarod trip! I went dog-sledding for 2½ days—that was wonderful, and why I wanted to go. We stayed with an Alaskan family 90 miles from Anchorage, and went out on snowmobiles at night to watch the race go by."
Woman from California.
"It was truly an adventure in the sense that we were off the beaten path. One of my favorite memories of the trip was the night we camped along the Yukon River and looking at the biggest, fullest moon I've ever seen." Woman on Yukon & Interior trip.

ADVENTURE BOUND RIVER EXPEDITIONS

John Wesley Powell's exploits in the 19th century as he river-rafted through the Grand Canyon in a wooden rowboat were unique. You can experience the excitement of riding the rapids on several of the beautiful rivers of the west with this experienced company. You ride an oared raft, a large pontoon raft with a motor, or paddle your own inflatable kayak through the rapids, the specialty of Adventure Bound.

"Women enjoy all our trips," notes Tom Kleinschnitz, company president. "On most trips we have more women than men."

You can spend a couple of days on the Colorado River in Westwater Canyon, three or four days on the Yampa and Green Rivers in Dinosaur National Monument or Desolation and Gray Canyons, or try a one-day trip through Ruby Canyon. For the more adventurous, ride the wild rapids of Cataract Canyon in May and June when the waves are at their highest.

In the evening, you camp alongside the river. There's time for a leisurely hike up a side canyon to discover hidden waterfalls and ancient carvings. Your suntanned guides whip up delicious meals over a stove while you relax and listen to the noise of the rushing water. Later by the campfire, as the stars sparkle in the sky, you watch the moon rise slowly over the canyon walls.

Price includes:
Guides, all meals, pre-trip material, transportation. Sleeping bags and tents available for rent.

Most popular:
Lodore, Green River, Dinosaur National Monument. 3 days, $450; 4 days, $570.
Desolation, Green River, Desolation & Grey Canyons. 4 days, $600; 5 days, $705.
Cataract, Colorado River, Canyonlands National Park. 2 days, $390; 3 days, $495; 4 days, $600; 5 days, $705; 7 days, $890.

Contact:
Robin Kleinschnitz
2392 H Road
Grand Junction CO 81505
Tollfree: 800-423-4668
Phone: 970-245-5428
Fax: 970-241-5633
e-mail: ab@raft-colorado.com
Website: http://www.raft-colorado.com
Children: 9 years and older is best, though younger children have come on trips.

Comments:
"I most enjoyed roughing it. Guides are fun and friendly, cook for you, and help set up camps. You feel really, really dirty for three days!" Woman on Cataract Canyon trip.

ALASKA WILDLAND

If you arrived in Alaska and visited one million acres a day, you'd need to stay a year to cover the state. That's the kind of statistic that overwhelms first-time travelers to Alaska trying to decide where to go.

Alaska Wildland, in business for over 20 years, believes in giving visitors a first-hand personal experience of the vast state, so they can enjoy the natural wilderness close up. Maximum number of people in a group is 16, and you travel by boat, railroad, and van. You visit beautiful parks, learn about low-impact travel, preservation, and nature, meet local residents, and expand your horizons. You may catch a glimpse of a moose and her newborn twins staring curiously from shore as you raft by, or watch determined red salmon braving steep currents and crashing waterfalls as they swim to ancient spawning beds. On most trips you'll see a range of wilderness creatures. There are 14 different species of whales swimming with porpoises and sea lions in the oceans; brown bears, Dall sheep, moose, and caribou are found in the national parks.

On a 10-day safari with cabin or camping accommodations, you visit Kenai National Wildlife Refuge, Kenai Fjords National Park, Chugach National Forest, and Denali National Park. A more challenging all-tent Camping Adventure, where you can help set up tents and cook meals, includes hikes along the trails of Chugach National Forest and the Wrangell-St. Elias National Park and Preserve, and a walk out on the Root Glacier.

Snow-lovers can join a week-long winter safari. You can try snowshoeing, cross-country skiing, dog mushing, and watch the spectacular Northern Lights. There are also Special Senior Safaris for older active travelers, and Family Safaris for children and parents.

Price includes:
Accommodations, excursions, equipment, guides, instruction, all meals, pre-trip material, transportation.

Most popular:
Cabin Safari, 9 days, $3,095 to $3,395.
Tent and Cabin Safari, 10 days, $2,495 to $2,895.
Alaska Camping Adventure, 10 days, $1,695 to $1,895.

Contact:
Kirk Hoessle or Jim Wells
PO Box 389
Girdwood AK 99587
Tollfree: 800-334-8730
Phone: 907-783-2928
Fax: 907-783-2130
Children: Family Safari, ages 6-11.

Comments:
"Our 12-day Safari was fun, excitement, a discovery and a challenge. We outsiders felt like the insiders. A superlative event in our lives." Couple from New York.

AMERICAN DUDE RANCHES

When I was doing research for this book, I spoke to a woman about her adventure vacation. She enthused about the week she spent out west where she went horse riding, fishing, hiking, and camping for the first time. She loved it!

If you'd like to try western life, one of the easiest ways is a stay at a dude ranch for a week. A dude is an outsider, someone who's not a cowboy! Dude ranches have always existed in the west. Some were working cattle ranches that welcomed visitors, while others were ranch-style places that preferred to look after vacationers instead of cattle. Today, as in the past, dude ranches offer western activities for visitors and provide all the comforts of home. You'll find ranches set in spectacular places, the views stretch to the horizon, and the hospitality is unrivaled.

Ranches can be elegant resorts with golf courses, gourmet meals, and saunas, or low key comfortable family-run places with cabins in the woods and cookouts under the stars. You can choose to stay high in the mountains or on the plains. You can pick a ranch that has room for ten visitors or 110. You can choose horse riding along peaceful trails at most of them, but there are also heated swimming pools, hot tubs, hiking, fishing, river rafting, overnight trail trips, evening activities from square dancing to videos, and great meals. There's no pressure to do anything—if you want to relax on the porch swing all day, no one will mind.

Active working ranches today still raise cattle and sheep, and sometimes llamas or ostriches. That's where you'll meet real cowboys, and may even get the chance to join an authentic cattle roundup. Ask some questions to make sure the place is right for you.

Questions To Ask

Where will I stay?
> Tent camping, cabins, rooms in a lodge, luxury suites?

Where are the bathrooms?

What will I sleep on?
> Double beds, single beds, bunkbeds, camp beds?

Are all the meals included?

What kinds of menus do you offer?

Are there separate tables or do we all eat together?

How many guests can you accommodate?
> This can range from less than 10 to over 100.

What kind of riding is offered?

How long will I ride each day?

I've never ridden before. Can I come?

Do you offer riding lessons?
How many horses do you have?
Do I have to bring any equipment?
 Boots, hats, saddles, bridles, horse grooming?
What clothes do I need?
Are there other things to do besides riding?
 Hiking, swimming, fishing, hunting.
Is liquor offered or can I bring my own?
What entertainment is there in the evening?

Where to Find Ranch Vacations

There are hundreds of ranches around the country ready to welcome visitors. Here's a sampling of good places that meet established standards.

American Wilderness Experience
PO Box 1486
Boulder CO 80306
Tollfree: 800-444-DUDE. Phone: 303-444-2622. Fax 303-444-3999
AWE publishes a dude ranch catalog listing dozens of places to stay in Colorado, Wyoming, Montana, Idaho, Oregon, Texas, Arizona, New Mexico, and British Columbia.

Arizona Dude Ranch Association
PO Box 603
Cortaro, AZ 95652
Write for a free list of 12 Arizona ranches.

Colorado Dude and Guest Ranch Association
PO Box 300
Tabernash CO 80478
Phone: 970-887-3128
Ask for a free directory describing 40 Colorado member ranches.

Dude Ranchers Association
PO Box 471
LaPorte, CO 80535
Phone: 970-223-8440
Ask for the directory of 100 member ranches in 11 Western states and British Columbia, Canada.

Wyoming Dude Ranchers Association
PO Box 618
Dubois, WY 82513
Phone: 307-455-2584
Ask for information about its 34 member ranches.

AMERICAN WILDERNESS EXPERIENCE (AWE!)

Celebrating 25 years of outstanding backcountry adventures, this company specializes in matching you to your perfect outdoors vacation. From horsepacking, hiking, walking, biking, and llama treks to whitewater rafting, canoeing, and sea kayaking—or a combination of adventures—they've tried them all, and picked the best.

"Very often we have more women than men on our trips," notes Dave Wiggins, company president. "The ratio is usually 55% women and 45% men. Women enjoy adventure, and are ready to try new things." He and his staff have been on the trips so don't hesitate to call and ask them anything you need to know.

AWE! produces a special catalog about Old West Dude Ranch Vacations where you can play cowboy to your heart's content. Ride your horse along shady trails with views of mountain peaks, then relax in the hot tub before a delicious home-cooked meal. In the spring and fall, you can even herd the cattle across open country on a roundup.

Water lovers can experience the excitement of whitewater rafting down the Main Salmon River in Idaho, as well as on the Green River and Cataract Canyon in Utah, and the Snake River in Oregon. Combo trips offer hiking, biking, fishing, and rafting in Montana and Utah, or hiking and canoeing inn to inn in Vermont. Walking and hiking trips explore the amazing rock scenery of Bryce, Zion, and Grand Canyon National Parks.

Winter escapes take you to sail in the Caribbean, swim with dolphins in Honduras, explore the hidden beaches of real Hawaii, and hike into Mexico's stunning Copper Canyon.

Price includes:
Accommodations, equipment, excursions, guides, all meals, pre-trip material, transportation.

Most popular:
Horsepack adventures, average $125 to $200 a day, average trip is 5 days. Mountain Sports Week Combo, 6 days, $830 (climb/horseback/mtn bike/raft) Montana Selway-Bitteroot Llama Trekking, 4 or 5 days, $650 to $810.

Contact:
Dave Wiggins
2820-A Wilderness Place
Boulder CO 80301-5454
Phone: 303-444-2622
Tollfree: 800-444-0099
Fax: 303-444-3999
e-mail: awedave@aol.com
Website: http://www.gorp.com/awe
Women only: Wilderness Canoeing in Minnesota Boundary Waters.
Children: Age 8 and older.

ANNAPOLIS SAILING SCHOOL

The boat sails through warm turquoise water as a light breeze blows you toward the shore, and you anchor near dazzling white sand beaches. You've spent the day sailing along Florida's Gulf of Mexico. That evening, after swimming and snorkeling, you relax on deck and watch the sun set in a mass of coral-tinted clouds.

Annapolis Sailing School, the oldest and largest sailing school in America, has a special program called Sea Sense for women only, as well as many programs for women and men. More than half of the Sailing School students today are women. Most popular trips are five- or seven-day cruising vacation courses in Annapolis, St. Croix in the Virgin Islands, or Florida. There are also weekend courses, and a Kid Ship Sailing School for children aged 5 to 15, co-ordinated with adult classes so families can learn together.

"We developed a simple, effective way to teach beginners to sail, and refined the techniques over the years," notes Jerry Wood, who founded the school in 1959. All courses meet or exceed the U.S. Sailing Association's keelboat certification standards, and instructors are certified by U.S. Sailing. All live-aboard cruising instructors are licensed by the Coast Guard. The school has over 100 boats, and has taught more than 130,000 students.

The all-woman Sea Sense program, run by founder-owners Captain Carol Cuddyer and Captain Patti Moore, offers week-long courses year-round.

Price includes:
Accommodations (depends on course), equipment, instruction, some meals, pre-trip material. Prices vary according to location and size of boat.

Most popular:
"Become a Sailor in a Weekend" $225: $205 additional person.
Cruising Courses, 5 days, $900 to $1,425.
Learn to Sail, 2 days, and Cruise Vacation, 5 days, $1,313 to $1,495.

Contact:
Rick Franke or Dinah King
PO Box 3334
Annapolis MD 21403
Tollfree: 800-638-9192
Fax: 410-268-3114
e-mail: annapway@clark.net
Women only: Sea Sense Programs.
Children: Minimum age 5.

Comments:
"What did I learn? Self-reliance. I can singlehand our boat now, and at last I feel confident that I could sail us home safely." Woman on cruising course.
"The offshore trip was excellent. It exceeded my expectations—not only did I learn a lot, but I had fun, made friends, and know for sure that the sea is in me. I'll never be the same." Woman on sailing course.

ARCHAEOLOGICAL TOURS

On a tour of Egypt, you cruise on the Nile to the Temple of Horus at Edfu, the most perfectly preserved ancient Egyptian temple in existence today. In China, you explore the five sacred Taoist mountains and visit Buddhist grottoes and caves. You relive the history of Greece by visiting Olympia, Crete, and Santorini, whose civilization was destroyed by a volcanic explosion in 1500 BC. In Vietnam and Cambodia, you learn the ancient legends of dragons and kings recreated in impressive monuments and traditional festivals.

Excursions with Archaeological Tours are a mixture of adventure and history. The company has been arranging specialized tours for 26 years. Most of the time the trips have more women than men, and women enjoy the learning aspects of the vacations. All the trips are led by distinguished scholars who stress the historical, anthropological, and archaeological significance of the areas visited. These scholars are not only well-informed, but chosen for their ability to communicate and share the experience of discovery.

"We believe that our tours should be both memorable and joyful," notes Linda Feinstone, president. "When you travel to foreign lands, you should not be isolated from the inhabitants, so we choose the best available accommodations in the mainstream of local life." Among dozens of programs are tours to Guatemala, Turkey, Yemen, Tunisia, Morocco, Sicily and Southern Italy, Indonesia, Malta, Sardinia, and Corsica.

Price includes:
Airfare from US, accommodations, excursions, guides, instruction, most meals, tips, pre-trip material, transportation, fully escorted trips.

Most popular:
The Splendors of Ancient Egypt, 20 days, $3,720, plus airfare.
Turkey: Anatolia, Crossroads of Europe & Asia, 21 days, $3,085, plus airfare.
Sicily & Southern Italy, 17 days, $3,565, plus airfare.

Contact:
Linda Feinstone, President
271 Madison Avenue, Suite 904
New York, NY 10016
Phone: 212-986-3054
Children: No young children.

Comments:
"We've taken at least ten trips with Linda. We never travel with anyone else, and can recommend her trips highly. One of the most difficult—and one of the most rewarding—was to Ethiopia. We spent a lot of time with the people of Northern Ethiopia who were very open and friendly. I'm an amateur archaeologist, and my great love is Egypt, so we're going to Sinai next time." Couple from Canton, Ohio.

BICYCLE AFRICA TOURS

Since 1975, David Mozer has been bicycling in Africa. He was a Peace Corps Volunteer in Liberia, spent two years teaching math and science, visited isolated villages directing an education extension program, and then explored the rest of West Africa.

In 1984 he established the International Bicycle Fund, a non-profit organization to encourage cross-cultural bicycle tours of Africa. He offers several two-week trips a year to Zimbabwe, Ethiopia, Eritrea, Mali, Uganda, Tanzania, Tunisia, Burkina Faso, Togo, and Benin.

"We specialize in soft adventure for people who want to learn more about Africa as well as see the beautiful sights," notes Mozer. "The program is ideal for the realist who appreciates the diversity in the world and the wonderful rewards to be gained from the modest rigors of bicycle touring." The terrain is paved and dirt roads, and groups cover about 40 miles a day. Overnight stays are in hotels and rustic traditional village housing, with opportunities to meet interesting local people.

In eastern Zimbabwe, the Mashonaland tour visits national parks, development programs, cave paintings, and the Great Zimbabwe ruins. In Zimbabwe's Matabeleland, you visit Victoria Falls National Park, take a raft ride, and see schools, a daycare training program, and an organic farm. In Tanzania, you ride from the tropical coast to the interior and climb Mount Kilimanjaro. In Uganda, from Kampala you ride to Kibale National Park to observe a variety of primates, and then ride along the Rift Valley Escarpment, and through the scenic mountains of the Buhoma-Kabale area.

Price includes:
Accommodations, excursions, guides, instruction, most meals, pre-trip material, transportation.

Most popular:
Zimbabwe Mashonaland, 15 days, $1,090.
Sahel Journey: Mali, 15 days, $1,290.
Tunisia Historic North, 15 days, $1,090.

Contact:
David Mozer
4887 Columbia Drive South, #H6
Seattle WA 98108
Phone: 206-767-0848
Fax: 206-767-0848
e-mail: intlbike@scn.org
Website: http://www.halcyon.com/fkroger/bike/bikeafr.htm
Women: About 75% of trips have more women than men.
Children: Older teenagers best

Comments:
"Thank you for the greatest experience of my life." Woman of 73.
"What we learned and what we saw and who we met are extraordinary for a tour. Thanks!" Woman from California.

CALL OF THE WILD

Carole Latimer has been a wilderness leader since 1978. Her Berkeley-based company offers day hikes, weekend escapes, and backpacking trips in California, with a few in Arizona and Alaska. The trips vary from easy hikes along the beach to observe northern elephant seals, to a 42-mile backpacking trip that climbs to the summit of 14,495-foot Mount Whitney, to a winter visit to Alaska for the Iditarod dog sled race, with snowshoeing, skiing, and snowmobiling.

There are also pre-trip classes for beginning backpackers, covering such topics as selecting lightweight gear, layering clothing, packing for a trip, purifying water, reading topographical maps, environmental awareness, and other essentials.

She believes good food and comfortable sleeping are an essential part of enjoying the outdoors. Her experiences led her to write *Wilderness Cuisine*, a popular cookbook that features Havasu Watercress Salmon and Thai Tom Yum soup. She's also an expert on how to take a hot shower using black garbage bags, ways to use nylon window screens as dish drainers and pot scrubbers, and always takes a headlamp instead of a flashlight so both hands are free.

Price includes:
Accommodations, equipment, excursions, guides, instruction, all meals, pre-trip material, transportation, and special items—flightseeing, yoga.

Most popular:
California: Mt. Tamalpais: Cataract Falls, 1 day, $25.
California: Backpacking Yosemite Backcountry, 3 days, $225.
Arizona: Grand Canyon South Rim Hike, 5 days, $695.

Contact:
Carole Latimer
2519 Cedar Street
Berkeley CA 94708
Tollfree: 800-742-9494
Phone: 510-849-9292
Fax: 510-644-3811
Women: All trips for women only.
Children: No.

COLORADO RIVER OUTFITTERS ASSOCIATION

More than 300,000 enthusiasts raft on Colorado's rivers every year. The Colorado River Outfitters Association (CROA) was created to help you choose the right trip.

Call or write and they'll send you a descriptive brochure about 45 different companies that lead raft trips in the state, with complete information on what's available and how to get in touch with them.

Contact:
Colorado River Outfitters Association
PO Box 1662
Buena Vista CO 81211
Phone: 303-369-4632

Among the listings:

American Adventure Expeditions in Buena Vista, Colorado, offers mild to wild river rafting as well as mountain biking, rock climbing, and kayaking trips.

Canyonlands Field Institute in Moab, Utah, a non-profit educational institution, offers raft, canoe, and inflatable kayak trips on the rivers of the Colorado Plateau with whitewater and serene canyons.

Bill Dvorak Kayak and Rafting in Nathrop, Colorado, offers rafting trips on 10 major rivers, plus instructional clinics. Try a combination trip with mountain biking, horseback riding, and visits to hot springs.

Mountain Waters Rafting of Durango, Colorado, offers challenging trips on the upper Animas River that require a physical fitness test for participants.

Scenic River Tours in Gunnison, Colorado, in business 18 years, takes you rafting on the Taylor, Gunnison, Arkansas, and Rio Grande as well as float fishing and on family outings.

Centennial Canoe Outfitters in Aurora, Colorado, is an exclusive canoe outfitter, specializing in guided trips for 2, 3, or 6 days on relatively peaceful sections of western rivers. No previous canoeing experience necessary.

Canyon Marine Whitewater Expeditions in Salida, Colorado, offers day trips from Denver and Colorado Springs to raft the rapids of the Royal Gorge or Browns Canyon on the Arkansas River. Excursions depart twice daily. You can also go float fishing for trout.

Pagosa Rafting Outfitters in Pagosa Springs, Colorado, offers rafting in southwestern Colorado on the San Juan, Piedra, Conejos, and Upper Animas rivers. They also run jeep tours of ghost towns and mines, hot air balloon rides, and, in winter, dog sledding, sleigh rides, and ski tours to cliff dwellings.

RIVER RAFTING PACKING LIST:
Where everything gets wet

Gear:
Camera at your own risk (take
 a disposable camera)
Sleeping bag
Lightweight tent
Air mattress or foam pad
Pillow
Flashlight
Day pack

Clothing:
Sunglasses with string
Hat with string
Handkerchief or bandanna
Raincoat, poncho, or rain suit
Jeans, sweat pants, and shorts
Swim wear
Shirts
Tennis shoes, or river sandals,
 or wetsuit booties
Dry camp shoes for evening or
 hiking
Socks, underwear
Sweatshirt, sweater, warm
 jacket

Personal Items:
toothbrush
toothpaste
soap
towel
Kleenex
shaving gear
comb
washcloth
mirror
sunscreen
suntan lotion
lip balm
insect repellent
medication as necessary
cash—pocket money for re-
 freshment stops, and tips
 for guides

How to Pack:
Wrap clothes and all your belongings in separate waterproof bags,
and put everything in a duffel bag lined with a plastic trash bag, or
a waterproof river bag. Make sure your total baggage is less than
40 pounds. Line your daypack with a plastic trash bag, and keep in
it what you need during the day. You won't be able to get to your
duffel bag once it's packed in the raft and you're on the river dur-
ing the day.

Leave at Home:
Equipment that has to stay dry
Valuable jewelry
Your best clothes
Your worries

COUNTRY WALKERS

Walking vacations in beautiful countryside with gourmet meals, and overnights in comfortable inns and hotels to recharge your energies are the specialty of this company, in business for 18 years. Many of their participants return year after year.

"People travel with Country Walkers for the sheer joy of it," say owners Bob and Cindy Maynard. "We strike a balance between leading you, and leaving you to find adventure."

In the United States, walks take you along the coast of Maine, the tree-shaded lanes of Vermont, and into the canyons in Utah and Arizona. In Europe, you can stroll through Italian hill towns, explore the wine country of Burgundy, or visit thatched cottages in the Cotswolds. Winter escapes include walking in the rainforests of Costa Rica, along flower-lined trails on Maui, or on New Zealand's glaciers, beaches, and mountains.

New trips include an Italian walking tour where you also learn how to make mouth-watering Tuscan dishes, a walking safari in Africa's Serengeti, and an Alaska trip with stops at the Alaska Coastal Wildlife Sanctuary, a cruise in the Kenai Fjords National Park, and a visit to a glacier.

Price includes:
Accommodations, guides, instruction, most meals, pre-trip material, transportation.

Most popular:
Italy: The Tuscan Miracle, 8 days, $2,150.
Peru: Sacred Valley of the Incas, 10 days, $2,550.
Italy: Tuscan Cooking Trip, 7 days, $2,600.
England: Cotswolds, 7 days, $1,850.

Contact:
Heather Killingbeck
PO Box 180
Waterbury VT 05676
Tollfree: 800-464-9255
Fax: 802-244-5661
e-mail: ctrywalk@aol.com
Women: More women 70% of the time.
Children: Age 12 and older welcome.

Comments:
"First time I'd done this, and it was more strenuous than I anticipated, but the group was excellent with great spirit. Loved the experience of being away from crowds, and came back with a real sense of achievement." Woman on Inca trek in Peru.
"What an experience! I will most remember our midnight canoe trip to Lake Moeraki, sunbathing in a creek at the base of Rob Roy Glacier, and the walk and helicopter ride on to Fox Glacier." Woman on New Zealand walk.

CROW CANYON ARCHAEOLOGICAL CENTER

Adventures in archaeology are offered at Crow Canyon. Set on a scenic 70-acre campus in southwestern Colorado near Mesa Verde National Park, this is one of the richest and most significant archaeological regions in America.

You go out in the field with professional archaeologists, working with a trowel and whisk broom to remove artifacts for analysis, and also in the lab where you wash, sort, analyze, and catalog artifacts. On-going excavations focus on Yellow Jacket Pueblo, the largest known village in the region. There's also a full-day tour of Mesa Verde National Park.

Special programs include "Faces of Women," examining women's lives through time and across cultures, led by a Native American Puebloan professor, Dr. Tessie Naranjo, who introduces women from the Navajo and Pueblo communities; weekend and summer workshops for educators; schools programs for children; Family Week, where adults and children work together; a study of Southwestern and Native American cuisine; and a visit to the Southern Ute Reservation to meet with tribal elders, spiritual leaders, and artisans to learn about their traditions and art forms.

The original center was established in 1968 by Edward and Joanne Berger. Today about 4,000 students a year participate in programs, and there's a staff of about 50. You stay in log hogans with showers, or in the lodge, and enjoy delicious meals.

Price includes:
Accommodations, equipment, excursions, guides, instruction, all meals, transportation.

Most popular:
Archaeological Excavation, 1 week, $795.
Family Week: Adults $795, Children (grade 7 and up), $475.
Cultural Explorations, 1 week, price varies with program.

Contact:
Lynn Dyer
23390 County Road K
Cortez CO 81321
Tollfree: 800-422-8975
Fax: 970-565-4859
e-mail: alr@csn.org
Women: Frequently have more women than men.
Children: 4th through 12th grades.

Comments:
"The level of research, skill, knowledge, and enthusiasm were exceptional. My least favorite part was the heat and the gnats!" Woman at Woods Canyon dig site.
"Everyone and everything was so wonderful. I learned so much. I enjoyed the digging and the tours. Everything surpassed my expectations!"
Woman at Yellow Jacket dig site.

EARTHWATCH

Founded in 1972, Earthwatch offers women and men the opportunity to work alongside eminent scientists and scholars on active research projects around the world for one or two weeks. Its over 35,000 members worldwide include educators, retirees, artists, engineers, craftspeople, technicians, and students among many others.

Earthwatch receives hundreds of proposals every year from scientists and scholars seeking help with their research. All projects are carefully evaluated, and those selected are listed in the Earthwatch Expeditions Catalog. To date, Earthwatch has been involved in 1,920 projects in 118 countries. More than 40,000 volunteers, known as the EarthCorps, have contributed over $31 million as well as 5,800,000 hours on environmental problems around the world.

The range of projects is mind-boggling. You track snow leopards in the Himalayas, uncover Aboriginal history in Australia, monitor wild dolphin societies in Florida, track black rhinos in Zimbabwe, and capture and study hawks in Michigan. In Kentucky, you walk through the dark, narrow corridors of Mammoth Cave searching for human remains dating back 4,000 years. In Europe, you hike or cross-country ski through the Forests of Bohemia to collect information on the effects of acid rain. In Tanzania, you net and band birds, check on insect supply, and monitor changes in light, temperature, and humidity to see how humans have affected the forest birds.

Price includes:
Accommodations, equipment, excursions, guides, instruction, all meals, pretrip material, transportation.

Most popular:
Costa Rican Sea Turtles, 10 days, $1,695.
Exploring Dolphin Intelligence, 1 week, $1,295.
Black Rhinos in Zimbabwe, 10 days, $1,995.
Mallorca Archaeology, 2 weeks, $1,795.

Contact:
Blue Magruder
680 Mount Auburn Street
PO Box 9104
Watertown MA 02272-9104
Tollfree: 800-776-0188
Phone: 617-926-8200
Fax: 617-926-8532
e-mail: info@earthwatch.org
Website:http://www.earthwatch.org
Women: Groups evenly split between women and men.
Children: 16 and over.

Comments:
"The dolphins were funny, charming, and full of joie-de-vivre."
Woman on dolphin project.
"Forests of Bohemia allowed me to understand relationships among politics, the environment, and the history of the region. Unforgettable experience!"
Woman on Bohemia project.

ECHO: THE WILDERNESS COMPANY

Echo has been running the rivers for 25 years. When they expanded and found themselves running trips on 18 rivers in five states, they decided that it was not fun any more. They now offer trips on five rivers and emphasize hands-on high quality in everything they do.

First-timers can start with a weekend ride down the Tuolumne River or the South Fork of the American in California, with great scenery and exciting whitewater. Oregon's Rogue River is a perfect family run, passing through Oregon's Coast Mountain Range with historic sites, wonderful views, and plenty of wildlife. The more challenging trips are on Idaho's Main Salmon and the Middle Fork of the Salmon. Crystal clear water, exhilarating rapids, great trout fishing, natural hot springs, and stunning scenery are everywhere. You may see deer, bear, bighorn sheep, and moose, and even a recently reintroduced wolf. Combine both the Salmon trips for an 11-day rafting adventure. Wildest rides are usually in the spring when the runoff is highest, and calmer ones in late summer.

Special guests on rafting trips include Rex Foster playing contemporary Texas folk music down the river, the Rogue String Quarter giving classical concerts, and a "Bluegrass on Whitewater" trip with Laurie Lewis and Tom Rozum's fiddle, guitar, mandolin, and songs.

Price includes:
Accommodations (camp out), equipment, excursions, guides, instructions, most meals, pre-trip material.

Most popular:
Middle Fork of the Salmon, 4, 5, or 6 days, $855 to $1,300.
Rogue River, 3, 4, or 5 days, $600 to $700.
Main Salmon, 5 days, $900.

Contact:
Joe Daly
6529 Telegraph Hill
Oakland CA 94609
Tollfree: 800-652-3246
Phone: 510-652-1600
Fax: 510-652-3987
e-mail: echo@echotrips.com
Website: http://www.echotrips.com
Women: Some years schedule trips for Women-Only or Mother/Daughter.
Children: Minimum age 7; 12-14 on some rivers.

Comments:
"The trip was fantastic. This was the first time I went camping, let alone river rafting, and I enjoyed every minute." Woman from Larchmont, California.
"I liked everything about this trip. It was one of the best vacations I've ever had. The weather was perfect, the guides outstanding, the scenery was breath-taking, and everyone got along great." Woman from Kirkland, Washington.

EXPEDITIONS, INC.

Rafting down the Grand Canyon is the adventure of a lifetime, and Dick and Susie McCallum, expert river rafters, are specialists in this region.

"I've been down the canyon in everything from a kayak to a 30-foot raft, and each trip has proved to be a rich, rewarding new adventure," notes Dick.

You can raft from Lee's Ferry to Lake Mead, 226 river miles, which takes 12 to 14 days. You can take a shorter trip and raft 87 river miles to Phantom Ranch, where you hike out of the canyon. Or you can hike into the canyon at Phantom Ranch, and raft the second part of the trip to Lake Mead, for eight or nine days.

Along the way, you may see bighorn sheep, deer, birds and reptiles, as well as prehistoric Indian sites on side hikes along the way. You learn the history of the canyon and those who tried to run it. You notice the contrast of vegetation, from desert cactus on the canyon slopes to cottonwoods and lush ferns beside waterfalls and creeks in side canyons. You pass rocks billions of years old, and high canyon walls stretching up to the sky.

The McCallums' oar-powered and paddle boats are 18 feet long, and have Dick McCallum's custom-made aluminum frames, as well as multi-inflatable air chambers. They're called oar boats when rowed by a boatman, and paddle-boats when passengers with paddles run the boat. Kayaks are also available for qualified boaters.

Price includes:
Accommodation (camp out), equipment, guides, all meals, pre-trip material.

Most popular:
Lee's Ferry to Phantom Ranch, 5 days, $1,000.
Phantom Ranch to Lake Mead, 8 days, $1,650.
Lee's Ferry to Lake Mead, 12 days, $2,050.

Contact:
Dick or Susie McCallum
625 N. Beaver Street
Flagstaff AZ 86001
Phone: 520-779-3769
Fax: 520-774-4001
e-mail: expedGC@aol.com
Women: Usually 50% women, 50% men.
Children: 12 or older.

Comments:
"A month has passed since we went down the river with you. I feel I'm still riding on the crest of those rapids. It was the ultimate experience for me." Woman on 13-day trip.
"The boatmen made the trip special. We loved them all. The food was excellent, each of us gaining weight. Thank you all for this fabulous trip." Woman on 5-day trip.

EXPERIENCE PLUS!

Rick and Paola Price began leading bicycle tours to Italy in 1972. Today, they offer cycling and walking tours in Europe, Costa Rica, and the United States. They pedal every route, stay in every hotel, and eat every meal on the itinerary: "We feel that the only way to deliver a quality product is to put a part of yourself in it. We emphasize great routes, great food, and comfortable, well-located hotels."

Days begin with a breakfast briefing to check the schedule that was discussed at the evening dinner. A leader rides ahead to mark the route with chalk arrows. The van takes luggage ahead and returns to follow the group. You travel at your own pace. When you arrive at the hotel, there's dinner, evening activities, and a briefing on the next day's events. Individualists can opt for self-guided tours with pre-designed itineraries. Every group has different levels: about a quarter are avid cyclists or walkers, a quarter beginners, and the majority active intermediates ready for the challenge of something new.

On the tour of Venice—classified as "flat as a pancake!"—you bike to nearby fishing villages and historic villas, enjoy a wine-tasting in a castle, and ride beside the canals. There's a bike trip across Italy from Pisa to Venice with stops at Leonardo da Vinci's birthplace, a tour of Florence, and a visit to the mosaics in Ravenna. In France, you can cycle in the chateaux country of the Loire Valley. Winter trips include cycling in Costa Rica to see butterflies, volcanoes, and beaches.

Walking programs explore the canyons of Utah and Colorado, the Oregon coast, southern France, Italy's Tuscany, and the delightful Italian seaside villages of the Cinque Terre.

Price includes:
Accommodations, equipment (21-speed bicycle), excursions, guides, most meals, tips, pre-trip materials, luggage shuttle, and Sag wagon.

Most popular:
Italy: Bike across Italy, Venice/Pisa, 12 days, $2,150.
Italy: Venice to Florence, 8 days, $1,495.
France: Provence & South of France, 11 days, $2,095.

Contact:
Jake Hartvigsen & Lynne Howard
1925 Wallenberg Drive
Fort Collins CO 80526
Tollfree: 800-685-4565
Phone: 970-484-8489
Fax: 970-685-4565
Women: About 70% of time more women than men on trips.
Children: Teenagers or children able to bike/hike with parents.

Comments:
"When our friends suggested a cycling trip, I almost fainted. I hadn't been on my bike for four years! So I spent a month getting in shape. Your trip was perfect for me—I biked all 160 miles! I thoroughly enjoyed the experience. I challenge another 53-year-old woman to take the leap!" Woman from Illinois on Portugal bike trip.

EXPLORATIONS, INC.

This company takes small groups to explore the Amazon jungle in Peru on foot or by water, and to the mountains of the Andes and the Sacred Valley of the Incas on discovery adventure tours led by knowledgeable local guides.

"While no trip to the rainforest is for the faint-hearted, you do not have to be a wilderness camper or marathon hiker as it is not a physically difficult trip," notes Charlie Strader, company president. "You are not going to a modern man-made theme park; there sometimes is rain and mud in a rainforest."

On safari, you stay in jungle lodges deep in forest reserves. You climb 100 feet high to observe the rainforest from the perspective of the treetop canopy walkway, a quarter of a mile long. You hike along the Medicine Trail, which shows the local rainforest plants now used in modern medicine today, and see spectacular native birds as well as dazzling orchids.

The week-long Amazon cruise travels more than 650 miles from Iquitos, Peru, along the world's largest river to admire the wildlife and vegetation along the way to Leticia, Columbia, and Tabatinga, Brazil, with visits to native villages. You see pink and grey freshwater dolphins at play, and take excursions at night to see nocturnal wildlife.

Price includes:
Airfare from Miami, accommodations, excursions, guides, instruction, most meals, tips, pre-trip material, transportation.

Most popular:
Amazon Jungle Safari, 8 days, $1,895.
Amazon Jungle Cruise, 8 days, $1,895.
Andean Inca Exploration, 8 days, $1,695.

Contact:
Charlie Strader
27655 Kent Road
Bonita Springs FL 34135
Tollfree: 800-446-9660
Phone: 941-992-9660
Fax: 941-992-7666
e-mail: cesxplor@aol.com
Women: Often have more women than men on trips.
Children: 12 years and up welcome.

Comments:
"We saw 110 species of birds, snakes, monkeys, and so much more. The canopy walkway was unbelievable—went up three times and felt totally safe." Woman from Florida.
"Pictures can't do it justice. It was better than I ever imagined it would be. We lived pretty much the way the natives lived - no electricity, only lanterns, and outdoor showers—and it was all part of the experience." Woman from Minnesota.

HAWK, I'M YOUR SISTER

Beverly Antaeus founded this company to teach women how to feel at home in the wilderness on canoeing trips.

"Learning the language of an unfamiliar place is the first step toward feeling competent and comfortable there," she notes. "We aim to teach you the language of forests, canyons, deserts, rivers, lakes, and the sea. We will teach you how to read the water and the sky, to camp safely and with low impact, to cook delicious and nourishing meals in any weather."

You canoe Montana's Upper Missouri River and follow the route of the Lewis and Clark expedition and Sacagawea, the Shoshone heroine of the explorations. You camp along the river, and see grass and tree-covered islands that shelter wildfowl and fawns, and the majestic formations of the White Cliffs. Day hikes explore the Missouri Breaks to spot bighorn sheep, antelope, elk, grouse, and coyotes.

Beverly and Sharon Olds lead a Writing Retreat where participants canoe 46 miles down the Missouri River from Great Falls to Judith Landing. There's also a land-based writing retreat at Heron Lake, New Mexico, led by Deena Metzger, where you can canoe on the lake.

Other trips visit Peru to explore the Peruvian desert, the Ballesta Islands, and take a train ride to the Lost City of Machu Picchu. In Russian Siberia, you canoe along the Armu River, enjoy warm welcomes at riverside villages, and admire the unique scenery.

Price includes:
Depends on trip. River trips include accommodations, equipment, guides, instruction, all meals, pre-trip material, transportation.

Most popular:
River Journeys, Montana and Utah, 9 days, $1,095.
Writing Retreat/Canoe Trip, Missouri River, Montana, 7 days, $1,495.
Peru: Ocean and Andes, 14 days, $2,820.

Contact:
Beverly Antaeus
PO Box 9109
Santa Fe NM 87504-9109
Phone: 505-984-2268
Women: All trips for women only.
Children: Late teens only, or on custom family trips.

Comments:
"I'd never camped, canoed or done outdoors activities, even as a child. Then I took Beverly's trip on the Missouri. I fell in love with it! I've taken five trips with her. It's superbly run and the greatest experience of my life."
Woman from Newton, Massachusetts.

HIMALAYAN HIGH TREKS

Effie Fletcher takes small groups on treks in Nepal, India, Tibet, Sikkim, and Bhutan. Trips are rated gentle, moderate, or strenuous, and pre-trip material suggests ways of getting into shape before you go. The tours emphasize cultural awareness of those who live there, and environmental responsibility about tourist impact. All trips are led by local guides with an American leader with First Aid training.

The Essential Everest expedition, rated gentle/moderate, provides a superb introduction to the diversity of Nepal. You have time to experience the ancient Hindu culture with a stay in the Kathmandu Valley, then travel into the mountains and hike to Namche Bazaar and to Tengboche monastery at over 12,000 feet. All nights are spent in comfortable guest houses.

The Annapurna Circuit, rated moderate/strenuous, and aimed at experienced hikers, is a month-long trek around Annapurna. You walk along old Tibetan-Nepalese trade routes, meet different ethnic and religious groups, stay in locally owned guest houses, and climb to the Thorung La pass at 17,800 feet.

In addition, you can take add-on trips to Royal Chitwan National Park to see elephants, rhinoceros, and tigers; drive from Lhasa to Kathmandu through spectacular mountain scenery; and tour Bhutan to see the beautiful Paro Valley and major monasteries.

Price includes:
Accommodations, equipment, excursions, guides, instruction, most meals, pre-trip material, transportation.

Most popular:
Nepal: Everest Classic, 34 days, $1,800.
Nepal: Annapurna Circuit, 30 days, $1,700.
India: Zanskar/Ladakh, 35 days, $2,600.
Nepal: Everest Spring, 24 days, $1,650.

Contact:
Effie Fletcher
241 Dolores Street
San Francisco CA 94103-2211
Tollfree: 800-455-8735
Phone: 415-861-5390
Fax: 415-861-2391
e-mail: effie@well.com
Website: http:/www.well.com/user/effie
Women: About 60% women on trips.
Children: 12 years and up with hiking and travel experience.

Comments:
"It wasn't an especially hard climb, but when you got up there, you could see Everest and Lhotse, and I felt on top of the world."
Teenager from California after climbing Gokyi-Ri, 18,000 feet.

PACKING LIST FOR EVEREST TREK
Foot Gear:
Hiking Boots. These can be lightweight; but medium weight leather boots are better. They must fit well and be broken in before the trek!

Sneakers or running shoes

Flip-flops (plastic thongs) for use in showers (don't go barefoot in Asia!) or sport sandals

Warm slippers or down boots

Clothing:
Windproof and waterproof hooded jacket and pants

Very warm down or synthetic jacket

Wool or acrylic fleece sweater

Gloves or mittens and a scarf

A light hiking hat with brim for sun protection

A warm hat

One or two light-weight long sleeved shirts

Two or three t-shirts

Two pairs of polypro, thermax, wool, or silk long underwear tops and bottoms

Three pairs of outer socks, thick wool

One or two pairs of lightweight long pants or skirts (you can't wear shorts in monasteries)

Two medium plastic bags to organize clothes, etc.

Four or more pairs of underwear

Bandannas

A clean set of clothes to wear in Kathmandu

Bathing suit

HORSE RIDING VACATIONS

People who like horses enjoy taking a vacation with them. There are plenty of options. You can choose to stay in one place at a dude ranch with horses, and ride daily. You can take classes and courses in Western or English riding. You can explore the canyons of Arizona and the high country of Colorado viewing the scenery from the saddle. You can take an adventurous safari in Africa or a gallop across the plains of Mongolia. You can trot along the beach by the ocean, or under shady trees in an Indiana national park, or alongside a peaceful lake in Vermont.

Horse Riding Vacation Companies:

American Wilderness Experience, AWE!
PO Box 1486
Boulder CO 80306
Tollfree: 800-444-DUDE
Phone: 303-444-2622
Fax: 303-444-399

Listed earlier in the book, this experienced adventure travel company recommends a wide range of horse-packing and ranch vacations in a variety of places. Call for a free catalog.

Bar H Ranch
PO Box 297
Driggs ID 83422
Tollfree: 800-247-1444
Phone: 208-354-2906
Fax: 208-354-8804.
Contact: Edie Harrop

Horsepack and trail riding trips for women, or ranch stays are the specialty here. Edie Harrop is the third generation to work this 500-acre ranch on the Idaho side of the Grand Tetons with spectacular views of peaks and glacial lakes. You take trail rides in the high country from base camp, help with the ranch work, or just relax, hike, fish, or sightsee.

Boojum Expeditions
14543 Kelly Canyon Road
Bozeman MT 59715
Phone: 406-587-0215
Fax: 406-585-3474
e-mail: boojum@mcn.net

If you're ready to try something new and have a strong sense of adventure, Boojum offers challenging trips to such places as Mongolia, China, Argentina, and Venezuela. Led by Linda Svendsen, these adventures can be the trip of a lifetime. Call for free catalog.

Equitour
Box 807
Dubois, WY 82513.
Tollfree: 800-545-0019
Phone: 307-455-3363
Fax: 307-455-2354

An established horse vacation company, Equitour offers over 60 riding tours in North America and in many countries, including Argentina, England, France, Ireland, New Zealand, and Tanzania. Vacation at Bitterroot Ranch in Wyoming, their headquarters, in an untouched wilderness area. Call for free catalog.

FITS Equestrian

In 1997 merged with **Eqitour** (see previous entry.)

Warner Guiding and Outfitting Ltd.
Box 2280
Banff, Alberta, Canada T0L 0C0
Phone: 403-762-4551
Fax: 403-762-8130

Offering a wide variety of rides for 34 years, you explore the mountains and dramatic scenery of the Canadian Rockies on either an Adventure Expedition ride into isolated areas of Banff National Park with camping out, or day rides from lodge-based vacations.

HOSTELLING INTERNATIONAL

American Youth Hostels are great places for women to stay when they travel because these are inexpensive, safe, and friendly places for people of all ages. You'll find 149 hostels across the US, and hundreds more in Europe, Scandinavia, and around the world.

Hostels vary from place to place. For less than $20 a night, you can stay in a Miami resort hotel close to Disney World, relax in a converted lighthouse on the California coast, explore a restored historic building in the heart of New York City, or enjoy an old ranch in the Colorado Rockies.

Most hostels offer dormitory-style rooms, separating men and women, though more and more offer private rooms for families, couples, and groups, which can be reserved in advance. You usually find a fully equipped do-it-yourself kitchen, so you can make your own breakfast or dinner if you don't want to eat out. Most hostels open in the evening, when you check in, and close after breakfast. Some offer 24-hour access so you can leave luggage.

You do have to bring your own sheets and towels, and hostels provide blankets and pillows. Also, you may be required to do a light housekeeping chore before you leave—sweep your room or clean the bathroom. Hostels always have plenty of leaflets, maps, and information about the area, and you can get some of the most useful information from talking to the other visitors and sharing experiences.

Contact:
Toby Pyle
733 15th Street NW, Suite 840
Washington DC 20005
Phone: 202-783-6161
Fax: 202-783-6171

Two Grannies Hostelling in Britain

Rachel Pollack and her friend Renae frequently travel together, leaving husband (Renae's) and children and grandchildren (both) in Colorado. Last summer, they took a Youth Hostel tour of England and Scotland. On the next page Rachel Pollack describes their experiences as they arrived in Glasgow after a few days in London.

Two Grannies at the Y

The Glasgow Youth Hostel is set atop a hill that overlooks a park and the River Clyde. Located in a smart, white row of terraced Georgian buildings, the hostel can sleep up to 158 people in dormitories or three double bunk-bedded rooms. The hostel was clean, the young desk personnel friendly. Indeed, everyone we met in Glasgow was chatty, eager to please, and enthusiastic. The university is near the hostel as is Mackintosh House, which holds a must-see James MacNeil Whistler Collection.

The rooms at the hostel—even with six beds—are neither expansive nor tiny. Call them cozy but you can turn around in them. Baths were surprisingly en suite. Sack sheets are the order of the day at youth hostels; they are reminiscent of sleeping bags, but keep you wrapped more tightly.

Breakfast at the Glasgow hostel was "continental style"—cold cereal and roll and jam. The hostel maintains a members' kitchen and laundry facilities. Eating is relaxed here, and noone pushed us out to make room for other diners, as in the over-crowded London hostel! The costs were about $12 for juniors and $15 for seniors. We happily shed our jeans for our 'good' clothes to go to the opera, wandered for hours through Ness Gardens, and the Burrell Collection. This is a lovely city that still revels in being named European City of Culture for 1990. People we met were filled with pride about their city's renaissance.

From Glasgow, we took the train to Chester, the gateway to north Wales, and stayed at Hough Green House. Each hostel is different, and this one is a large Victorian house in the middle of a residential neighborhood. It holds 130 beds. Here again we were assigned a multi-bedded room, but did not have the luxury of spending the first night alone as we did in Glasgow; there were six other women already snugly ensconced. Overnight charges for under 18s were about $11, and for seniors about $18, plus an extra $1.50 for a bath towel (refundable when you returned the towel).

None of the hostels we stayed at had enough lighting to read in bed, although most had tiny reading lamps attached to headboards. Renae, who plans for all contingencies, brought a reading lamp that wraps around the head. Fortunately, there are several common rooms at Hough Green for reading, talking, or quiet times—a pleasure for both of us to catch up with our journals, or talk to other people before retiring for the night.

HURRICANE CREEK LLAMA TREKS

Caravans of llamas have been used for centuries in the highlands of South America to transport salt, grain, and root crops among trading centers throughout the Andes mountains. Today, llamas have found a new home in the North American backcountry, carrying loads of camping gear for vacationing hikers.

When you hike with friendly and companionable llamas, you need carry only a daypack for your lunch, camera, and rain gear. The llamas will tote the heavy loads, including fresh food for delicious wilderness meals, roomy tents, and personal gear. You may lead a llama and make a new friend, or amble along at your own pace. While no special skills are required, participants should be in good health and able to walk up to eight miles a day at altitudes between 4,000 and 8,000 feet.

Stanlynn Daugherty has been outfitting llama treks in northeast Oregon for 12 years. In late spring she leads a trip into the Hells Canyon National Recreation Area, visiting North America's deepest gorge, where you may see large herds of elk and spectacular wildflower displays. Summer treks traverse the Eagle Cap Wilderness, an area carved by glaciers nearly 12,000 years ago, with rugged marble and granite peaks, and crystal clear alpine lakes filled with brook and rainbow trout.

Group size is limited to ten guests. Before and after the treks, you stay in a charming bed and breakfast inn in Joseph, Oregon.

Price includes:
Accommodations before and after trips, camp equipment, guides, all meals, pre-trip material, transportation to trailhead, pack llamas.

Most popular:
Hurricane Creek Loop Hike, 7 days, $800.
Women's Wilderness Trek, 6 days, $650.
Brownie Basin Base Camp, 6 days, $700.

Contact:
Stanlynn Daugherty
63366 Pine Tree Road
Enterprise OR 97828
Tollfree: 800-528-9609
Phone: 541-432-4455
Fax: 541-432-4455
e-mail: stanlynn@oregontrail.net
Women: All trips appeal to women; one Women's Wilderness Trek offered.
Children: Minimum age: 6. Children cannot ride the llamas.

Comments:
"I've taken three trips with Stanlynn and I'm so spoiled I couldn't go with anyone else. I just like the animals—they're easy to be around. It's much easier to get into the back country without having to carry anything, and the groups are fun."
Woman from Texas.

INTERNATIONAL EXPEDITIONS

A world leader in nature travel and a supporter of environmental projects, International Expeditions, founded in 1980, offers an array of nature trips around the world led by naturalists and local guides.

At the Amazon Center for Environmental Education and Research, a result of IE's first International Rainforest Workshop in the Peruvian Amazon seven years ago, there are annual workshops with botanists, zoologists, and field researchers sharing their expertise. The ACEER lab and Canopy Walkway is set in a wilderness area of more than 250,000 acres of primary rainforest in the Peruvian Amazon. A new Women in Conservation workshop provides information on how to empower rural Amazon women to become more active in conservation. There are also 8-day river boat voyages from Iquitos, Peru, on the Amazon.

Other IE trips take you sailing on a classic Tall Ship among the Indonesian islands of Bali, Lombok, and others, to see the exotic Komodo dragons and flying fruit bats. In Uganda, where there are more than 1,000 species of birds, you visit one of the last remaining mountain gorilla habitats.

In South America, IE has supported Bolivia's Noel Kempff Mercado National Park, an area incredibly rich in its diverse species and habitat. You can also cruise around the Galapagos Islands in the Pacific, where Darwin landed more than a century ago, and marvel at tame bluefooted boobies, fearless seals, and land and sea iguanas.

Price includes:
Airfare from US and other airfares, accommodations, excursions, guides, instruction, all meals, land transportation, extensive pre-departure literature.

Most popular:
Amazon Voyage, 8 days, $2,198.
Amazon Rainforest and Canopy Walkway, 8 days, $1,898.
Belize Naturalists Quest, 11 days, $2,398.

Contact:
Steve Cox
One Environs Park
Helena AL 35080
Tollfree: 800-633-4734
Phone: 205-428-1700
Fax: 205-428-1714
e-mail: intlexp@aol.com
Women: Trips usually 60% female.
Children: 9 years and older.

Comments:
"We saw so many birds and mammals. My list is endless. The monkeys were the best. One morning, we were totally engulfed in lovely butterflies. Pink and Gray River Dolphins followed our ship. I'd go again tomorrow!" Woman on Amazon Voyage trip.
"Exceeded my expectations, especially the interaction with experts on rhinos and elephants. Tented camps were luxurious, no roughing it!"
Woman on African Savannah Workshop.

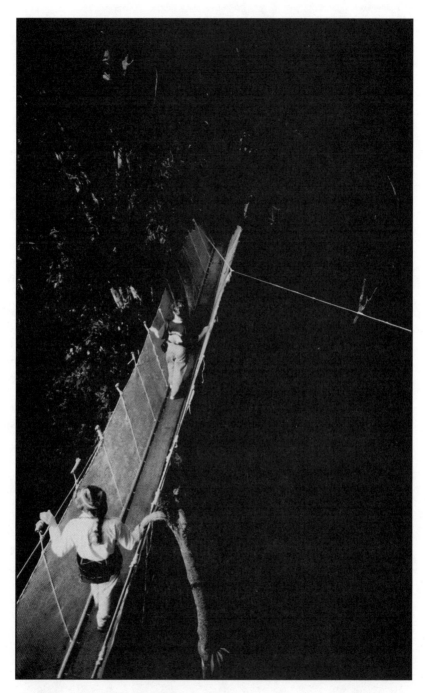

International Expeditions Amazon Canopy Walkway

JOURNEYS INTERNATIONAL

Joan and Will Weber founded this company in 1978 to offer small group and individually designed nature and cultural travel to Asia, Africa, and the Americas. Their goal is to let travelers enjoy a direct, active, and intimate involvement with distant cultures and environments on a flexible tour. Most trips are for men and women, as well as several well-designed trips for families with school-age children.

They have a few all-women trips that offer more opportunity for cross-cultural interaction, especially in societies where women are traditionally kept in the background when men are present. The Women's Cultural Trek in Nepal's Kathmandu Valley takes you into the lives of Nepalese Hindu and Buddhist women. You visit villages, homes, schools, and markets, and learn enough of the language for conversation, as well as trekking among Sherpa communities in the Everest region. In Ladakh, the Women's Trek stays in local people's homes as well as camping, and you meet school teachers and village women, observe how cloth is woven and silver is made, and visit Dharmsala, the home of the exiled Dalai Lama. You walk in the lowland rainforests of Panama on the Women's Darien Explorer Trek, as well as seeing coastal mangrove swamps, and hiking up to the cloud forests in the mountains. You visit the towns of La Palma and El Real, stay in peaceful Indian villages, see native dances and crafts, and have plenty of time to birdwatch and observe nature.

Other Journeys trips visit Mexico's Copper Canyon, Ecuador's culture and rainforests, Peru's Inca Trail, Turkey's Turquoise Coast, Botswana's Okavango Delta, Japan, Papua New Guinea, Australia, and the Pacific islands of Hawaii, Fiji, Tonga, and Samoa.

Price includes:
Accommodations, equipment, excursions, guides, some meals, pre-trip material.

Most popular:
Million Animal East Africa Safari, 17 days, $2,445.
Nepal Women's Cultural Trek, 20 days, $2,195.
Islands of Aloha, Hawaii, 11 days, $1,550.

Contact:
Pat Ballard
4011 Jackson Road
Ann Arbor MI 48103
Tollfree: 800-255-8735
Phone: 313-665-4407
Fax: 313-665-2945
e-mail: journeysmi@aol.com
Women: Special all-women treks.
Children: All ages on family trips.

Why Women-Only Trips?

Pat Ballard, Journeys International, Director of Sales, explains why the company has been offering a few trips for women only.

Women are often the majority on cultural adventure trips, and in this company many of us working here are women. I don't want to be negative about men, but when men are along on trips in some areas—like South America or Asia—the women in the countries we go to aren't comfortable with men being part of the group. They're not used to having men around all the time, as we are in the United States. Because of that, we lose the opportunity for a lot of in-depth cultural experiences. We felt we wanted to take advantage of those opportunities, so that's why we started with an all-women trip to Nepal.

It was very successful. The difference is amazing—we really notice it in India. When we trekked in Southern India, in some of the back country villages, women are usually never allowed out when men are around, so we never saw them. On an all-women trek, we were welcomed into their homes, we visited with them and had tea, and it was a wonderful cultural experience that we would not have had if there had been men in the group. We hope to offer eight or nine all-women trips over the next two years in Asia and in South America.

MOBILITY INTERNATIONAL USA

"People with disabilities have the right to travel, to learn, and to experience other cultures," is the philosophy of this organization. "They can study in Germany, volunteer in Malaysia, live with a host family in Mexico, travel with a service dog, or apply for scholarships."

Since 1981, Mobility International, a nonprofit organization, has worked to expand equal opportunities for persons with disabilities in international educational exchange, leadership development, disability rights training, travel, and community service.

MIUSA offers several international educational exchanges involving youth, adults, and professionals from the US and more than 40 countries. Exchanges last from two to four weeks, and are held throughout the year. Delegates live with homestay families and take part in leadership training, workshops and seminars, adaptive recreation, language classes, and community service projects in Asia, Central America, Europe, and South America.

MIUSA publishes several guides, including *Leadership Development Strategies for Women with Disabilities: A Cross-Cultural Survey, A World of Options: A guide to international exchange, community service, and travel for persons with disabilities,* (3rd edition), *You Want To Go Where? A Guide to China for Persons with Disabilities,* and videos on young people with disabilities traveling in England and Costa Rica, leadership training, and homestays.

Members receive a quarterly newsletter, discounts on videos and publications, and access to MIUSA's travel information and referral services. MIUSA training workshops and materials encourage the full participation of people with disabilities in all international opportunities.

Contact:
Susan Sygall
PO Box 10767
Eugene OR 97440
Phone: 541-343-1284 (Voice & TDD)
Fax: 541-343-6812
e-mail: miusa@igc.apc.prg

MYTHS AND MOUNTAINS

Tours that focus on folk medicine and traditional healing, cultures and crafts, natural history and the environment, and religion and holy sites, are offered in Bolivia, Chile, Ecuador, India, Nepal, Thailand, and Tibet by this company, founded by Dr. Antonia Neubauer. Her own extensive travel experiences inspired her to invite other travelers to share the cultural, environmental, and spiritual wisdom of people she met along the way.

In Ecuador, an apprentice shaman introduces you to shamans in different parts of the country. You participate in powerful rituals, experience herbalism classes deep in the rainforest, and attend healing sessions at private homes. In Bolivia, you meet the Kallawayas, medicine men of South America, who live in the 16,000-foot-high mountains of the Andes.

There's a Buddhist Odyssey in Tibet, where you visit different Buddhist sites, with Lobsang Samten, former assistant to the Dalai Lama, or you can take a tour of the Kailas region, including Mount Kailas in western Tibet. The Indian Himalayas are the focus of a natural history tour of Kinnaur and Spiti, on the border with Tibet.

Andean cultures and crafts are the highlight of a trip to Peru, where you meet weavers, potters, tapestry weavers, and painters. You can also spend a month studying Spanish and living with families in Cuenca, Ecuador, or choose a shorter tour of southern Ecuador's Indian markets and villages.

Price includes:
Accommodations, some equipment, excursions, guides, most meals, transportation.

Most popular:
Nepal: Pilgrimage to Muktinath, 27 days, from $2,775.
Tibet: A Buddhist Odyssey, 22 days, from $4,675.
Ecuador: Artists and Mountains, 10 days, from $2,185.

Contact:
Colleen Dalton
976 Tee Court
Incline Village NV 98451
Tollfree: 800-670-6984
Phone: 702-832-5454
Fax: 702-832-4454
e-mail: edutrav@sierra.net
Women: Some trips have more women.
Children: Depends on difficulty of trip.

Comments:
"I'd never been trekking, and I worked really hard hiking to get ready, and it wasn't beyond my ability. I loved the camping and the food."
Woman on Nepal Pilgrimage to Muktinath.
"Relaxing, incredibly peaceful, and great fun! A first class adventure all the way."
Woman on Camel Safari in India.

NATIONAL WOMEN'S SAILING ASSOCIATION

Organized in 1991 by a group of active women sailors, the National Women's Sailing Association was founded to make sailing more accessible to women. In 1994, the founding group organized a national membership association to educate and help other women discover or continue enjoy the sport of sailing. President Doris Colgate, Offshore Sailing, is a longtime advocate of encouraging more women to sail.

"My passion for sailing started with a course at Offshore Sailing School," notes Colgate. "I was 26, and had never been on a sailboat before and I absolutely fell in love with the sport. Over the years, sailing has opened a whole new world, helped me develop new and lasting friendships, and greatly enhanced my life experiences."

She hopes that NWSA will do the same for other women. The organization offers educational programs to sailors of all ages and in all walks of life. The emphasis is on acquiring the skills and information to help women gain confidence and knowledge in sailing. NWSA supports the all-women America's Cup team, and hopes to help more women reach local competition, even the Olympics. Membership dues and corporate support provide grants and scholarships for young women to take sailing classes. An Adventure Sail program to introduce teenage girls to sailing has started in six cities.

NWSA also publishes a *Women's Sailing Resources* guide, *Take the Helm*, a newsletter with information about sailing events, and a national membership directory.

Price includes:
Accommodations, equipment, instruction, most meals, pre-trip material.

Most popular:
Navigation Course aboard 95' schooner in Boston Harbor, $345.
Women's You Can Sail Escape, Captiva Island, Florida, 1 week, $1,195.
Caribbean Rally, British Virgin Island, $1,445.

Contact:
Doris Colgate
16731 McGregor Boulevard
Fort Myers FL 33908
Tollfree: 800-566-6972
Phone: 941-454-1700
Fax: 941-454-1191
e-mail: Offshore@packet.net
Women: All women sailing programs.
Children: 16 and over.

Comments:
"When you sail as a couple, with a more experienced partner, you don't realize at first that someone else is making all the decisions. Until a woman gets onto a boat as captain, without anyone to second-guess her, she can't really gain confidence. There's something about the dynamics of a sailing couple that can keep her from taking responsibility." Barbara Marrett, NWSA Advisory Council member.

NATURE EXPEDITIONS INTERNATIONAL

"About 75% of all NEI participants are women," notes president Christopher Kyle, "and they say they like the educational component and the small groups."

Founded in 1973, NEI was a pioneer in adventure travel. Its trips are led by experts in the fields of anthropology, biology, geology, and natural and cultural history, who have masters degrees or equivalent professional training. Today, it offers expeditions to 32 different destinations on six continents with a wide variety of itineraries.

The Alaska Wildlife Expedition is designed for first-time visitors who want to experience the incredible diversity of wildlife and the spectacular scenery; you explore Glacier Bay, Kenai, and Denali national parks, and the colorful cities of Sitka, Juneau, and Fairbanks.

In the rainforest, you spend four days cruising the Amazon, with stops at villages where you meet native people. You stay at a rainforest lodge; see native birds, butterflies, and mammals; experience the high canopy walkway; and take nighttime excursions to spot nocturnal animals.

The Galapagos trips are led by naturalists trained at the Darwin Research Station. In East Africa, a wildlife safari includes deluxe camping in Kenya's Samburu and Tanzania's Serengeti national parks. In Botswana, a wildlife safari takes you on a float through grassy waterways to spot hippo, elephant, crocodile, and brilliantly colored birds. In the United States, there are tours of southwest Indian country, to Oregon, and Hawaii. Other trips visit Australia, New Zealand, Antarctica, and the South Pacific.

Price includes:
Accommodations, equipment, excursions, guides, instruction, most meals, tips, pre-trip material, land transportation, some airfare, travel information.

Most popular trips:
Amazon Expedition: Spanning the Continent, 17 days, $2,990.
Alaska Wildlife Expedition, 9 or 15 days, $2,690/$3,790.
Galapagos Adventure, 11 days, $2,490.

Contact:
Christopher Kyle
6400 E. El Dorado Circle, Suite 210
Tucson AZ 85715
Tollfree: 800-869-0639
Phone: 520-721-6712
Fax: 520-721-6719
e-mail: naturexp@aol.com
Women: 95% of time more women than men on trips.
Children: 10 years or older.

Comments:
"It was wonderful! Our days were long but they went so fast. We saw glaciers, elk, bear, whales, fox, and so many birds. The twelve of us in the group ranged in age from 30 to 79, and we all seemed to be interested in the same things."
Woman on Alaska 15-day trip.

NICHOLS EXPEDITIONS

Mountain biking, hiking, rafting, sea kayaking, and international adventures are offered by Nichols Expeditions, which was started by Chuck and Judy Nichols in 1978. They offer dozens of trips for beginners and experts.

"Nineteen years ago we began operating tours and have chosen to remain a small company dedicated to eco-conscious adventure travel. We love what we do and feel there are no greater rewards than the number of folks who return year after year to try a new adventure or repeat a favorite trip," they say.

An all-woman mountain biking trip in Canyonlands National Park is led by Jacquie Phelan, founder of Wombats—Women's Mountain Bike and Tea Society. Jacquie is an experienced teacher and motivator who helps women learn and improve their cycling skills while having a great time. There are also mountain bike tours to visit the North Rim of the Grand Canyon, Kokopelli's Trail between Colorado and Utah, and Payette National Forest in Idaho.

Raft trips take you to the Salmon River in Idaho and the Green River in Utah. In Alaska, there are rafting, hiking, and sea kayaking tours. You can sea kayak and whale watch in Baja, Mexico; tour Costa Rica's beaches, mountains, and jungles; visit South America and trek the Inca Trail to Machu Picchu; or cruise the Galapagos Islands to view the spectacular wildlife.

Price includes:
All equipment, guides, instruction, all meals, land transportation.

Most popular:
Mountain bike: White Rim Trail, Canyonlands National Park, 4 days, $585; 5 days, $675.
Sea kayak: Sea of Cortez, Baja, 7 days, $880.
Trek: Inca Trail to Machu Picchu, 9 day, $1,350.

Contact:
Nichols Expeditions
497 North Main Street
Moab UT 94532
Tollfree: 800-648-8488
Phone: 801-259-3999
Fax: 801-259-2312
e-mail: nichols@sisna.com
Website:
http://www.nicholsexpeditions.com
Women: About 10% of trips have more women than men.
Children: 7 and up on some trips.

Comments:
"Many of us did things we didn't know we could do! But with the gentle personal instruction of the Nichols' guides, we felt we could do anything!"
Woman on raft trip in Alaska.
"I love the participation—everybody pitches in, helps with meal preparation and clearing up, sharing—that's a high for me. I've taken four bike trips. They're all wonderful— challenging for me, and when I finish, I'm glad I pushed myself to do it."
Woman from California.

NORTHERN LIGHTS EXPEDITIONS LTD.

Thousands of years ago, Eskimos first designed and handcrafted their kayaks for traveling and hunting. Since 1983, David Arcese and Northern Lights has run kayaking adventures in the Inside Passage for anyone who wants to see Orca whales, harbor seals, river otters, and Dall's porpoises, and the spectacular scenery of Vancouver Island and British Columbia, with evergreen forests climbing up steep mountainsides and eagles soaring over the sheltered bays.

The Inside Passage covers 20 miles of islands, waterways, and calm ocean that lies between Vancouver Island and the mainland. You can choose from several trips in the warm summer months. You can start in the tiny boardwalk village of Telegraph Cove, exploring the islands for a week, camping at different places, or include a seaplane ride from Port McNeil into camp, or a flight out at the end. There's a Mystery Tour where you kayak into different locations in the Vancouver Island region and camp out. Non-campers can stay at Farewell Harbour Yacht Club on a private island, and go out for day-long kayak expeditions.

Don't worry if you've never paddled a kayak before—though you should be in reasonably good shape. The company provides state-of-the-art equipment, including special kayaking rain gear and life vests. Three skilled guides accompany every trip. You'll enjoy delicious meals at campsites and at lunch stops.

Price includes:
Accommodations, equipment, excursions, guides, instruction, all meals, pre-trip material, transportation, seaplane flights.

Most popular:
Inside Passage Sea Kayaking, $949-$999.
Sea of Cortez Sea Kayaking, $995.

Contact:
David Arcese
PO Box 4289
Bellingham WA 98227
Tollfree: 800-754-7402
Phone: 360-734-6334
Fax: 360-734-6150
e-mail: slim@seakayaking.com
Website: www.seakayaking.com
Women: 95% of time there are more women than men on trips.
Children: Few trips for 12-16 with parents.

Comments:
"We had a fabulous time, saw many Orcas, eagles, dolphins and porpoises, and ate great food! Our trip exceeded all of our expectations." Woman from California.
"Super! It was a luxury to have three terrific guides; we had great access and all the personal instruction we wanted. We laughed the whole trip."
Woman from North Carolina.

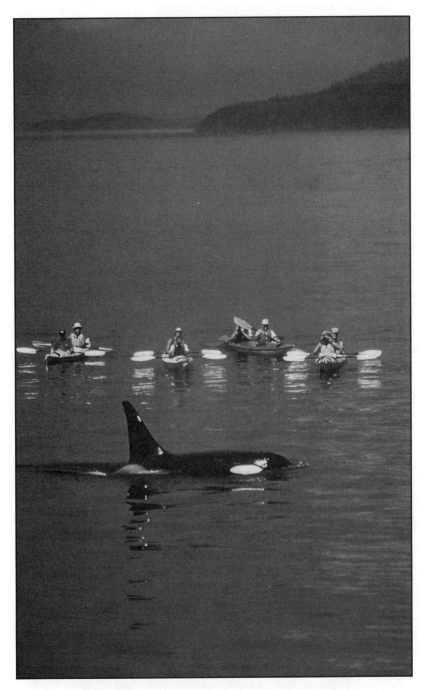

Northern Lights Kayakers Meet an Orca

OFFSHORE SAILING SCHOOL

Even landlubbers with no sailing experience can discover the joy of sailing after a week's hands-on experience on the water at Offshore. You learn about rigging and sails, types of boats, getting underway, proper winching techniques, the mechanics of wind and sail, heeling and stability, spinnaker techniques, and more.

Steve and Doris Colgate have been the guiding force of Offshore Sailing School since it began in 1964. Doris is president, has participated in virtually every major ocean race, and is the author of the *The Bareboat Gourmet*. Steve, the CEO, learned to sail at 9, made his first Transatlantic Race at 19, and has raced in two America's Cup Trials, over 12 Bermuda Races, the Olympics, and more. He is a board member of the American Sail Advancement Program, and author of eight books, including *Fundamentals of Sailing, Cruising and Racing*, an internationally recognized text for beginning and advanced sailors. He has prepared the full curriculum for the Offshore Sailing School.

You choose a course at your level: Learn to Sail for beginners, Performance Sailing for more advanced students, Bareboat Cruising Preparations, Live Aboard Cruising, Racing, and a Women's You Can Sail Escape week.

Most courses are offered at a variety of locations including Florida's Captiva Island; Tortola in the British Virgin Islands; Newport, Rhode Island; New Jersey; Chicago; and Connecticut. Instructors are certified by US Sailing, the official governing body for sailing. More than 80,000 sailing students have graduated successfully with Offshore.

Price includes:
Accommodations, equipment, excursions, instruction, most meals, pre-trip material.

Most popular:
Women's You Can Sail Escape, Captiva Island, FL, 7 days, $1,195.
Learn to Sail package, 5-7 days, Captiva Island, FL, $995.
Live Aboard Cruising package, 1 week, Tortola, BVI, $1,645.

Contact:
Kirk Williams
16731 McGregor Boulevard
Fort Myers FL 33908
Tollfree: 800-221-4326
Phone: 941-454-1700
Fax: 941-454-1191
e-mail: offshore@packet.net
Women: Weekly sailing courses for women only.
Children: 7 and older.

Comments:
"They make sailors out of you, ready or not! The comradeship which develops among students and instructors is fondly remembered and cherished." Woman from Texas.
"Thank you for the experience of a lifetime. Sailing has changed my life and I plan to take only sailing vacations from now on!" Woman from Ohio.

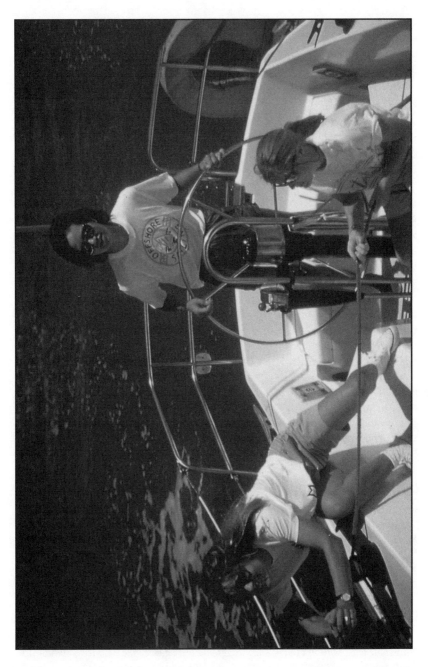

Offshore Sailing School: Learning the Ropes

OUTDOOR VACATIONS FOR WOMEN OVER 40

"As women hit that big zero, whether it's 50 or 60 or 70, they're realizing their own mortality," says Marion Stoddart. "If they don't do the things they want to do now, they'll never do them."

In 1983, Stoddart created Outdoor Vacations for Women Over 40 to provide active vacations for older women because: "You hear about men who go off on fishing and hunting trips and leave their wives because they're not interested," she says. "Well, there's a group of women who want to do outdoor things who are married to men who don't. If my husband enjoyed doing these things, I'm sure I would never have started this business."

Her year-round trips offer camping and snorkeling in the Virgin Islands, cross-country skiing in Vermont and Colorado, kayaking and whalewatching in Baja, Mexico. You can explore Australia's Great Barrier Reef, live on a barge in Amsterdam, bike on Cape Cod, walk through England's Cotswolds, river raft and canoe in Arkansas, whitewater raft in Oregon, or hike in Mexico's Copper Canyon.

The company offers a few multi-generational trips for mothers/daughters, grandmothers/granddaughters, and aunts/nieces. More than half of the women who come are married. Ages range from 40 to 83, the average being 57 or 58. Most women want new adventures, to have fun, be active in the outdoors, and do some things they have not done before.

Price includes:
Accommodations, equipment, excursions, guides, instruction, most meals, tips, and pre-trip material.

Most popular:
Cross-country ski week, different places each year, $1,600-$1,800.
Walking Tour in British Isles, 10 nights, $2,700.
Bike & Barge in Holland, 10 nights, $2,600.

Contact:
Marion Stoddart or Nancy Ross
PO Box 200
Groton MA 01450
Phone: 508-448-3331
Fax: 508-448-3514
e-mail: ov40fun@aol.com
Women: Always women over 40, except for multi-generational trips when at least two generations must be represented, one participant over 40 and the other 21 or older.
Children: No one under 21 on trips.

Comments:
"They're all very fine trips. Part of the great excitement is meeting new people."
Woman from Massachusetts.
"Awesome trip! Marion always encourages you but never makes you feel you have to do it. I often travel with my husband, but I love adventure trips with other women because I feel totally free!" Woman from Ohio.

OVERSEAS ADVENTURE TRAVEL

Dazzling adventures to exotic places at affordable prices that include international airfares and cultural programs is the specialty of OAT. Now owned by the Grand Circle Corporation, you'll find many active older people on trips, both women and men. For a time, OAT had women-only trips to Nepal, Bolivia, and Africa, led by well-known women guides from those countries, which proved very successful but are not offered at the moment.

In South America, you explore Machu Picchu, the Amazon rain forest, and the fabled Galapagos Islands, to see blue-footed boobies and Galapagos seals. The Four Worlds of the Andes is an introduction to the history and culture of the people of the Andes, with visits to La Paz, Cuzco, Lima, and Lake Titicaca.

The expedition to Antarctica takes you to observe fluffy baby penguins sitting on stone nests and you float close to seals basking on icebergs. In Egypt you take a camel ride in the desert and see the awesome pyramids. In Turkey, you tour Istanbul and sail a yacht down the coast. African safaris show you the wonders of the Serengeti, Tanzania, Kenya, Botswana, Zimbabwe, and South Africa. View wildebeest, zebras, giraffes and elephants while you stay in luxury tented camps. In Asia, you visit Thailand, India, and Nepal.

Trips are rated Easy, Moderate, or Challenging, depending on the terrain, where you stay, the altitude, and the activities, so you can pick the one that fits your needs.

Price includes:
Airfare from US, accommodations, equipment, excursions, guides, instruction, most meals, pre-trip material, land transportation.

Most popular:
Real Affordable Costa Rica, 10 days, $1,890.
Turkey's Magical Hideaways, 17 days, $3,290.
Peru, Ecuador, and Galapagos, 18 days, $3,990.

Contact:
Overseas Adventure Travel
625 Mount Auburn Street
Cambridge, MA 02138-9461
Tollfree: 800-221-0814
Phone: 617-876-0533
Fax: 617-876-0455
Women: Majority of trips have 65% women or more.
Children: 10 and over.

Comments:
"I've taken four OAT trips—Africa, Tanzania, Peru and the Galapagos, and Costa Rica—and I just think they're great. We don't even shop around any more because we know what to expect - small groups, fine accommodations, and I loved every one of the trips." Woman from Colorado on Costa Rica trip.
"I loved it. It felt like I was running around in a National Geographic special!"
Woman from California on Peru and Ecuador trip.

RAINBOW ADVENTURES

In 1982, when Susan Eckert started Rainbow Adventures to offer adventure vacations to women over 30, she was told that the idea wouldn't work. Today her successful company offers dozens of exciting trips worldwide.

Most women who sign up are between 30 and 70, are or have been married, and have between one and three children. The average traveler is 50 years old, and she's quite satisfied with her life and successful in her current job or situation. She's also confident about how she looks and feels, and makes an effort to stay in good physical condition. Many women return year after year because they like challenging themselves by learning a new skill or activity, enjoy taking an adventure that's out of the ordinary, want to be physically active, and report that they "feel great" about themselves when they go home. All that Susan asks of participants is that they bring a sense of humor, show willingness to be flexible and agreeable, accept situations as they exist, and be a good-natured realist.

She offers trips year-round. You can take a winter Caribbean sailing cruise, hike in springtime in Arizona's Sonoran Desert, or enjoy exploring Utah's Red Rock Country by raft, jeep, van, and jetboat with no camping. Horseriders and hikers follow the authentic Oregon trail and cross the Continental Divide near South Pass City, Wyoming, in July. You can hike in Glacier and Yellowstone National Parks, trek in Nepal, sea kayak in Baja, and cast your line at the Annual Women's Labor Day Fly Fishing Clinic in Big Sky, Montana.

Price includes:
Airfare from US on most international trips, accommodations, equipment, excursions, guides, instruction, most meals, pre-trip material, transportation on land.

Most popular:
Montana Cowgirl Sampler, 1 week, $1,550.
Sailing in the Caribbean, West Indies, 1 week, $1,495.
Safaris to Africa, 17 days, $6,000

Contact:
Susan Eckert
15033 Kelly Canyon Road
Bozeman MT 59715
Tollfree: 800-804-8686
Phone: 406-587-3883
Fax: 406-587-9449
e-mail: RainbowAdv@aol.com
Women: All trips for women over 30 years of age only.
Children: No children.

Comments:
"A life-changing experience! It was fabulous. Hiking was my favorite—those views of the mountains! That trip motivated me to learn to fly, a long-time dream, and next month I get my pilot's license!"
Woman from Tennessee on Montana Cowgirl Sampler.

ROCKY MOUNTAIN RIVER TOURS

"It's Sheila's Dutch-oven cooking from our own five-acre garden and our crew of 'old' masters river guides who bring guests back again and again," says Dave Mills. He's run rafting trips since 1978 on the Middle Fork of the Salmon River. A native of Idaho, he's been rafting for 26 years, and he and his wife enjoy sharing their love of the wilderness with visitors.

More women than men join the trips each summer to enjoy the excitement of rafting through some of the most untamed, rugged, and beautiful scenery in Idaho on the protected Salmon River. You can ride through the rapids and calm waterways in oar-powered rafts, or you can crew a paddle boat, or paddle your own inflatable kayak.

You camp by white sand beaches, hot springs, and tall conifers. There's always time for personal outdoor experiences, and you are welcome to hike, fish, birdwatch and swim along the way. You may see deer, elk, mountain sheep, goats, and even an otter family. Native cutthroat and rainbow trout still thrive in the river, but the chinook salmon has disappeared because of human intervention along its migratory waters.

Sheila Mills has perfected the art of Dutch-oven cooking. The meals include her delicious Spicy Pesto Lasagna, Grilled Idaho Catfish, Dilly Casserole Bread, Lemon Broccoli Risotto, and delights such as pear-cranberry cobbler, sticky buns, and Cornmeal Buttermilk Griddle Cakes. Her recipes are published in a new cookbook, *Rocky Mountain Kettle Cuisine II*.

Price includes:
Accommodations, equipment, excursions, guides, instruction, all meals, transportation. Camp and river gear included on all trips.

Most popular: Launch dates remain the same yearly.
4-day trips, May 18, 25; June 4; September 3, 10; $850.
6-day trips, June 13, 22; July 1, 9, 17, 22; August 2, 10, 18; $1,345.

Contact:
Sheila & Dave Mills
Idaho's Middle Fork Salmon
PO Box 252
Boise ID 83701
Phone: 208-345-2400.
Summer: PO Box 207, Salmon ID 83467
Phone Summer: 208-756-4808
Fax: 208-345-2688
e-mail: rockymtn@micron.net
Women: 55% of trips have more women.
Children: Age 6 and up. July/August best when water is warmer.

Comments:
"Fabulous! Everyone involved is wonderful! I love the enjoyment of nature, preservation of the earth, the environment—and great food. I took an all-women trip in the spring one year which was terrific, even though it was very cold!"
Woman from North Carolina.

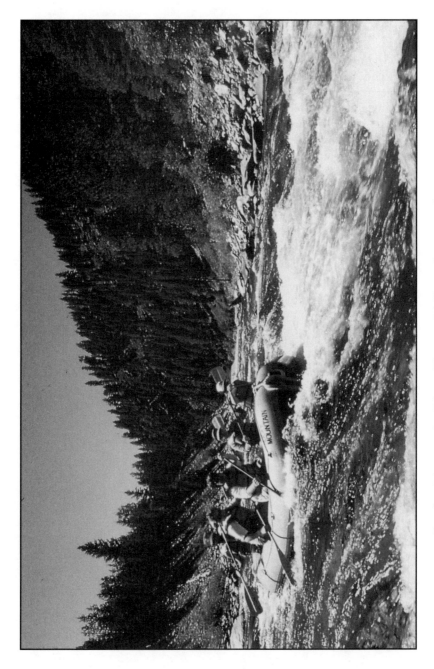

Rocky Mountain River Tours: Riding the Rapids

VERMONT STATE PARKS

If you'd like to volunteer for the Host/Volunteer program in any of Vermont's 45 State Parks, an RV site is provided free in exchange for 20 hours of work a week. Some of these are equipped with water or electric hook-ups, some with septic hook-ups, and most have dump stations and flush toilets and hot showers nearby.

Ideally, you volunteer for six weeks in the summer. You welcome visitors, assist with registration and fee collection, organize and direct recreational activities, provide information, or do light maintenance—rake sites, pick up litter, and mow the lawn.

If you prefer to vacation and go hiking or camping on your own, there's a total of 2,200 tent and RV campsites, usually open from Memorial Day weekend through Labor Day or Columbus Day. You'll find plenty of beautiful trails to walk along under the trees, beaches with facilities, boat rentals, and concession stands.

Price includes:
Accommodations only.

Most popular:
Camping in tents or RVs, 1 night, for up to 4 people, $10-$12.
Camping in lean-tos or on lean-to sites, for up to 4 people, $14-$16 a night.
Additional fees required for more than 4 people.

Contact:
Larry Simino
103 South Main Street, 10 South
Waterbury VT 05671-0603
Phone: 802-241-3664
Fax: 802-244-1481
e-mail: lsimino@fpr.anr.state.vt.us

VICTORY CHIMES

Built in Delaware in 1900, the windjammer *Victory Chimes* began life as a three-masted schooner carrying lumber on Chesapeake Bay. After 50 years as a cargo boat, she sailed to Maine to begin her life carrying vacationers on cruises up and down the picturesque coast. Captain Kip Files and Captain Paul DeGaeta bought her in 1990, and today, refurbished and with new navigational and safety equipment, she is the largest windjammer under the flag of the United States, and the last three-masted schooner from the Golden Age of Sail.

You can spend a week aboard, enjoying the adventure as the wind fills the sails and you speed over the ocean waves as well as modern comforts like hot showers. You can do as much or as little as you want. There's always time for a swim, a ride in the rowboat, or an energetic walk along the shore. You can help hoisting and lowering the sails, practice plotting a course with compass and chart, or learn marlinespike seamanship with a crew member. Delicious meals include homemade breads, fresh blueberry pancakes, and fresh caught lobsters. Lunches are usually served on deck. You sleep in comfortable cabins equipped with electricity and heating.

Victory Chimes sails from the small coastal city of Rockland, Maine, and crosses Penobscot Bay to cruise among the islands dotted with pine trees, stopping for the night in hidden coves, fishing villages that have changed little since 1900, and popular resort towns. Each week the cruise route is different, depending on where the wind blows, and you may see Monhegan Island and Boothbay Harbor, or Bar Harbor and Mount Desert Island.

"When you come aboard, you've arrived at your destination," says Captain Files. "I never know where I'll be taking the boat in any given week, but wherever we do go, I guarantee you that it's going to be beautiful."

Price includes:
Accommodations, equipment, guides, instruction, all meals, pre-trip material.

Most popular:
Half-week cruise in June, 3-5 days, $375.
Race Week in July, 7 days, $725.
Week Cruise in August, 7 days, $725.

Contact:
Captain Kip Files
PO Box 1401
Rockland ME 04841
Tollfree: 800-745-5651
Phone: 207-265-5651/207-594-0755
Women: Often more women than men.
Children: Welcome.

Comments:
"It's like stepping off the world. It's very restful and peaceful, and you come back with a different perspective." Woman who takes an annual vacation on the ship.

WAGON TRAIN TRIPS

You can recreate an adventure of the past if you want to find out what it was like to cross the country in a covered wagon. With growing interest in pioneer trails and pioneer history, several companies now offer the chance to ride an authentic wagon train just as the early settlers did when they crossed the country.

You can choose a one-day trip, or recreate the covered wagon experience with a multi-day trip complete with camping in a circle, getting meals from the chuck wagon, and attacks by marauding Indians. You choose whether to sit inside the wagon, often with padded seats, ride alongside on a horse, or help drive the horses. The following companies offer you an authentic adventure into history.

Flint Hills Overland Wagon Train Trips

Since 1979, this company has been offering authentic wooden wheel covered wagon rides through the scenic Flint Hills of Kansas. You leave at 9:00 on Saturday morning and meet the wagon train for the day-long trip, camp out overnight, and return about noon the next day. Trail riders can bring their own horse and ride beside the wagons. The wagons roll along at about 3 miles an hour and you may have to get out and walk when they go up or down steep rocky slopes.

Prices:
2-day trips, $140 adults, $75 children 5-12, 4 and under, free. One day only, deduct 20%. Trail riders per person, $75. Must have own horse and feed.

Contact:
Flint Hills Overland
PO Box 1076
El Dorado KS 67042
Phone: 316-321-6300
Children: All ages welcome.

Comments:
"It was great to be transported to beautiful quietness. It also gave us a much greater appreciation for our pioneer ancestors." Woman from Ridgeway, New Jersey.

Oregon Trail Wagon Train

Relive the 1850s by traveling across the Nebraska prairies on original pioneer routes. You learn to grease wagon wheels and pack the trail bags. There's square-dancing, a ride along authentic trail ruts, cookouts around the campfire, historic artifacts, muzzle loading and rifle demonstration, Pony Express Mail service, and even an Indian attack.

(Oregon Trail Wagon Train, contd.)

Prices:
4-day, $479 adults, $399 children under 12: 6-day, $579, Children, $484.

Contact:
Oregon Trail Wagon Train
Route 2, Box 502
Bayard NE 69334
Tollfree Nebraska: 1-800-742-7595
Tollfree out-of-state: 1-800-228-4307
Phone: 308-586-1850
Fax: 308-586-1848
Children: All ages welcome

Comments:
"June 14, 1852. We started at 6:00 am and came twelve miles and stopped for lunch near Scotts Bluff on the Platte River. It commenced raining and blowing a perfect hurricane and we were obliged to form a corral with our wagons for the purpose of preventing a stampede of cattle. Grazing is very good here, but could find no 'buffalo chips' for fuel." Excerpt from Enoch W. Conyers' diary.

Wyoming Wagons West

Wagons West offers Covered Wagon Treks through the Mount Leidy Highlands across from the Tetons in Jackson Hole, Wyoming. You ride in authentic replicas of a pioneer covered wagon—updated with rubber tires and foam-padded seats for your comfort that convert to bunkbeds at night. The trip takes you back in time to the days of the pioneers with the creak of wagons, the smell of leather, sagebrush, and woodsmoke, and a new panorama around every bend of the trail.

You can choose to ride in the wagons or on gentle riding horses. Enjoy chuckwagon meals, guided side rides, and cowboy songs around the campfire. You sleep in wagons, tents, or outside under the stars. This family-run business has been in operation for 25 years. Trips leave Jackson, Wyoming, each Monday, Wednesday and Friday, in June, July, and August, for treks of two, four, or six days.

Prices:
2-day, $300 adults, $260 children under 16: 4-day, $560 adults, $470 children: 6-day, $750 adult, $650 children.

Contact:
Everett D. Peterson
PO Box 1156
Afton WY 83110
Tollfree: 800-447-4711
Phone: 307-886-9693
Fax: 307-886-5284
Children: All ages welcome.

Comments:
"How about adopting me and letting me cook next year? I loved it."
Woman from Connecticut.

WILDERNESS TRAVEL

"Making dreams come true" is the credo of this adventure travel company. Offering 100 trips on six continents, you can choose high mountain treks and luxurious inn-to-inn hikes, sea kayaking in Fiji, a rainforest camp with Cofan Indians in the Amazon, an elephant safari in Thailand, or a horse festival in the hidden regions of Tibetan China.

The company emphasizes cultural preservation and environmental protection, and supports several conservation and cultural groups. All trip leaders are naturalists, authors, or photographers, and experienced guides with knowledge of the language, customs, and natural history of the places you visit. Groups are kept small, with a maximum of 15 people, and participants are active, enthusiastic travelers from all walks of life.

In Africa, you can choose from several safaris to view wildlife. In South America, expeditions to Patagonia show you glaciers and whales. You can trek the famous Inca Trail to Machu Picchu, or go trekking along wilderness trails in Chile and Bolivia. In Asia, visit the breathtaking peaks of Everest and Annapurna in the Himalayas, the Karakoram Range of Pakistan, and the snow-covered mountains of Nepal. In China you follow the historic Silk Road. In Vietnam, you stay in a bamboo house on stilts.

In Europe, you hike in the Alps, walk in the medieval hill towns of Italy, or stroll through southern France. There are also trips to Ireland, the Basque country, and the highlands of Scotland.

Price includes:
Accommodations, most meals, equipment, excursions, guides, pre-trip material.

Most popular:
Galapagos Adventure, 9 days, $1,855.
Sea Kayaking Tierra del Fuego, 16 days, $2,695.
Everest Adventure, 17 days, $1,795.
Serengeti & Kilimanjaro Climb, 17 days, $3,795.

Contact:
Scott Senauke
801 Allston Way
Berkeley CA 94710
Tollfree: 800-368-2794
Phone: 510-548-0420
Fax: 510-548-0347
e-mail: info@wildernesstravel.com
Women: Often more women than men.

Comments:
"A wonderful balance of beauty, adventure, culture, and camaraderie. Keni's introduction to his customs and relatives made the trip special."
Woman on sea kayak trip in Fiji.
"Bhutan, its people and culture, were wonderful, and the high mountain walking some of the finest I've ever done." Woman on Bhutan Festival Trek.

WILDERNESS WOMEN

Founded in 1995 by Marilyn Stone of Denver, Colorado, Wilderness Women helps women experience traditionally male outdoor sports in a supportive environment in order to increase self-confidence and facilitate connections with other women.

"Brute strength is not necessarily crucial or desirable to be successful," notes Marilyn Stone. "Finesse and creativity count a bunch in outdoor sports from fly fishing to rock climbing."

In Colorado, you can join a five-day hunt for elk and mule deer during rifle season, or go fly fishing with instruction from an expert. There's a rock climbing weekend, a 25-mile-a-day bike tour in the mountains, a horsepack adventure in White River National Forest, several interpretive walks in Rocky Mountain National Park, and backpacking. Winter programs take you cross-country skiing and snowshoeing in the west, and on trips to Costa Rica.

The group offers seminars for beginners on a variety of outdoor topics including archery, kayaking, rock climbing, pistol shooting, knot tieing, avalanche awareness, winter driving, hunting, backpacking, and wilderness survival. There are monthly networking meetings in Denver, a members directory listing their interests, retail discounts, and a newsletter. Dues are $35 a year.

Price includes:
Accommodations, equipment, excursions, guides, instruction, all meals usually, pre-trip material.

Most popular:
Horseback Riding in Colorado Rockies, $150-$175 a day.
Fly Fishing on San Juan River, 4 days, $710.
Hut to Hut Cross Country Ski Trips, 4 days, $580.
Annual Wilderness Women Rendezvous, weekend, $100-$150.

Contact:
Marilyn Stone
PO Box 19777
Denver CO 80219-0777
Phone: 303-922-7700
Fax: 303-922-7700
e-mail: voodoo@aol.com
Women: Women only.
Children: No children on trips.

Comments:
"It's a great group! The cross-country skiing in Colorado with a half-day avalanche awareness training in the back country was wonderful. The whitewater rafting on the Arkansas River was great fun. On the horseback trip we rode into the wilderness for a couple of hours to a campsite with tents waiting, and the guides cooked dinner."
Woman member in Colorado.
"Beginning Archery was great. It was fun to meet other women who enjoy archery and were on the same level as myself. It's just what I needed."
Woman member from Colorado.

WILDLAND ADVENTURES

This company offers dozens of trips to exotic destinations, including Costa Rica, Peru, Belize, Africa, Ecuador, and the Galapagos Islands. Or choose an adventure honeymoon, family trip, or yoga vacations combining travel with health and personal development.

Founded in 1986 to offer authentic and personal travel experiences in the world's exotic natural environments and native cultures, a network of guides and outfitters in Latin America, Africa, and Turkey lead the trips. WA was distinguished as one of the best eco-tourism travel companies in the world by *Conde Nast Traveler* magazine.

Go to Costa Rica to explore the rain forests, the Monteverde cloud forest, and the jungles of Tortuguero, or join a Rain Forest Workshop with the Organization for Tropical Studies, led by field biologists and top naturalist guides. The Costa Rican Nosara Yoga Retreat offers hiking and horse riding with yoga, massage, aromatherapy, meditation, and vegetarian cuisine.

The safaris to Kenya and Tanzania combine vehicle drives to see game in the major national parks with a few days of wilderness camping where you hike with local Maasai natives. In Peru, you experience the best of the Amazon jungle at the Tambopata Macaw Research Center. In Turkey, you explore western Turkey with a village home-stay, and then sail along the coast in a traditional vessel, taking hikes to see ancient Greek, Roman, and Byzantine ruins. New nature and culture tours are also available in Guatemala and Panama.

Price includes:
Internal airfare, accommodations, most meals, equipment, excursions, guides, instruction, pre-departure dossier, group transportation.

Most popular:
Costa Rica: Tropics Trails Odyssey, 8 days, $1,595.
Kenya Trails Safari, 12 days, $2,295.
Turkey: Turquoise Coast Odyssey, 19 days, $2,595.

Contact:
Kurt Kutay
3516 NE 155th
Seattle WA 98155
Tollfree: 800-345-4453
Phone: 206-365-0686
Fax: 206-363-6615
e-mail: wildadve@aol.com
Website: www.wildland.com
Women: 55% of travelers are women.
Children: Generally 8 years and older.

Comments:
"The Galapagos was the highlight of my trip to Ecuador. We saw boobies, tortoises, sea lions, sharks, eels, penguins, land iguanas, etc. The water was cold but I went snorkeling anyway." Woman on Galapagos Islands trip.
"So many places and experiences I enjoyed—the stay with a village family, the fabulous scenery and food along the beautiful coast, the splendor of the palaces and mosques." Woman on Turquoise Coast Odyssey.

WOMANTOURS

Gloria Smith loves cycle touring and that enthusiasm inspired her to invite other women to share her adventures. She leads personally researched bike tours for women.

"Women working together are generous and supportive," she notes. "On a bike tour, women from all walks of life feel free to learn new skills, test their abilities, and make new friendships that can last a lifetime."

Gloria's tours take you to Yellowstone and the Grand Tetons in Wyoming, the Canyons of the Southwest, and the Canadian Rockies. For wine-lovers, there's a tour through the vineyards of California's Napa Valley to the Pacific Coast, with wine-tastings along the way. In the east, you bike along the Natchez Trace in the rolling hills of the Appalachian Mountains to the lowlands of the Mississippi River Basin, following trade routes established by Native Americans and frontier traders.

A winter escape takes you to enjoy New Zealand's summer. You bike along the east coast of South Island on quiet roads with spectacular scenery, and stay in private homes or small hotels and guesthouses. The west coast trip includes views of the snowy peaks of the Southern Alps, a farm stay, sea kayaking on a lagoon, and hiking to glaciers.

If you don't want to bike the whole way, there's no pressure—the support van is always available to ease your tired leg muscles.

Prices include:
Accommodations, guides, most meals, tips, pre-trip material, van support.

Most popular:
Southwest Utah: Zion, Bryce, Grand Canyon, 9 days, $1,160.
California Wine Tour, 6 days, $850.
New Zealand, 14 days, $1,985.

Contact:
Gloria Smith
PO Box 931
Driggs ID 83422
Tollfree: 800-247-1444
Phone: 208-354-8804
Fax: 208-354-8804
Women: All women trips.
Children: No.

Comments:
"We like men, but who needs them to show you how fast they can do it?" Gloria Smith.

WOODSWOMEN INC.

Dedicated to providing educational, comfortable, safe experiences for women of all ages in some of the most beautiful places on the planet, Woodswomen began in 1977 with a few canoe trips for women. Today, its catalog lists dozens of adventure trips in the US and abroad, and more than 8,000 women have participated in their programs.

"Women report incredible benefits from these experiences," notes Peggy Willens, the administrative manager. "Some participants see themselves as active and capable outdoorswomen for the first time, while other use the experience to commemorate an important transition in their lives. For many women over 45 or 50, they come away with an increased appreciation of their own skills and strengths."

In winter, there's dogsledding and cross-country skiing in Minnesota. In summer you can take a horseback riding weekend in Wisconsin to a campsite on the banks of a lake, with a full day's ride through woodlands and over streams. You can go canoeing on the Namekagon River or Rainbow Island. Visit Alaska for a sea kayaking adventure paddling about five hours a day to see porpoises, whales, otters, seals, and birds, with campsites along the way.

In Cozumel, Mexico, you snorkel and sunbathe on the beaches and bike to historic ruins and untouched beaches. In Ecuador, you visit open-air markets and snow-capped volcanoes, and cruise the Galapagos Islands to see green sea turtles, iguana, pelicans, and penguins. On an African safari, you visit the Serengeti and experience a trek on 19,000-foot Mount Kilimanjaro.

Price includes:
Accommodations, equipment, guides, instruction, most meals, pre-trip material, land transportation.

Most popular:
Horsepacking in Wisconsin, 4 days, $375.
Kenai Fjords Sea Kayaking, 6 days, $995.
Galapagos Islands Cruise, 12 days, $3,450.
Grand Canyon Backpack, 10 days, $685.

Contact:
Peggy Willens
25 West Diamond Lake Road
Minneapolis MN 55419
Tollfree: 800-279-055
Phone: 612-822-3809
Fax: 612-822-3814
Women: Women only.
Children: 5 to 11 years old most popular ages.

Comments:
"The accomplishment that I felt at the completion meant a lot to me. I had kayaked for the first time, braved the wet, rainy weather without losing it, and met some great women." Woman on sea kayaking trip.
"I liked the encouragement and support; demonstrations of one-to-one guiding; sense of humor displayed by guides. Lots of caring and concern for us all!"
Woman on climbing trip.

YELLOWSTONE LLAMAS

If you've never met a llama before, be prepared for a pleasant surprise. They are gentle sure-footed creatures, smaller than horses, graze much like deer, and have soft padded feet that leave almost no impact on fragile alpine trails. They have been domesticated in South America for over 4,000 years, but have only recently become popular in this country, mainly to carry packs on their backs on hiking trips. Anyone can lead a llama after only a few minutes of basic instructions because they are cooperative, quiet, gentle, and hardworking.

Since llamas carry the heavy gear, you hike with a light daypack. The Gavins lead llama treks to several Montana destinations. A short hike takes you to the Black Canyon of the Yellowstone, where you descend into the canyon along a rushing river, with great trout fishing. The hike to Lost Cabin Lake begins at 7,600 feet near abandoned gold mines, takes you through pine forest to a campsite in a huge meadow, before a short hike to Lost Cabin Lake at 9,000 feet.

Renee and Will Gavin have been leading llama treks for 14 seasons in the Northern Rockies, and have been operating an outfitting business and breeding farm since 1984. Will is an active outdoorsman, mountaineer, and backpacker with over 20 years experience in the Rocky Mountains. He's also a professional geologist. Renee was a practicing attorney who now devotes her time to the llama farm and freelance writing. They've produced a video series called *All About Llamas* to educate llama owners.

Price includes:
Accommodations camping, equipment, excursions, guides, instruction, fishing, all meals, land transportation, llamas as pack animals.

Most popular:
Campfire Lake Trek, 5 days, $800.
Lost Cabin Lake Trek, 4 days, $640.
Black Canyon Trek in Yellowstone Park, 3 days, $480.

Contact:
Renee Gavin
Box 5042
Bozeman MT 58717
Phone: 406-586-6872
Fax: 406-586-9612
e-mail: llamas@mcn.net
Women: 80% of time more women than men.
Children: Age 7 and older.

Comments:
"The llama is one of the nicest creatures anybody went for a walk with. They carried ice chests full of the good food the Gavins prepare in their farm kitchen."
Woman on llama trek.

A Day With Yellowstone Llamas
by Renee & Will Gavin

Our days start with the smell of coffee on a crisp mountain morning. As the sun climbs over the mountain peaks, a hearty breakfast gets you ready for a day of hiking through some of the most beautiful country in the United States. After the llamas are loaded with camping equipment, we usually hike three to eight miles at a comfortable pace to the next camping site. There we will have a leisurely lunch while the guides set up camp and take care of the llamas.

After lunch you can hike around the area to view the spectacular scenery, fish, or just relax around camp with a good book and watch the llamas peacefully grazing in an alpine meadow. As the sun starts to set, hors d'oeuvres are served and the wine is opened while dinner is prepared. The peaks turn a rose red from the alpenglow, and trout quietly break the surface of a high mountain lake. We happily feast on a superb meal.

APPENDICES

TRIP REFERENCE LISTS

GEOGRAPHIC DESTINATIONS
In the USA
Adventure Alaska Tours
Adventure Bound
Alaska Wildland
American Dude Ranches
American Wilderness Experience (AWE!)
Annapolis Sailing School
Call of the Wild
Colorado River Outfitters Association
Country Walkers
Crow Canyon Archaeological Center
Earthwatch
Echo: The Wilderness Company
Expeditions, Inc.
Experience Plus!
Hawk, I'm Your Sister

Horse Riding Vacations
 Bar H Ranch
 Boojum Expeditions
 Equitours
 FITS Equestrian
Hostelling International
Hurricane Creek Llama Treks
National Women's Sailing Assocation
Nature Expeditions International
Nichols Expeditions
Northern Lights Expeditions, Ltd.
Offshore Sailing School
Outdoor Vacations for Women Over 40
Rainbow Adventures
Rocky Mountain River Tours
Vermont State Parks
Victory Chimes Windjammer
Wagon Train Trips
 Flint Hills Overland Wagon Trips
 Oregon Trail Wagon Train
 Wyoming Wagons West
Wilderness Women
WomanTours
Woodswomen Inc.
Yellowstone Llamas

Africa

Bicycle Africa Tours
Country Walkers
Earthwatch
Horse Riding Vacations
 Equitours
 FITS Equestrian
International Expeditions
Journeys International
Nature Expeditions International
Overseas Adventure Travel
Rainbow Adventures
Wilderness Travel

Wildland Adventures
Woodswomen Inc.

Asia
Archaeological Tours
Country Walkers
Earthwatch
Himalayan High Treks
Horse Riding Vacations:
 Boojum Expeditions
International Expeditions
Myths and Mountains
Nature Expeditions International
Overseas Adventure Travel
Rainbow Adventures
Wilderness Travel
Wildland Adventures

Australia & New Zealand
Country Walkers
Earthwatch
International Expeditions
Journeys International
Overseas Adventure Travel
Wilderness Travel
Womantours

Canada
American Wilderness Experience
Earthwatch
Horse Riding Vacations:
 Warner Guiding & Outfitting

Caribbean, Mexico & Hawaii
American Wilderness Experience
Annapolis Sailing School
Earthwatch
Hawk, I'm Your Sister

Horse Riding Vacations:
 Boojum Expeditions
 Equitours
 FITS Equestrian
International Expeditions
Journeys International
National Women's Sailing Association
Nature Expeditions International
Offshore Sailing School
Outdoor Vacations for Women Over 40
Overseas Adventure Travel
Rainbow Adventures
Wilderness Travel
Woodswomen Inc.

Central & South America
American Wilderness Experience
Country Walkers
Earthwatch
Experience Plus!
Explorations, Inc.
Hawk, I'm Your Sister
Horse Riding Vacations:
 Boojum Expeditions
 Equitours
 FITS Equestrian
International Expeditions
Journeys International
Nature Expeditions International
Overseas Adventure Travel
Wilderness Travel
Wilderness Women
Wildland Adventures
Woodswomen Inc.

Europe
Country Walkers
Earthwatch
Experience Plus!

Horse Riding Vacations:
Equitours
FITS Equestrian
Outdoor Vacations for Women Over 40
Wilderness Travel

SPECIALIZED VACATIONS
All-Women Vacations
Bar H Ranch
Call of the Wild
Hawk, I'm Your Sister
National Women's Sailing Association
Outdoor Vacations for Women Over 40
Rainbow Adventures
Wilderness Women
Womantours
Woodswomen Inc.

Bicycle Touring and Horse Riding
American Dude Ranches
American Wilderness Experience
Bicycle Africa Tours
Experience Plus!
Horse Riding Vacations
 American Wilderness Experience
 Bar H Ranch
 Boojum Expeditions
 Equitours
 FITS Equestrian
 Warner Guiding & Outfitting
Nichols Expeditions
Rainbow Adventures
Wagon Train Trips
 Flint Hills Overland Wagon Train Trips
 Oregon Trail Wagon Train
 Wyoming Wagons West
Wilderness Travel
Womantours
Woodswomen Inc.

Climbing Mountains
Call of the Wild
Himalayan High Treks
Journeys International
Myths and Mountains
Overseas Adventure Travel
Rainbow Adventures
Wilderness Travel
Wilderness Women
Woodswomen Inc.

Hiking & Walking
Adventure Alaska Tours
Alaska Wildland
American Wilderness Experience
Archaeological Tours
Call of the Wild
Country Walkers
Crow Canyon Archaeological Center
Earthwatch
Experience Plus!
Explorations, Inc.
Himalayan High Treks
Hurricane Creek Llama Treks
International Expeditions
Journeys International
Myths and Mountains
Nature Expeditions International
Nichols Expeditions
Outdoor Vacations for Women Over 40
Overseas Adventure Travel
Rainbow Adventures
Vermont State Parks
Wilderness Travel
Wilderness Women
Wildland Adventures
WomanTours
Woodswomen Inc.
Yellowstone Llamas

On the Water Vacations
Adventure Alaska Tours
Adventure Bound
Alaska Wildland
American Wilderness Experience
Annapolis Sailing School
Colorado River Outfitters Association
Echo: The Wilderness Company
Explorations, Inc.
Hawk, I'm Your Sister
International Expeditions
Journeys International
National Women's Sailing Association
Nature Expeditions International
Nichols Expeditions
Northern Lights Expeditions
Offshore Sailing School
Outdoor Vacations for Women Over 40
Rainbow Adventures
Rocky Mountain River Tours
Victory Chimes Windjammer
Wilderness Travel
Wildland Adventures
WomanTours
Woodswomen Inc.

Sports Vacations
American Wilderness Experience
Annapolis Sailing School
Colorado River Outfitters Association
Echo: The Wilderness Company
Expeditions, Inc.
Experience Plus!
Hawk, I'm Your Sister
National Women's Sailing Association
Nichols Expeditions
Northern Lights Expeditions
Offshore Sailing School
Outdoor Vacations for Women Over 40

Overseas Adventure Travel
Rainbow Adventures
Rocky Mountain River Tours
Victory Chimes Windjammer
Wilderness Women
WomanTours
Woodswomen Inc.

Off the Beaten Track
Adventure Alaska Tours
Alaska Wildland
Archaeological Tours
Bicycle Africa Tours
Call of the Wild
Earthwatch
Expeditions, Inc.
Experience Plus!
Explorations, Inc.
Hawk, I'm Your Sister
Himalayan High Treks
Horse Riding Vacations
Hurricane Creek Llama Treks
International Expeditions
Journeys International
Myths and Mountains
Nature Expeditions International
Nichols Expeditions
Northern Lights Expeditions
Outdoor Vacations for Women Over 40
Overseas Adventure Travel
Victory Chimes Windjammer
Wilderness Travel
Wildland Adventures
WomanTours
Woodswomen Inc.
Yellowstone Llamas

Bibliography

Grateful acknowledgment is made to the following for permission to reprint previously published material. Any errors or omissions in the list are entirely unintentional. If notified, the publisher will be pleased to make any additions or amendments at the earliest opportunity.

Anthologies:
Celebrated Women Travellers of the Nineteenth Century by W. H. Davenport Adams (W. Swan Sonnenschein & Co., London, 1883).

Maiden Voyages, Mary Morris, editor (Vintage Books, 1993).

Travelers' Tales: A Woman's World, MaryBeth Bond, editor (Travelers Tales/O'Reilly & Associates, 1995).

Unsuitable for Ladies, Jane Robinson, editor (Oxford University Press, 1994).

Books and Publications:
Archibald, Julia A., "A Journey to Pike's Peak," *The Sibyl* magazine, April 1, 1859 (Middletown, NY, Vol. III, No. 19).

Berners, Dame Juliana, "The Treatise of Fishing with an Angle," *Maiden Voyages* magazine, Summer 1996.

Bird, Isabella L., *Six Months in the Sandwich Islands* (Charles E. Tuttle, Tokyo, Japan, 1974: John Murray, London, England, 1890).

Birtles, Dora, *North-west by North* (Jonathan Cape Ltd., London, 1935; Virago Press/Beacon Press, Boston, 1987).

Burton, Lady Isabel (excerpt from anthology).

Cameron, Agnes Deans, *The New North; an account of a woman's 1908 journey through Canada to the Arctic* (Western Producer Prairie Books, Saskatchewan, 1986).

Cole, Mrs. H. W., *A Lady's Tour Round Monte Rosa* (Longman, London, 1859)

David-Neel, Alexandra, *My Journey to Lhasa* (Heinemann Ltd., London, 1927; Virago Press, London, 1986).

D'Aunet, Leonie (excerpt from anthology).

Davidson, Lillias Campbell (excerpt from anthology).

Edwards, Amelia, *A Thousand Miles Up The Nile* (G. Routledge and Sons, London, 1891; J. P. Tarcher Inc., Los Angeles, 1983).

Eyre, Mary (excerpt from anthology).

Hall, Sharlot Mabridth, *Sharlot Hall On The Arizona Strip*, edited by C. Gregory Crampton. (Northland Press, Arizona, 1975).

Haun, Catherine, from *Women's Diaries of the Westward Journey*, edited by Lillian Schlissel (Schocken Books, New York, 1982)

Kenney, Cale, "Après Ski," from *Howlings: Wild Women of the West*, (Winter 1996).

Martineau, Harriet (excerpt from anthology).

Pfeiffer, Ida, *A Lady's Voyage Round the World* (Longman, London, 1851; Century Hutchinson, London, 1988).

Selby, Bettina, *Riding to Jerusalem: A Journey Through Turkey and the Middle East* (Little Brown and Co., 1985).

Seton-Thompson, Grace Gallatin, *A Woman Tenderfoot* (Doubleday, Page and Co., New York, 1900).

Smith, Agnes (excerpt from anthology).

Tweedie, Ethel Brilliana, *A Girl's Ride in Iceland* (excerpt from anthology).

Workman, Fanny Bullock and William Hunter Workman, *Algerian Memories* (Anson D. F. Randolph & Co., New York, 1895).

Workman, Fanny Bullock and William Hunter Workman, *In the Ice World of Himalaya* (New York: Cassell & Company Limited: 1901).

Publications:

Howlings: Wild Women of the West, Kenney Communications, PO Box 6004, Denver, CO 80206 (303-355-6601).

Maiden Voyages Magazine, 109 Minna Street, Suite 240, San Francisco, CA 94105 (510-528-8425), e-mail: info@maidenvoyages.com

Journeywoman, 50 Prince Arthur Avenue, Suite 1703, Toronto, Canada M5R 1B5 (416-929-7654), e-mail: jwoman@web.net

Wilderness Women Newsletter, PO Box 19777, Denver, CO 80217-0777 (303-922-7700) e-mail: voodoo@aol.com

Women's Cycling, 135 N. Sixth Street, Emmaus, PA 18098, (610-987-8663), e-mail: DWBicMag@aol.com

Womens Sports and Fitness, 2025 Pearl Street, Boulder, CO 80302 (303-440-5111).

Woodswomen News, 25 West Diamond Lake Rd., Minneapolis, MN 55419 (800-279-0555).

Recommended Adventure Travel Books

Alexander, Caroline, *One Dry Season: In the Footsteps of Mary Kingsley* (Vintage Departures, New York, 1991).

Bird, Isabella, *A Lady's Life in the Rocky Mountains* (Virago, London, 1986).
> *Unbeaten Tracks in Japan* (Virago/Beacon, Boston, 1987).
> *The Golden Chersonese* (Century, London, 1983).
> *Journeys in Persia and Kurdistan* (Virago, London, 1988).
> *Korea and Her Neighbors* (Tuttle, Vermont/Japan, 1986).
> *Yangtze Valley and Beyond* (Virago/Beacon, Boston, 1987).

Bryson, Bill, *The Lost Continent* (Harper, New York, 1989).

Cahill, Tim, *Jaguars Ripped My Flesh* (Bantam, New York, 1987).

Davidson, Robyn, *Tracks* (Pantheon Books, New York, 1980).

Dodwell, Christina, *A Traveller on Horseback* (Sceptre/Hodder & Stoughton, 1988).

Edwards, Amelia, *Untrodden Peaks & Unfrequented Valleys* (Virago/Beacon, Boston, 1987).

Frank, Katherine, *A Voyager Out: The Life of Mary Kingsley* (Ballantine, New York, 1987).

Gellhorn, Martha, *Travels with Myself and Another* (Eland Books, 1978).

Hansen, Eric, *Motoring With Mohammed* (Houghton Mifflin, Boston, 1991).

Huxley, Elspeth, *The Mottled Lizard* (Penguin Group, 1981).

Iyer, Pico, *Video Night in Kathmandu* (Vintage, New York, 1989).

Kaye, Evelyn, *Amazing Traveler Isabella Bird* (Blue Penguin, Colorado, 1994).

LaBastille, Anne, *Women and Wilderness* (Sierra Club Books, 1980).

Markham, Beryl, *West With The Night* (Virago, 1984).

Miller, Luree, *On Top Of The World* (The Mountaineers, Washington, 1984).

Mackworth, Cecily, *The Destiny of Isabelle Eberhardt* (Ecco, New York, 1975).

Olds, Elizabeth Fagg, *Women of the Four Winds* (Houghton Mifflin, Boston, 1985).

Rapaport, Roger, & Marguerita Castanera, editors, *I should have stayed home* (Book Passage Press, California, 1994).

Scott, Evelyn, *Escapade* (Penguin Books, 1987).

Settle, Mary Lee, *Turkish Reflections* (Touchstone, New York, 1991).

Stark, Freya, *The Valleys of the Assassins* (J. P. Tarcher, Los Angeles, 1983).

Thayer, Helen, *Polar Dream* (Delta/Dell, 1993).

Waugh, Evelyn, *Scoop* (Little Brown, Boston, 1977).

THANKS AND ACKNOWLEDGMENTS

This has been a fascinating book to research and write. I discovered so many interesting women who've taken great adventure vacations and were delighted to tell me about them. I also read and selected from the writings of daring women from the past who loved adventurous travel but were hampered by voluminous skirts and limited opportunities. In addition, I learned about the growing number of companies that specialize in adventure travel for women, as well as traditional companies that offer a few women-only trips—two new developments in this area.

This book couldn't have happened without Boulder Media Women, whose Friday morning coffees and monthly potlucks have been the inspiration for so many good ideas. My special appreciation to BMW members Claire Walter, Diana Somerville, Reed Glenn, and Kathryn Black for contributing such excellent articles to the book.

Sincere thanks also to all those creative women who responded to my request for submissions, including members of the American Society of Journalists and Authors, particularly Sally Wendkos Olds. I could not use every submission, but I read them all. I was delighted to discover excellent writers in

magazines when I was looking for relevant articles, and appreciate their permission to reprint. Every writer included in the book owns the copyright to her article; should you be interested in reprints or excerpts, please contact the publisher and we'll pass the request on.

One of the most enjoyable parts of my research was to interview women around the country who had recently taken adventure travel vacations with companies listed in the book. I thoroughly enjoyed talking with them and acknowledge the first-hand recommendations of: Pat Davis, Michelle Smith, Barbara Mansfield, Susan Graham, Francine Herrick, Jeannette Vasilakes, Elaine Frances, Sondra Zeidenstein, May Pulliam, Mary Ann Kerins, Nancy Lee Malm, Gail Podrabsky, Wanda Bravdica, Helen Feldmeier, Ann Uphoff, Susan Johnson, Patty Pilz, Susan Percer, Linda Roth, Esther Price, Nancy Lehton, and Jeanna French. Their names were given to me by the selected organizations included in the book.

My deep appreciation to Laura Caruso and Janet Gardner, who took the time to read through the manuscript and tell me what they thought. Thanks to Sallie Greenwood, who let me browse through her excellent collection of books by and about 19th century women travelers to find some of the pieces for the book. Thanks also to Sheryl Shapiro for her speedy copy-editing. And many thanks to the dedicated women—and men— who wrote, researched, and published books by and about women travelers.

Finally, and most important, my unlimited, adoring, and grateful appreciation to my fantastic partner and husband, Christopher Sarson, for designing and creating the layout for this book, our eighth publication together. It is amazing that once again we managed to get through the arduous and demanding process and are still speaking to each other. Our computers are perfectly compatible, but the human element is always more volatile.

STATE TOURIST BUREAUS

Alabama Bureau of Tourism
532 South Perry Street
Montgomery AL 36130
205-261-4169: 800-392-8096

Alaska Division of Tourism
PO Box E
Juneau AK 99811
907-465-2010

Arizona Tourism Office
1480 E. Bethany Home Road
Phoenix AZ 85014
602-255-3618

Arkansas Department of Parks
One Capitol Mall
Little Rock AR 72201
501-682-7777: 800-643-8383

California Tourism Office
1121 L Street
Sacramento CA 95814
916-322-2882: 800-TO-CALIF

Colorado at Denver Visitor Bureau
225 West Colfax
Denver CO 80202
Phone: 303-892-1505: 800-645-3446

Connecticut Dept. of Tourism
370 Asylum Street
Hartford CT 06103
203-244-1900: 800-243-1685

DC Visitors Association
1575 I St., NW, Suite 250
Washington DC 20005
202-787-7000

Delaware Tourism Office
99 Kings Highway
PO Box 1401
Dover DE 19903
302-736-4271: 800-441-8846

Florida Division of Tourism
126 Van Buren Street
Tallahassee FL 32301
904-487-1462

Georgia Department of Tourism
PO Box 1776
Atlanta GA 30301
404-656-3590

Hawaii Visitors Bureau
2270 Kala Kaua Avenue
Honolulu HI 96800
808-923-1811

Idaho Travel Council
State Capitol Building
Boise ID 83720
208-334-2470: 800-635-7820

Illinois Travel Center
Department of Commerce
310 S. Michigan Avenue, #108
Chicago IL 60604
312-793-2094: 800-223-0121

Indiana Department of Commerce
Tourist Development
1 North Capitol Street
Indianapolis IN 46204
317-232-8860: 800-2-WANDER

Iowa Tourist Travel
600 East Court Avenue
Des Moines IA 50309
515-281-3100: 800-345-IOWA

Kansas Department of Travel
400 West 8th Street/5th floor
Topeka KS 66603
914-296-2009

Kentucky Department of Travel
2200 Capitol Plaza Tower
Frankfort KY 40601
502-564-4930: 800-225-TRIP

Louisiana Office of Tourism
PO Box 94291
Baton Rouge LA 70804
504-925-3860: 800-334-8626

Maine Division of Tourism
97 Winthrop Street
Hallowell ME 04347
207-289-2423: 800-533-9595

Maryland Office of Tourism
45 Calvert Street
Annapolis MD 21401
301-974-3519: 800-331-1750

Massachusetts Division of Tourism
100 Cambridge Street
Boston MA 02202
617-727-3201: 800-942-MASS

Michigan Travel Bureau
PO Box 30226
Lansing MI 48909
517-373-0670: 800-543-2YES

Minnesota Office of Tourism
250 Skyway Level
375 Jackson Street
St. Paul MN 55101
612-296-5029: 800-328-1461

Mississippi Division of Tourism
1301 Walter Sillers Building
PO Box 849
Jackson MS 39025
601-359-3426: 800-647-2290

Missouri Division of Tourism
Truman State Office Building
PO PO Box 1055
Jefferson City MO 65102
314-751-4133

Montana Travel Division
1424 9th Avenue
Helena MT 59620
406-444-2654: 800-541-1447

Nebraska Division of Tourism
301 Centennial Mall South
PO PO Box 94666
Lincoln NE 68509
402-471-3794: 800-228-4307

Nevada Commission of Tourism
State Capitol Complex
Carson City NV 89710
702-885-3636: 800-NEV-ADA8

New Hampshire Office of Vacation Travel
PO PO Box 856
Concord NH 03301
603-271-2665

New Jersey Office of Tourism
CN-826
20 West State Street
Trenton NJ 08625
609-292-2470: 800-JER-SEY7

New Mexico Tourism
Joseph Montoya Building
1100 St. Francis Drive
Santa Fe NM 87503
505-827-0291: 800-545-2040

New York Division of Tourism
One Commerce Plaza
Albany NY 12245
518-474-4116: 800-CALL-NYS

North Carolina Tourism Division
430 Salisbury Street
PO Box 25249
Raleigh NC 27611
919-733-4171: 800--VIS-ITNC

North Dakota Tourism Division
Liberty Memorial Building
Capitol Grounds
Bismarck ND 58505
701-224-2525: 800-472-2100

Ohio Department of Tourism
PO Box 1001
Columbus OH 43266
614-466-8844: 800-BUC-KEYE

Oklahoma Tourism Department
505 Will Rogers Building
Oklahoma City OK 73105
405-521-2406: 800-652-6552

Oregon Division of Tourism
539 Cottage Street NE
Salem OR 97310
503-378-3451: 800-547-7842

Pennsylvania Travel Department
416 Forum Building
Harrisburg PA 17120
717-787-5453: 800-VIS-ITPA

Rhode Island Tourism
7 Jackson Walkway
Providence RI 02903
401-277-2601: 800-556-2484

South Carolina Department of Parks,
Recreation & Tourism
PO Box 71
Columbia SC 29202
803-734-0122

South Dakota Tourism
Capitol Lake Plaza
711 Wells Avenue
Pierre SD 57501
605-773-3301: 800-843-8000

Tennessee Department of Tourism
PO Box 23170
Nashville TN 37202
615-741-2158

Texas Travel Information
PO Box 5064
Austin TX 78763
512-462-9191

Utah Travel Council
Council Hall
Capital Hill
Salt Lake City UT 84114
801-533-5681

Vermont Travel Division
134 State Street
Montpelier VT 05602
802-828-3236

Virginia Division of Tourism
Suite 500
202 West 9th Street
Richmond VA 23219
804-786-2951: 800-VIS-ITVA

Washington State Tourism
101 General Administration Building
Olympia WA 98504
206-753-5600: 800-544-1800

West Virginia Tourism Office
State Capitol Complex
Charleston WV 25305
304-348-2286: 800-CAL-LWVA

Wisconsin Division of Tourism
123 West Washington Avenue
PO PO Box 7606
Madison WI 53707
608-266-2161: 800-432-TRIP

Wyoming Travel Commission
Frank Norris Travel Center
I-25 & College Drive
Cheyenne WY 82002-0660
307-777-7777: 800-225-5996

USA TERRITORIES
American Samoa Government
Office of Tourism
PO PO Box 1147
Pago AS 96799
684-633-5187

Guam Visitors Bureau
Pale San Vitores Road
PO PO Box 3520
Agana GU 96910
Phone: 671-646-5278

Marianas Visitors Bureau
PO PO Box 861
Saipan, CM
Mariana Islands 96950
670-234-8327

Puerto Rico Tourism Company
PO PO Box 125268
Miami FL 33102-5268
212-541-6630: 800-223-6530

US Virgin Islands
Division of Tourism
PO Box 6400, Vitia
Charlotte Amalie
St. Thomas, USVI 00801
809-774-8784: 800-372-8784

INDEX

BOOKS BY EVELYN KAYE

Active Woman Vacation Guide

Exciting descriptions of world-wide adventure vacations where you hike, bike, climb, sail, horsepack, trek, scuba, and river-raft, PLUS true stories by women travelers of yesterday and today.

$17.95. 250 pages, softcover, photos, resource lists, index. ISBN 0-9626231-8-0.

Amazing Traveler Isabella Bird

Spectacular biography tells inspiring story of a 19th century Englishwoman who defied convention and her own ill health to become the outstanding explorer and travel author of her day.

"I can't wait to take this one home and spend the weekend with Isabella Bird." *Feminist Bookstore News*

$19.95. 224 pages, softcover, photos, bibliography, index. ISBN 0-9626231-6-4.

Free Vacations & Bargain Adventures in the USA

FREE vacations in state and national parks around the USA when you volunteer to lead nature walks or welcome visitors to campgrounds. Also bargain outdoor adventures—hiking, biking, canoeing, and rafting—that preserve the environment.

"This book gives countless details, and comments from people who have taken the vacations." *TCE Newsletter, New York*

$19.95. 250 pages, softcover, illustrations, resource lists, index. ISBN 0-9626231-7-2.

Travel and Learn:
Where to go for Everything You'd Love to Know

Award-winning guide in new 3rd edition describes more than 2,000 outstanding educational vacations with museums, universities, colleges and groups around the world.

"A handy and concise reference guide. Clearly written and well-organized." *ALA Booklist*

$19.95. 250 pages, softcover, illustrations, resource lists, index. ISBN 0-9626231-5-6.

Family Travel: Terrific New Vacations for Today's Families

Exciting and affordable vacations recommended by real parents! Discover dinosaur digs, dude ranches, house exchange, European trips, ski vacation bargains, and farm stays.

"Good for families seeking alternatives to theme parks and expensive hotels." *Backpacker.*

$19.95. 220 pages, softcover, illustrations, resource lists, index. ISBN 0-9626231-3-X.

ORDER toll-free 1-800-800-8147

with your Visa or MasterCard.

or write:

BPP Sales
3031 Fifth Street
Boulder, CO 80304-2501
Phone: 303-449-8474
Fax: 303-449-8525

Please send:

ACTIVE WOMAN ___ copies @ $17.95

AMAZING TRAVELER ___ copies @ $19.95

FREE VACATIONS ___ copies @ $19.95

TRAVEL AND LEARN ___ copies @ $19.95

FAMILY TRAVEL ___ copies @ $19.95

Shipping & Handling: $4 per book

10% discount for 2 or more books

TOTAL ..

Method of Payment:

❑ Enclosed is my check payable to Blue Panda Publications
❑ Please charge my Visa/MasterCard:

 # _____

 expires _____

Address:

Street: _____

City: _____ State: ___ ZIP: _____

Phone: _____

BPP Guarantee:

Your money back if you are not completely satisfied!
No questions asked!